MAINE ON GLASS

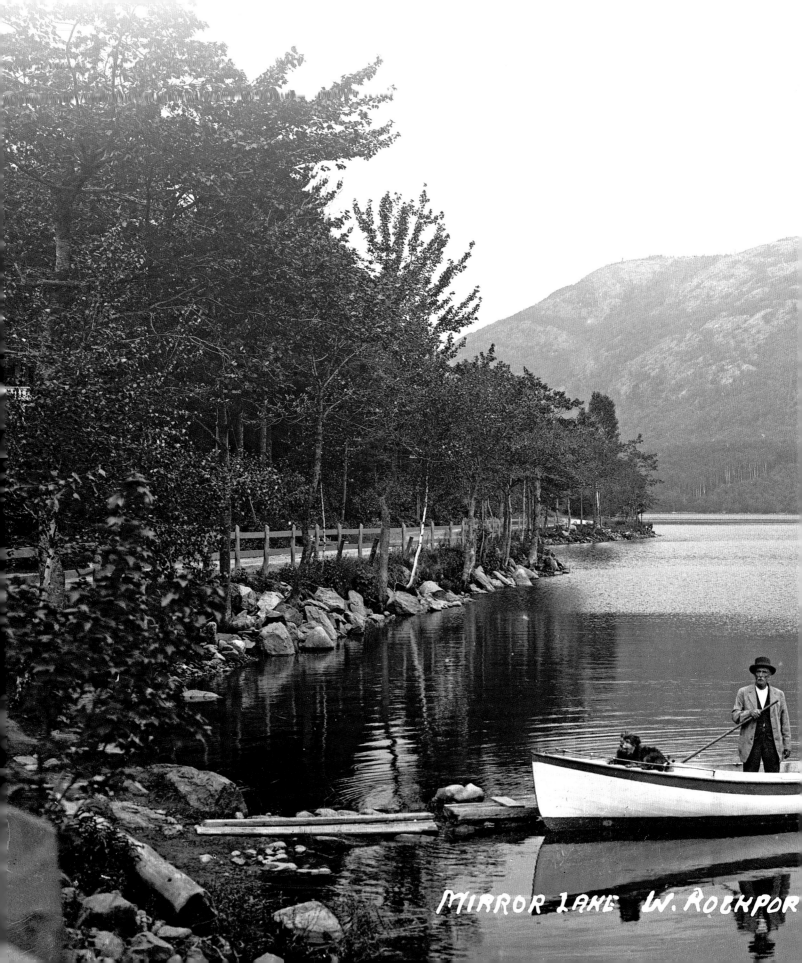

MIRROR LAKE W. ROCKPOR

MAINE ON GLASS

The Early Twentieth Century in Glass Plate Photography

W. H. BUNTING, KEVIN JOHNSON, *and* EARLE G. SHETTLEWORTH, JR.

Published with the Penobscot Marine Museum

TILBURY HOUSE
PUBLISHERS

16.

Tilbury House Publishers
12 Starr Street
Thomaston, Maine 04861

800-582-1899
www.tilburyhouse.com

ISBN 978-0-88448-378-6
First Printing: August 2016

Library of Congress Control Number: 2016943732

Text and Jacket design by Lynda Chilton, Chilton Creative
Printing and binding by Versa Press, East Peoria, Illinois

14 15 16 17 18 19 VER 10 9 8 7 6 5 4 3 2 1

To Wayne Hamilton and Polly Saltonstall, whose support
for the acquisition and archiving of the Eastern
Illustrating and Publishing Company Collection made this book
possible, and to the many volunteers who
have helped along the way.

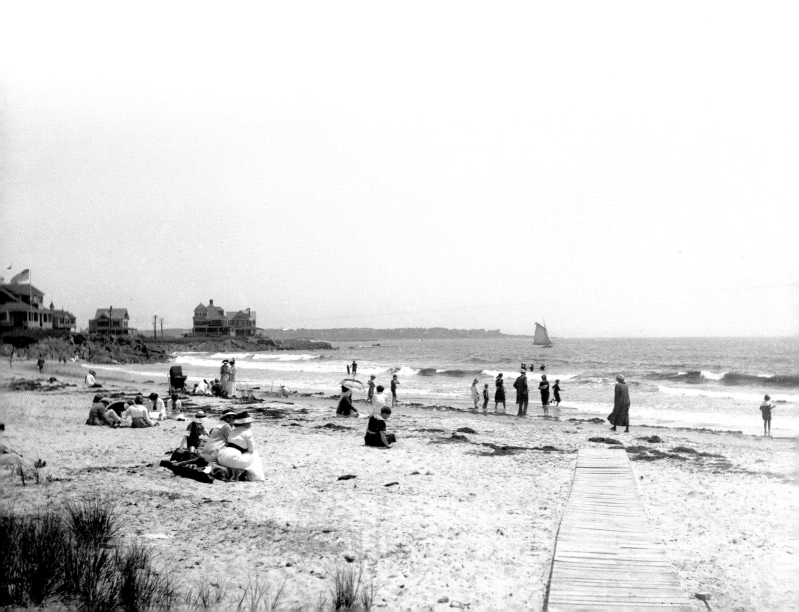

TABLE OF CONTENTS

Lincoln County

Dresden, 50

East Boothbay, 52

Boothbay Harbor, 54

Southport, 56

Monhegan Island, 58

Sagadahoc County

Woolwich, 60

Bath, 64

Phippsburg, 66

Cumberland County

Brunswick, 68

Androscoggin County

Danville Junction,

Auburn, 68

Cumberland County

New Gloucester, 70

South Portland, 72

York County

Biddeford Pool, 73

Biddeford, 74

Kennebunkport, 75

Limerick, 76

York, 77

Denmark, 78

Harrison, 79

Oxford County

Albany, 80

Rumford, 81

East Peru, 82

East Dixfield, 83

Franklin County

Rangeley, 84

Stetsontown Township,
Rangeley Lakes Region, 86

Phillips, 90

Weld, 92

North Jay, 93

Jay, 94

Farmington, 95

Kennebec County

Vienna, 96

Somerset County

Smithfield, 97

Madison, 98

Solon, 99

Cambridge, 100

Ripley, 101

East Dover, 102

Piscataquis County

Derby Village at Milo Junction, Milo, 103

Abbott, 104

Monson, 105

Somerset County

Misery Gore, 106

Rockwood, 107

Piscataquis County

T3 R11 WELS, 108

Sebois Stream, T6 R7 WELS, 109

Penobscot County

Patten, 110

Aroostook County

Island Falls, 112

Masardis, 114

Ashland, 115

Portage, 119

Eagle Lake, 120

Fort Kent, 123

Upper Frenchville, 124

Daigle, New Canada Township, 125

Van Buren, 126

Caribou, 127

Fort Fairfield, 128

Easton, 134

Mars Hill, 135

Houlton, 136

Wytopitlock Village, Reed Township, 137

Washington County

Danforth, 140

Baileyville, 141

Calais, 144

Pembroke, 146

Dennysville, 147

North Lubec, 148

Columbia Falls, 150

Jonesport, 152

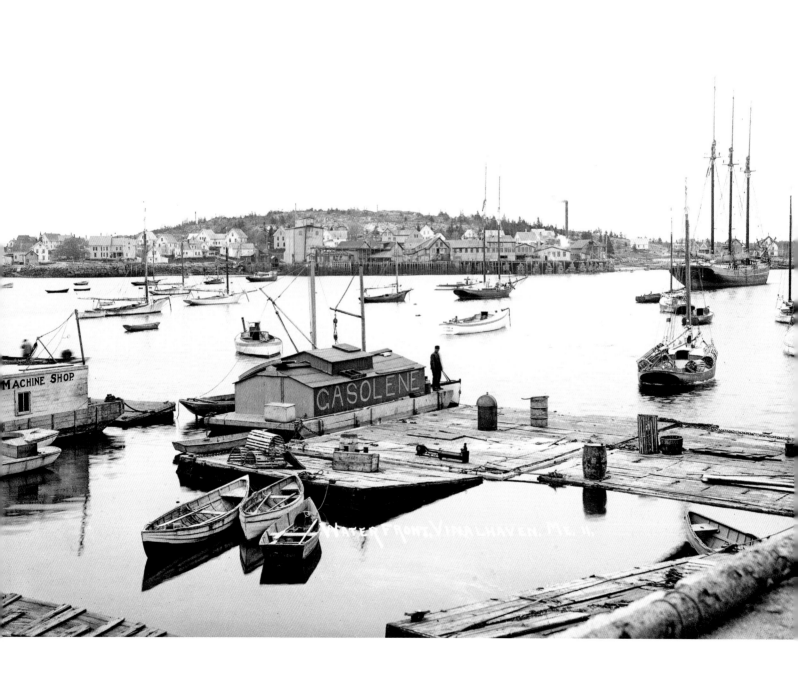

MACHINE SHOP.

GASOLENE

WATER FRONT, VINALHAVEN, ME.

PREFACE

When I started collecting Maine postcards as a child in the 1950s, I read an advertisement in *The Antique Trader,* a weekly trade paper, for the Eastern Illustrating & Publishing Company in Belfast. A self-addressed, stamped envelope brought me a mimeographed list of photo postcards of Maine steamships, trains, lighthouses, and other popular subjects. At ten cents each, I ordered reissued cards featuring black-and-white photos of views that went back almost fifty years. In the 1950s Eastern had been in business long enough to come full circle, marketing copies of some of its earliest images as collector's items.

Eastern Illustrating continued to produce postcards until its sale to *Down East* magazine in 1989. *Down East*'s plans to sell reproductions of historic postcards and use Eastern images in its publications never materialized. Instead, the company's 35,000 negatives, both glass and celluloid, were donated in 1993 to the Maine Photographic Workshops in Rockport.

The cataloging of the collection was underway when it was given to the Penobscot Marine Museum in Searsport in 2007. With the collection came its talented and devoted curator, Kevin Johnson. Under Kevin's leadership, the collection has flourished at the museum. Large-scale digitization projects have been accomplished, and 15,000 more Eastern negatives have been located and repatriated to the collection. The on-line accessibility of the extraordinary Eastern archive has become a model for other institutions.

The desire to share the wealth of historical images in the Eastern collection is the motivating force behind this book. For our journey through these photographs, we could have no better guide than William H. Bunting, the author of *Portrait of a Port: Boston 1852 to 1914; A Day's Work; Live Yankees; Sea Struck;* and other books. Bunting is a master of interpreting the contents of old photographs, and his insightful and illuminating commentaries for the pictures in *Maine on Glass* are no exception. Each of Bill's brief essays adds to our understanding of Maine life a century ago.

Back in the 1950s, a premium was placed on colored postcards mass-produced by lithography. Gradually, however, collectors and dealers came to appreciate the quality and range of images found in real photo postcards. As Rosamond B. Vaule states in her book *As We Were,* "Known as 'real photos,' these were real photographs, aristocrats of the genre and spectacular examples of vernacular photography." *Maine on Glass* offers us a rich sample of such vintage photographs.

Earle G. Shettleworth, Jr.
Maine State Historian

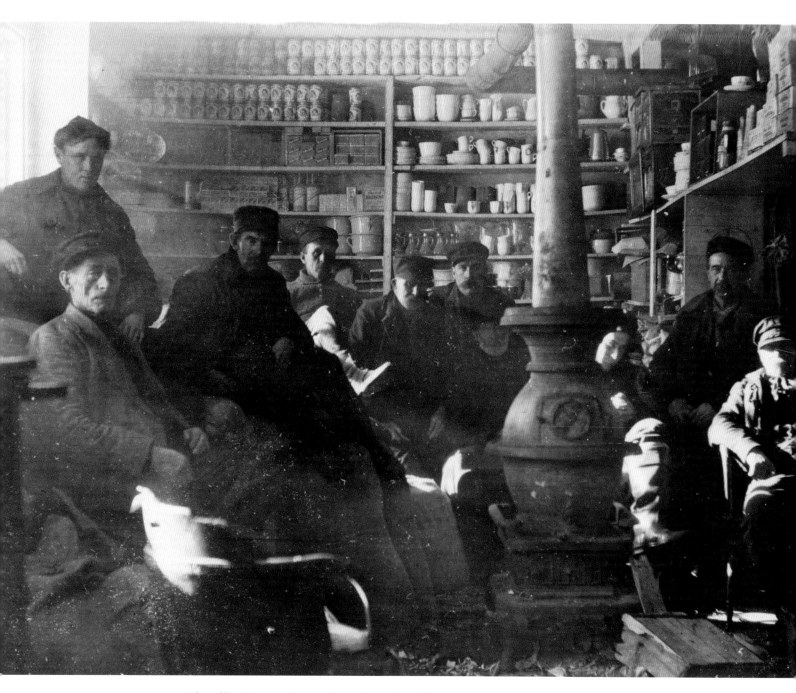

Elwell's Store, Saturday Cove, Northport, ca. 1907. Frank P. Blodgett photo; courtesy Maine Historic Preservation Commission

Belfast, Maine
A Center for Photography
by Earle G. Shettleworth, Jr., Maine State Historian

For nearly four decades, from 1909 to 1947, Herman Cassens made Belfast, Maine—a prosperous coastal city of approximately five thousand residents—the home of one of the nation's leading producers of photographic postcards. Cassens' enterprise, the Eastern Illustrating & Publishing Company, was a welcome addition to a community that hosted an active seaport, the county seat, and manufactured goods as diverse as shoes, cigars, and window sashes. By the early 1900s, Belfast also claimed its share of summer tourists. The combination of a beautiful harbor and tree-lined streets of stately nineteenth-century houses attracted visitors to the city, some of whom purchased historic homes for seasonal residences. Others built new cottages on the outskirts of town or in nearby Bayside.

But the Eastern Illustrating & Publishing Company was not the only photographic enterprise in Belfast. In choosing to locate there, Cassens joined a well-established tradition of local photographers.

First demonstrated in France in 1839, photography arrived in Maine when Samuel P. Long took pictures in Portland, Gardiner, and Augusta in May and June of the following year. Belfast had its first resident photographer by November 1841 in the person of Charles W. Perkins, who made daguerreotype portraits for three to four dollars each. From that point on, the city experienced a steady stream of daguerreotypists, including Phineas P. Quimby, who was active from 1847 to the 1850s. A watch and clockmaker, Quimby is remembered as a philosopher, mesmerist, healer, and the leader of the New Thought movement, which was based on the belief that every disease has a mental cause.

Most Belfast photographers from 1841 to the end of the Civil War produced portraits of individuals, families, and groups in the form of daguerreotypes, ambrotypes, tintypes, and albumen prints. Beginning in the mid-1860s, the popularity of stereo views as a domestic entertainment resulted in photographers expanding into outdoor photography. Between 1865 and 1890, four Belfast photographers made many stereo views depict-

Belfast in winter, ca. 1880.
W. C. Tuttle stereo view; courtesy Maine Historic
Preservation Commission

ing every aspect of the city: its harbor, water-front, streets, business district, public buildings, churches, homes, industries, and special events. Whether the interior of a printing office or the ruins of a downtown fire, little escaped the cameras of C. H. Pease, Henry L. Kilgore, William C. Tuttle, and Edward N. Wight, and their stereo views constitute the most comprehensive record of the community's appearance in the nineteenth century. Of the four photographers, Tuttle was the most enterprising, with seven studios for portrait and landscape work in Belfast, Kents Hill, Castine, Madison, Stonington, Windsor, and Bayside.

Following passage of the Private Mailing Act of 1898, postcards grew rapidly in popularity as a convenient way of communication, a souvenir of travel, and an object of collecting, and by 1900 they were replacing stereo views as a means of featuring a city's attractions. Until World War I broke out in Europe in 1914, most American cards were mass-produced color lithographs, many of which were printed in Germany. The curtailment of foreign sources by the war increased the market for American makers such as Eastern, which used a photographic process to print each card from a negative.

Given the economic vitality of early-twentieth-century Belfast, it is not surprising that the city served as the location for three other producers of real photo postcards: Charles A. Townsend, Frank P. Blodgett, and Melvin A. Cook.

Born in Rutland, Vermont, in 1871, Townsend started his career there as an insurance agent. About 1902 he moved to Belfast to work as an agent for the Metropolitan Insurance Company, and two years later he began to sell his photographs of the Belfast area at the City Drug Store. In June 1905, the City Drug Store offered Charles Townsend's hand-colored platinum prints of local scenes to "interest summer visitors." At the same time the store displayed Townsend's real photo postcards, referring to them as "direct photographs." (Kevin Johnson describes the production of "real" photo postcards in his piece below.) The price was six for twenty-five cents, more expensive than color lithographed cards, which sold for ten cents a dozen.

From 1905 until his death in 1932, Townsend made real photo postcards the focus of his business. In contrast to Herman Cassens, who covered New England and New

York, Townsend limited himself to the Maine coast from York to Mount Desert Island. The exceptions were his scenes at Mount Kineo on Moosehead Lake, campus views of Colby College in Waterville and the University of Maine at Orono, and the occasional New Hampshire card. Within these geographic parameters, Townsend produced large quantities of cards that set standards of technical quality and aesthetic excellence.

Most of Townsend's postcards depicted the popular subjects of the day: landscapes, streetscapes, public and commercial buildings, churches, summer hotels, cottages, and homes. Topical views included

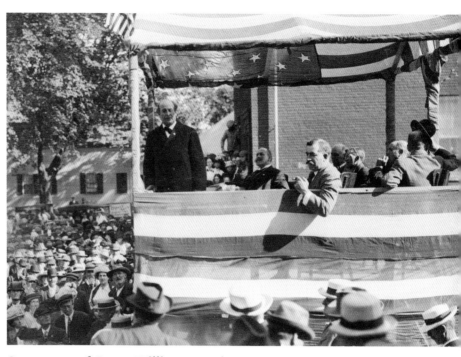

Secretary of State William Jennings Bryan (center) speaking in Belfast in September 1913. Charles A. Townsend postcard view; courtesy Maine Historic Preservation Commission

a political speech by William Jennings Bryan in Belfast, a ship launching on the city's waterfront, and the frozen harbor in winter. The process of making real photo postcards allowed for a rapid turnaround time in placing cards for sale. In February 1913, Townsend took views of the Belfast Food Fair at 10 a.m. and had cards of the event on sale before 3 p.m. that afternoon.

Growing up on a farm in rural Morrill, Frank P. Blodgett moved to Belfast to work in a shoe factory. From 1906 to 1911, Blodgett operated a photographic studio in the city and produced real photo postcards under the name "Blodgett's Art Photos." When Blodgett moved to Pasadena, California, Charles Townsend may have acquired some of his negatives.

Melvin A. Cook was active as a photographer in Belfast from 1919 to 1945, making him a contemporary of both Herman Cassens and Charles Townsend. Cook offered a wide range of photographic services, and more than 5,000 of his negatives are preserved by the Belfast Historical Society. His real photo postcards of the area were issued under the label "Cook's Studio."

In assessing the significance of Herman Cassens' contribution to the making of real photo postcards, it is important to understand the role played by Belfast's established reputation as a center of photographic activity. In this context, Cassens thrived in the company of his three talented contemporaries—Townsend, Blodgett, and Cook.

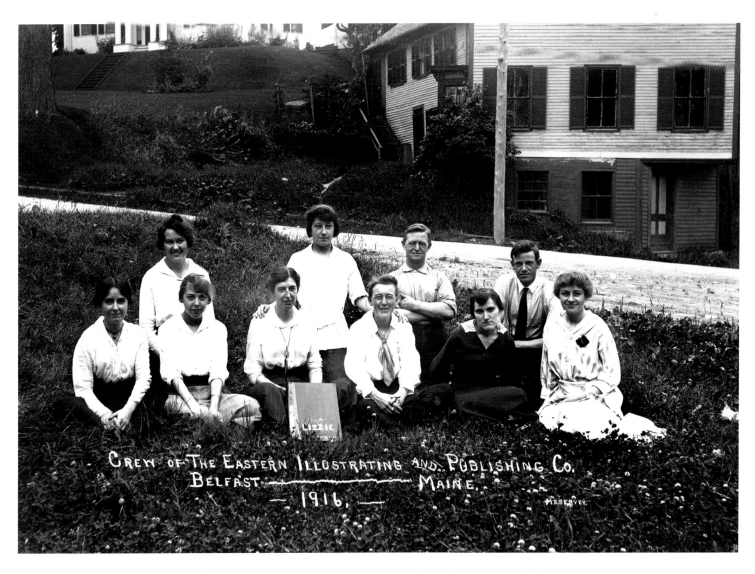

CREW OF THE EASTERN ILLUSTRATING AND PUBLISHING CO.
BELFAST ———————— MAINE.
— 1916. —

The Eastern Illustrating & Publishing Company

by Kevin Johnson, photo archivist, Penobscot Marine Museum

The Eastern Illustrating & Publishing Company was founded in 1909 by Rudolph Herman Cassens of Rockland, Maine. He was born in 1875 to German immigrants and was known to have the "German work ethic." He had big aspirations for his company: to photograph every town from Maine to California. He never fulfilled his dream, but he and his photographers thoroughly covered New England and upstate New York, as well as a smattering of towns in Ohio, Pennsylvania, Maryland, North Carolina, and Florida. Bermuda, New Brunswick, and southern Quebec were also photographed. He did not intend to create historical records. He was a businessman, and his obituary does not even mention that he was a photographer. The archive left behind, however, is a remarkable photographic survey of the towns and villages his photographers visited in the first half of the twentieth century.

In 1900 Cassens married Lillian Hanson, the daughter of a prominent Belfast businessman, Edgar Hanson. Hanson was an eight-term mayor of Belfast and owner of one of the two local newspapers, the *Waldo County Herald*. Cassens learned the publishing business working for the *Chicago American,* then returned to Belfast to work for his father-in-law's paper. He started the postcard company in the same building, later moving across the street to a large, house-like building that became "the factory."

The timing of Cassens' decision to start a postcard business was perfect. Postcards had become an absolute rage. Comparable to email, texting, or Instagram, the postcard was a new, informal way of communicating with brief text and an image, making it the perfect complement to a time when the automobile and the shift to an urban society from a rural one had uprooted people all over the country and put them on the move. Additionally, a large number of immigrants were entering the country, and tourism was becoming more popular. Postcards were the easiest way to keep in touch, and they quickly became collectibles and souvenirs. In 1905, seven *billion* postcards were sent worldwide. On one day in September 1906, 200,000 postcards were mailed from Coney Island. In 1913 the number of postcards sent in the U.S. alone was 968,000,000, more than seven per person.

The type of postcards that Eastern Illustrating produced represented a small niche in the postcard market. The majority of postcards made at the turn of the twentieth century were mass-produced lithograph or letter-press halftones, mostly printed in Europe. Eastern Illustrating's cards were "real photo postcards," meaning that they were silver-gelatin prints made by exposing a glass plate negative onto photo paper card stock and developing it in a traditional wet darkroom. (That is to say, the glass plate negative was placed in a printing machine that fed postcard stock; the plate was contact printed; the exposed cards were immersed in a developer bath, then a stop bath, then a fix bath; and finally the prints were sepia toned and washed.) This allowed smaller runs of each card to be made, satisfying the needs of general stores and other retailers in rural New England. Eastern played up this aspect and referred to their cards as "genuine."

Eastern was the largest manufacturer of real photo postcards in the United States, producing, at its peak, more than a million postcards a year. The Belfast newspaper, the *Republican Journal*, featured this description in 1923:

> *Comparatively few people in Belfast realize the volume of business trans-*
> *acted by this concern, which was started in Belfast in 1909. For the past five*
> *or six weeks it has averaged between 70,000 and 75,000 postcards a week. It*
> *has four automatic machines, which develop 100 cards at a time, and also*

TUMBLEDOW LAKE AND MT. WELD
© 1914 BY R.H. CARSENS

has three men traveling on the road, by automobile. Some twenty women and girls are employed by this company. They also handle a large mail order business, receiving 8000 or 9000 orders each day in the busy season. Most of the business is done in four months, but the company has customers who furnish it with winter negatives, that is, winter scenes, so that a certain number of people are employed all year round.

The business plan was straightforward and formulaic. Photographers left Belfast in late spring when the roads were hard enough to drive on. Each drove a Model T or Maxwell that was outfitted with a box on the back to hold photography equipment and luggage. Each traveled to his designated region of New England or New York and, upon entering a town, would usually set up in a boardinghouse, hotel, or campground. He (all the photographers were men) would then set about photographing the major landmarks around town. These would include churches, the town hall and library, schools, stores, places of industry, and usually several street scenes. Building a rapport with the people in these communities was useful for finding the local landmarks and best views. The "bird's-

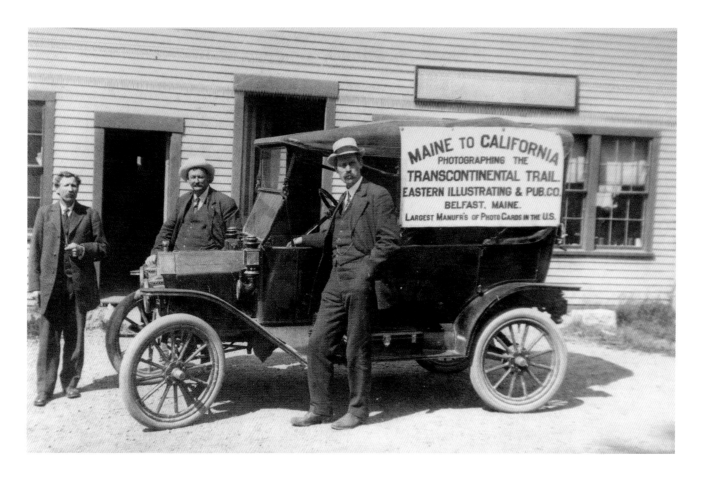

eye view" was a favorite. The lakes and mountains of New England provided many summer tourist destinations and summer camps for children, on which the Eastern photographers capitalized.

The exposed plates were sent back to the factory in Belfast, where they were processed and sample postcards were made. Numbers written in pencil on the sides of the plate matched up to a list of the subjects of the photographs. This informed the factory girls what to title the plates. The titles were handwritten in reverse in black washable ink directly onto the glass plates. The sample cards were returned to the photographer, who then took orders from the stores or businesses that would sell them. The sample cards ended up in cloth-bound sales books that the photographers would use to take orders when revisiting an area. Change happened at a slow pace in the teens and 1920s, and a postcard view would remain relevant for five years or more.

The photographers were both artists and salesmen, and one would think they had an idyllic life. They drove through rural New England or the Adirondacks and stopped in all the towns and villages to make photographs during the beautiful summer season. They made straight commission on the postcards they sold, and with postcards retailing at two for five cents, it was probably not a lucrative job. Their talents and point of view varied. Some seemed to prefer empty streets and unpeopled views, while others would

gather people to pose. Cassens himself made many of the early views, a good number with his copyright on the negative. His brother Ned worked in Vermont and the Adirondacks. Their best photographer was Horace Ellingwood of Ellingwood Corner in Winterport, known for his coastal views.

While the photographers were all men, the factory in Belfast was "manned" mostly by women. The employees were primarily family members, and they were worked long days—by one account, twelve-hour days with a half-hour for lunch for eleven dollars per week. Working the production end of the business involved titling the negatives, printing the cards, processing them in chemical baths, drying them on racks, and then trimming, packing, and shipping them. The glass plates were kept in their original boxes. The names of towns were written on the box ends, and sample postcards were often kept in between the plates to demonstrate how the plates should be printed. In addition to postcards, Eastern did a variety of custom work. Customers could send in their own negatives to be made into postcards. Often these were film negatives that had to be taped to a clear glass plate to be printed by the postcard-printing machine. If a glass plate was broken, a copy negative would be made by photographing an existing postcard of the image. They used generic scenes for multiple towns by modifying the titles.

The company was successful through the 1930s, but very few new photographs were made during the Second World War, and the demand for the black-and-white postcards diminished as color became more available. In 1945 Cassens sold the business and its assets for $7,000 to Alton Crone, and Cassens died two years later.

Under a succession of owners, Eastern continued to make real photo postcards into the mid-1950s, eventually switching to color. Crone sold the company to Goodrich, who then sold it to Walter Reneault, who sold it to David Hastings in 1971 after briefly relocating it to New Hampshire following a dispute with the state of Maine over inventory taxes. Hastings owned the business from 1971 to 1989 and ran it out of his home in Tenants Harbor. During this time, Hastings did all the new photography, and the company experienced a resurgence that increased its annual output from 50,000 to 950,000 cards. In 1989 Hastings sold Eastern Illustrating to the owners of *Down East* magazine, who were thinking of entering the vintage postcard business and wanted access to the old negatives as archival stock for their magazine. Neither of these ideas was realized,

THE SEAGULL, BELFAST, ME.

and *Down East* ultimately sold the business name to Andy Payson, a former salesman for Eastern, who still makes postcards and calendars under that name as of 2016.

The archival collection of glass plate negatives—filling hundreds of boxes and weighing several tons—was housed in at least three Belfast locations before being moved to a storage area in the Camden Health Center when *Down East* magazine acquired it. It was moved again in 1993 to Union Hall in Rockport upon being donated by *Down East* to the Rockport Institute of Photographic Education, the non-profit arm of the Maine Photographic Workshops (currently Maine Media Workshops). While it sat in various unsecured storage places over the decades, negatives "escaped" at an alarming rate. Archiving and digitizing of the remaining 35,000 negatives began under Maine Photographic Workshops ownership, and when it became apparent that the collection was incomplete, a hunt for the missing negatives was initiated.

Great progress was made on the collection during its years in Rockport, but the school was struggling financially, and funding the project was costly. The school was put up for sale in 2006. When a pipe burst in the Union Hall in February 2007, the resulting flood soaked the collection, which was stored in the basement, and all seemed lost. But a group of volunteers moved the collection from the building to the school's dining hall, and over the next six weeks the collection was dried out plate by plate. The majority survived with very little damage. David Lyman, the owner of the school, decided then to donate the collection to the Penobscot Marine Museum, and in the spring of 2007 the collection was moved once more, perhaps for the last time, to the museum in Searsport, just five miles from where the whole project began.

The collection has grown since its move to Searsport. Many of the negatives that "escaped" had ended up in the hands of antique dealers and postcard collectors. Several generous donations allowed some of these to be purchased, and others were donated to the museum by their owners. Another group of more than 300 negatives was about to be auctioned in an estate sale when it was discovered that they had been stolen while the collection was in Rockport. That group has since been reunited with the rest. In all, more than 15,000 negatives have been recovered from twenty-two different sources. Others remain at large, and it is unclear how many may exist.

CHIMNEY POND.

Since its arrival at the Penobscot Marine Museum, the Eastern Illustrating collection has had a complete makeover. Nearly all the negatives have been rehoused in archival envelopes and boxes. Nearly 35,000 have been scanned and catalogued and are available on the Internet through the museum's online database for all to enjoy. The images have been used to create numerous exhibits, to illustrate books and magazines, to enhance documentaries, to complement school projects, and to decorate scores of homes and businesses. One can learn more about the collection, obtain research CDs, and order prints by visiting the museum's website, www.PenobscotMarineMuseum.org

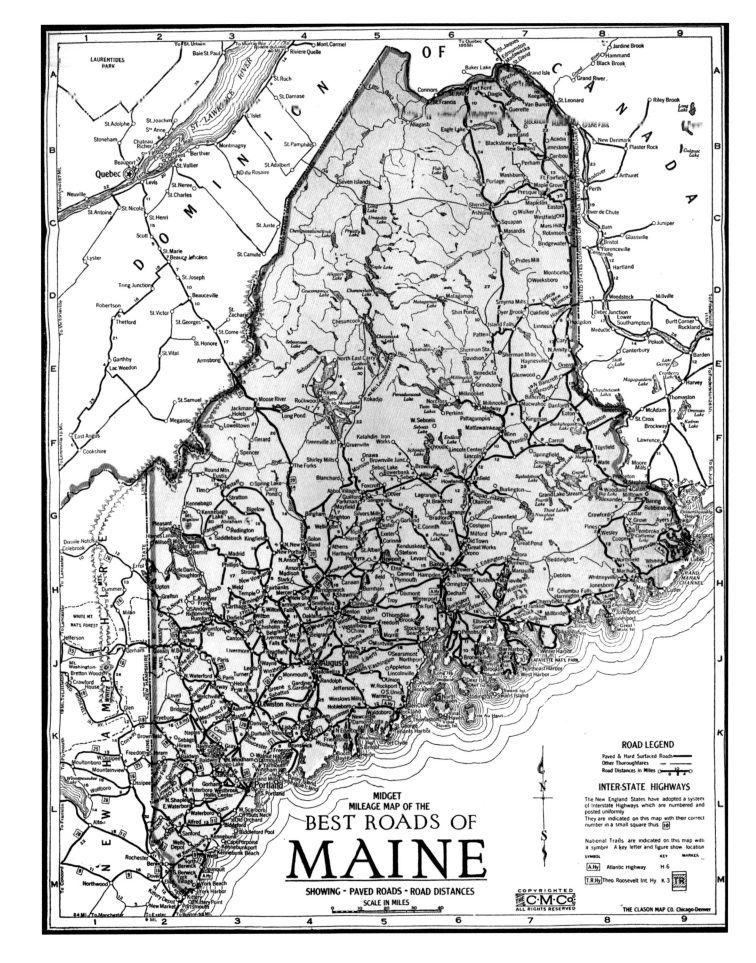

MIDGET
MILEAGE MAP OF THE
BEST ROADS OF
MAINE
SHOWING · PAVED ROADS · ROAD DISTANCES
SCALE IN MILES

ROAD LEGEND

Paved & Hard Surfaced Roads ——————
Other Thoroughfares — — — —
Road Distances in Miles

INTER-STATE HIGHWAYS

The New England States have adopted a system of Interstate Highways which are numbered and posted uniformly.

They are indicated on this map with their correct number in a small square thus [10]

National Trails are indicated on this map with a symbol. A key letter and figure show location.

SYMBOL	KEY	MARKER
A.Hy	Atlantic Highway	H-6
T.R.Hy	Theo. Roosevelt Int. Hy.	K-3

MAINE IN THE EARLY TWENTIETH CENTURY
by W. H. Bunting

Early twentieth-century Maine was living in the shadow of nineteenth-century Maine, which had been famed worldwide for lumbering, shipbuilding, and its seafaring people. It was said that so many cotton ships from Bath lay in the Liverpool docks that waterfront denizens thought Bath was its own country. Maine people cleared and farmed millions of acres in the nineteenth century. They built towns and cities, built railroads, and developed myriad water powers, with some driving big woolen and cotton mill complexes. They also developed a culture distinctive even in northern New England.

(Never mind that the foundational West Indies trade and the antebellum cotton trade, which built many of the grand houses that still grace old ship-owning towns, were made possible by slave labor systems, or that rum distilled from West Indies sugar fed endemic alcoholism. History is never as simple as it is taught in grade school.)

Maine's Civil War record was outstanding, and its politicians were formidable players in national politics. The dry and independent Down East Yankee became a stock figure in the national cast of colorful regional characters. Expatriate Mainers, of whom there were many, excelled in numerous fields and helped to spread the state's brand far and wide.

The twentieth century came on the stage just as Maine was facing the demise, decline, or disruption of a number of core industries, including shipbuilding and seafaring, lumbering (replaced by papermaking), granite quarrying, lime burning, ice cutting, brick-making, and important elements of its agricultural economy. Its great rivers were becoming increasingly polluted. Old State House powers-that-be were shoved aside as paper company and hydropower lobbyists took over the rump-sprung couches stationed outside State House committee rooms. Native Mainers departed in search of greener pastures, and immigrants from many countries arrived in search of the same thing.

The state once known by its proud motto "Dirigo"—I lead!—became "Vacationland," a rustic, even quaint summer resort for vacationers from more advanced and prosperous states.

This road map of Maine circa 1925 shows most of the places visited in this book. (Courtesy The Maine Historic Preservation Commission)

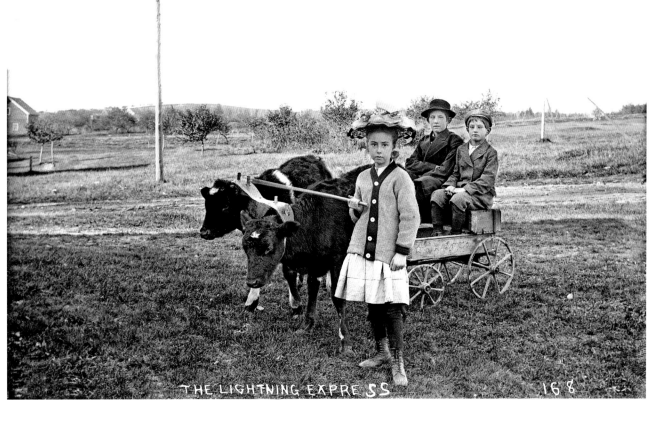

THE LIGHTNING EXPRE SS 168

Whereas nineteenth-century Maine has attracted copious attention from historians, early twentieth-century Maine generally has not. Aside from the brief period of intense and crucial World War II shipbuilding at South Portland and Bath, it was almost as though Maine had slipped away into a fogbank. Hopefully this book of images will help to cast some light on the lives of Maine people during those years in the shadows.

As described above by Earle Shettleworth and Kevin Johnson, the pool of images considered for this book consisted of photos taken on glass negatives in the early decades of the twentieth century, give or take a few years, and a few images on film. However, no attempt has been made in this book's selection of images to present a broad, balanced overview of life in Maine during this period. The Eastern Illustrating & Publishing Company collection, though vast, was created within parameters that limit its scope.

Instead, images for this book were selected first for their visual qualities and then for the stories they tell and by how well they stack up against the competition. The selection is heavily weighted toward Waldo County—the home of the Eastern Illustrating Company (which we'll hereafter call EIC)—and far northern Aroostook County. Aroostook, which experienced an economic boom in the early twentieth century, was a prime new sales territory. A region quite distinct from the rest of Maine, Aroostook yielded images that were likely the object of a good deal of curiosity elsewhere.

It is significant that most of the tens of thousands of EIC negatives were exposed at locations that could be reached by automobile. Mainers enthusiastically adopted the

automobile and headed out on the state's crude roads, where they were joined by visiting out-of-state motorists. By 1912 the Maine Automobile Association was publishing a hefty annual statewide guidebook, which treated auto-touring in Maine almost as an adventurous exploration or sporting event. EIC's business model targeted many businesses that catered to auto-tourism.

Prime EIC customers included the proprietors of auto campgrounds, sporting camps, tourist homes, hotels, and children's camps. Specializing in picturing small-town Maine, EIC photographers recorded countless elm-shaded main streets, local geographical landmarks, and notable public buildings. And so on. Farms were an exception because there was nothing novel about farms—in 1910 Maine had 60,000 of them—and farmers had no reason to buy postcards unless they were also taking in summer tourists.

THE TRIANGLE FILLING STATION ELLSWORTH, MAINE

As an archive of early twentieth-century Maine architectural photography, the EIC collection has no equal. However, many small town villages, main streets, churches, and schools looked pretty much alike, and while such images are today prized by local historians, the appeal of a book limited to such photographs would be, well, limited. It was thus a great pleasure to discover that, along with taking the thousands of these standard stock-in-trade images, EIC photographers also left us many unexpected glimpses of Maine life.

The ordering of images for this book could have followed many different systems, most of them unsatisfactory in one respect or another. After due consideration the chosen path was to begin in Waldo County, at Belfast, the home of EIC. From Belfast we will loop up through Thorndike and Winterport, then turn south along the west bank of the Penobscot River, pass through Belfast once again, and continue toward southern Maine as an EIC photographer might have done, heading southwest to Knox, Kennebec, Lincoln, Sagadahoc, Androscoggin, Cumberland, and York Counties.

From York County we will turn clockwise, heading north to Oxford, Franklin, and Somerset Counties, then east to Piscataquis County, and then north again to Aroostook. After taking a broad look at Aroostook, we head south to northern Penobscot County and then to far-eastern Washington County, there turning west again to Hancock County, southern Penobscot County, and back to Waldo County and Belfast, home again, safe and sound.

The process of ordering images within any one county is not so straightforward and involves juggling several factors, including subject matter, geographic location, and aesthetics. It would be best if the reader simply takes the images as they come, knowing that they are not placed at random. And as to the matter of dating images, this often was something of a game utilizing clues such as utility lines, automobile models, and fashions in clothing. In many cases it simply could not be done to any degree of certainty. So be it. Readers whose first reaction upon viewing an historic image is to ask when it was taken will have to adjust their expectations.

And finally, it was fun to learn that one of the most active EIC photographers was Horace Ellingwood, of Ellingwood Corner, Winterport. My three-greats-grandmother Sarah Ellingwood Patten was a native of nearby Hampden, so I suppose Horace and I must be cousins of some sort, and I am pleased to be able to bring some of Cousin Horace's work back to the light of day.

The Fleet
Camp Wyonegonic

9

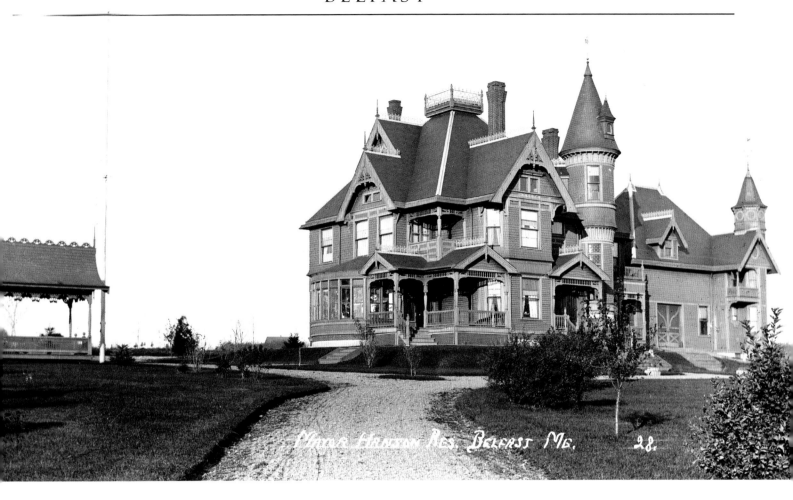

Mayor Hanson's House The not-so-humble abode of ten-term mayor Edgar F. Hanson was built in 1892–93 to a mail-ordered design most aptly termed Queen Anne on steroids—or alcohol-laced sarsaparilla. Hanson, a former publisher (and the father-in-law of the Eastern Illustrating Company's Herman Cassens), had been the manager of the Dana's Sarsaparilla Company, the producer of a hugely successful beverage. The house was built with ill-gotten gains from the sale of Dana stock.

The huge American patent medicine industry, built on desperation, gullibility, addictions, and greed, was a colorful if disgraceful blot on the post–Civil War American body politic. The press was long reluctant to bite the hand that so generously fed it with advertising revenue.

In 1889 Hanson initiated an advertising blitz pushing Dana's Sarsaparilla, a 27-proof concoction patented by a Belfast doctor, which was claimed to cure diseases of the heart, liver, and kidney. A stock company was created under its name, and in just six months in 1891, half a million bottles were sold. This attracted Boston investors who, in 1892, paid $300,000 cash (the equivalent of $8 million in 2016) for a controlling interest, giving the original stockholders a 1,200 percent profit on top of a 125 percent dividend. In 1894 the headquarters moved to Boston, and two years later the company was bankrupt.

In 1906 Hanson was sentenced to a year in federal prison for mail fraud regarding a stock-purchasing scheme involving a company he had organized in 1894 called Nu-Tri-Ola. Bogus nostrums sold under its brand included "Blood and Nerve Food," "Skin Food," "Liver and Kidney Treatment," "Vaginela," and "Laxative Granules." He was also pushing a purported fire-extinguishing compound called "Invictus."

The house burned down in 1923.

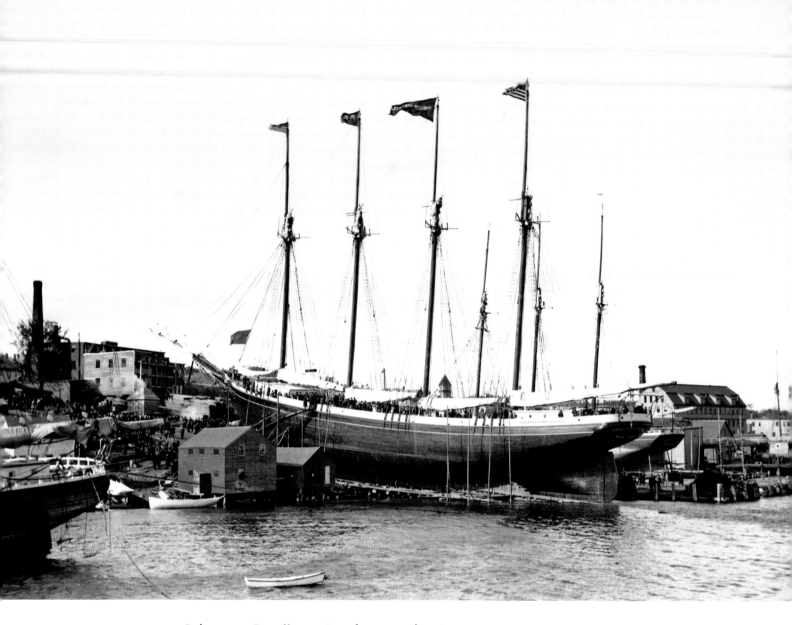

Schooner *Pendleton Brothers* on the Ways With guests packed on board and onlookers gathered ashore, the handsome four-masted schooner *Pendleton Brothers* is launched from the Pendleton shipyard on October 22, 1903. Below her black waist she is painted a "bronze green" with a coppered bottom. The three-masted schooner beyond the *Pendleton Brothers* is on the port's 1,000-ton marine railway. Installed in 1885, it was horse-powered until converted to steam in 1900. In order to move the carriage 160 feet, the one or two horses on the sweep had to walk twenty-six miles.

In the 1870s and '80s, Belfast was home to a fleet of handsome, home-built centerboard three-masted schooners of shoal draft (to squeeze over the St. Johns River bar), carrying Waldo County ice and hay to Jacksonville. They returned with hard pine shipbuilding timber. Belfastians formed businesses, built a marine railway, and wintered in Jacksonville.

An earlier *Pendleton Brothers* built in 1899, also a four-master, foundered in 1902. The second *Pendleton Brothers* went ashore in the Florida Straits in 1913. Her owners lost doubly, as she would have been worth a large fortune in the wartime boom a few years later.

Schooner _Pendleton Brothers_ on the Wavelets "She floats!" A puff of white steam shows that the shrill whistle plumbed to the _Pendleton Brothers'_ donkey boiler is adding to the excitement. The donkey engine hoisted the anchor and the sails, greatly reducing the size of the crew.

Two wartime schooners aside, Belfast shipbuilding ended with the four-masted schooner _Pendleton Sisters_ in 1906. Pendleton Brothers were New York shipbrokers, managing owners, chandlers, and insurance agents who hailed from (and summered on) Islesboro, and who owned outright, or shares in, about one hundred vessels. The _Pendleton Brothers_ was built and owned by Captain Fields C. Pendleton, the father of the brothers.

Wooden ships were "modeled," or designed, by carving a model. The _Pendleton Brothers_, a thing of beauty, shares a strong resemblance with four Belfast-built four-masted, barkentine-rigged "coffee clippers" modeled by William Brown, who died in 1899. Conceivably the lines from one of Brown's models could have been adjusted for the schooners.

Stockton native John Wardwell, a former master builder in a Belfast yard and likely influenced by Brown, modeled vessels of similar grace. One of his finest creations, the four-master _Robert H. McCurdy_, was launched at Rockland this same day.

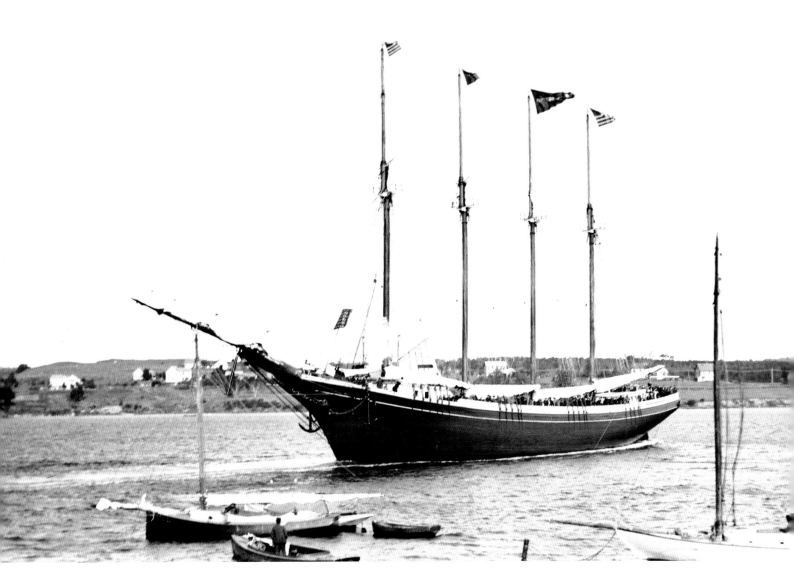

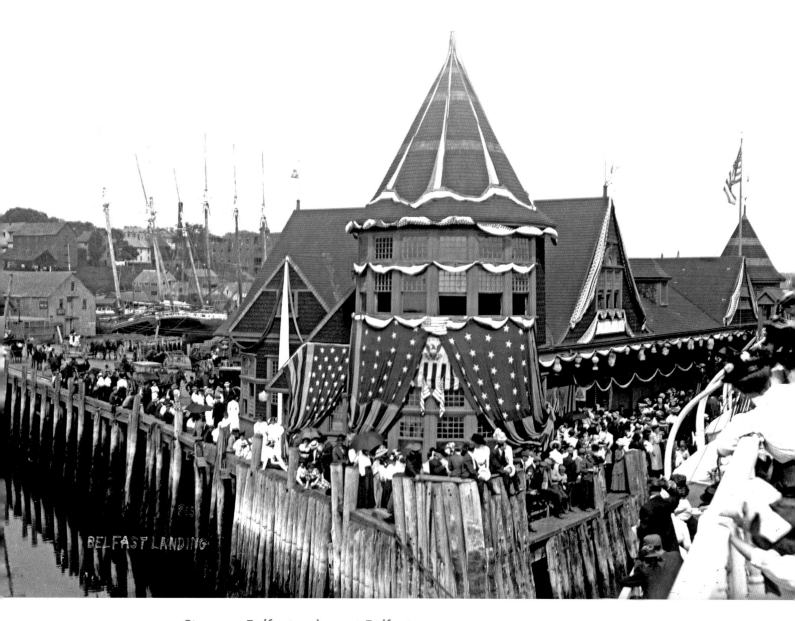

BELFAST LANDING

Steamer *Belfast* arrives at Belfast At eight o'clock on the morning of June 22, 1909, the new steamer *Belfast* gently approaches the Eastern Steamship Wharf at Belfast in the course of her maiden run from Boston to Bangor. According to the *Boston Transcript* the following day:

> *The watchers on shore had sighted the city's namesake, and they began… expressing their welcome with the ship still half a mile away. Firearms of various sorts, from small cannon down to revolvers, boomed and snapped as fast as they could be loaded and reloaded; handkerchiefs, tablecloths, sheets, and other articles were… waved wildly…. The Belfast Band, known all over Maine, played until the steamer was tied up to the wharf, and then, when the Belfast-bound passengers had gone ashore, Mayor Edgar F. Hanson made a speech…thanking the company for honoring his city and bestowing praise for the service so long given to Belfast and other places on the line. [Eastern Steamship] President Austin made response from the deck… overlooking the crowd and ended by inviting the populace aboard.*

Steamer *Belfast* at Wharf Measuring 335 feet overall yet drawing only ten feet of water, the *Belfast* and her sister *Camden* must have been challenging to handle in confined harbors on windy days, even though the two outboard (of three) propellers were fitted with reverse gears and presumably could be backed independently. Discretion being the better part of valor, the departing sisters backed well down Belfast Harbor before turning to head up the bay. Steamboat pilots on this foggy coast had long relied upon the strong backing power of older side-wheelers to avert disaster.

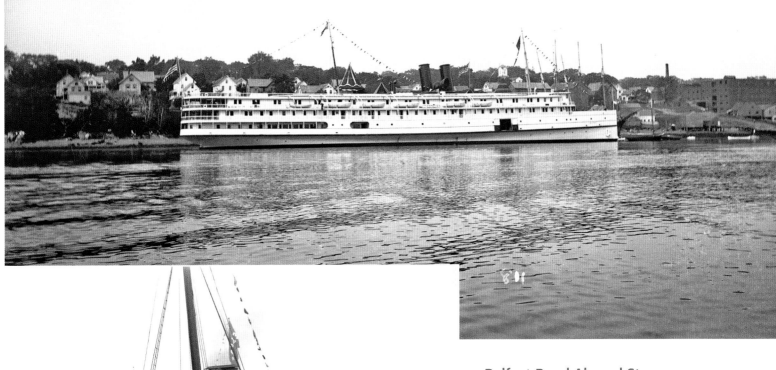

Belfast Band Aboard Steamer *Belfast* The celebrated thirty-five-piece Belfast Band—along with the graduating class from Belfast High School and two hundred other special guests—boarded the new steamer for her first trip "up the river" from Belfast to Bangor. The band played for the welcoming crowds gathered at every landing.

Town bands, heavy on brass and inspired by German immigrant "oompah" bands, flowered in the late 1800s. The Belfast Military Band was formed in 1889, and, "by indefatigable practice," earned itself high demand for civic occasions, holidays, and excursions. The two drum majors were William H. Sanborn, who weighed 260 pounds, and Donald O. Roberts, who was, at 40 pounds, the smallest man in the State of Maine.

Nationally, community bands went into a steep decline after the First World War. In need of new markets, instrument makers turned to promoting the teaching of music in schools.

Town Teams In this battle of town teams, Thorndike trounced rival Troy, 13 to 3. A formal portrait of the Troy team, taken in 1915 or 1916, shows but three players wearing shirts lettered TROY, indicating the informality that characterized town team baseball. Challenging field conditions—even holes where an outfielder secreted his liquid refreshment—were the norm.

Note that the umpire, for safety, cowers behind the pitcher. Although baseball was the national sport, the flock of women in the grass in the far background, taking refuge under black umbrellas, suggests that the passion for the sport was gender-linked.

Today billiard table–smooth school diamonds are the norm, but the mixed-age town teams common throughout New England into the 1950s have vanished.

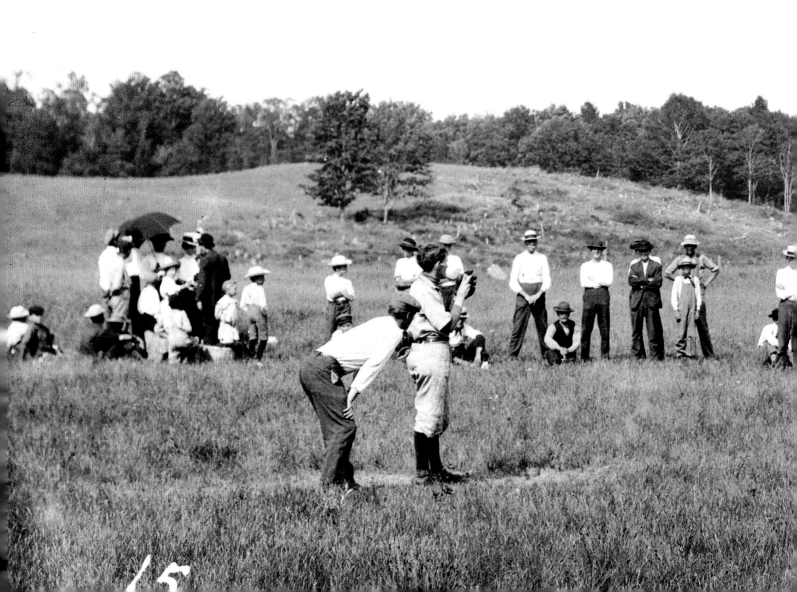

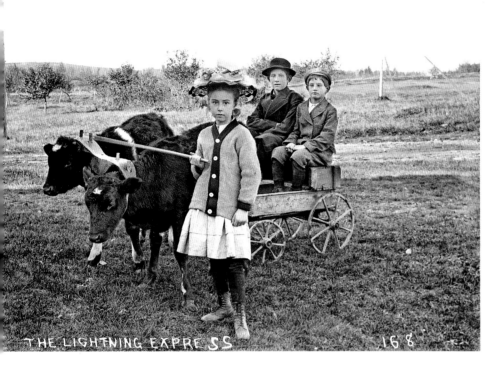

THE LIGHTNING EXPRESS 168

The Lightning Express The young drover, Mary Alice "May" Ellingwood, is the daughter of Eastern Illustrating photographer Horace Ellingwood, and the location is probably Ellingwood's Corner. The training, or "handying," of bull calves for future draft use may begin when they are a few days old. Within their first six months they will be castrated, becoming steers. They will not be called oxen until they reach age five, should they be so fortunate.

"The Lightning Express" designation usually appeared on postcards from the Jim Crow South showing an ancient black man perched on a wreck of a wagon with a sway-backed old ox between the shafts rigged out with a mule collar worn upside down. Here it refers to an old prejudice that associated the ox with slow motion and backwards ways of farming. Yet oxen remained in good standing on many Maine farms through the 1930s because they were still considered of good use. Also, any days-old healthy calf in a barnyard can outrun and out-maneuver any fancy pants postcard publisher.

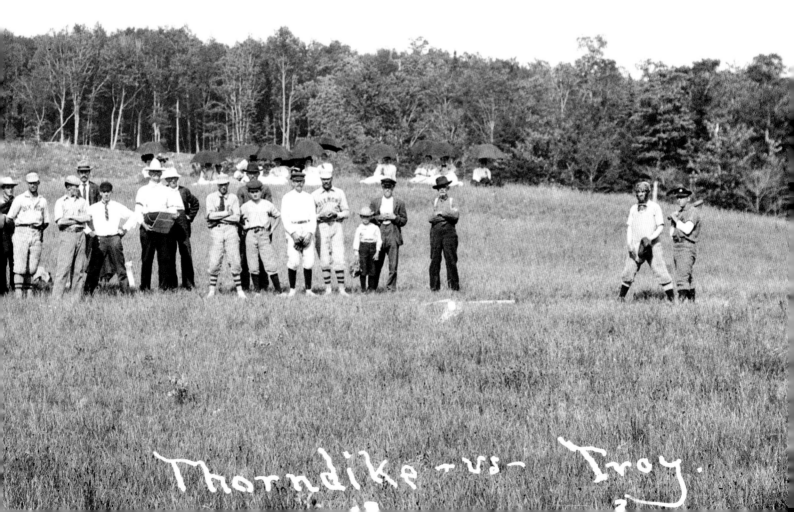

Thorndike -vs- Troy.

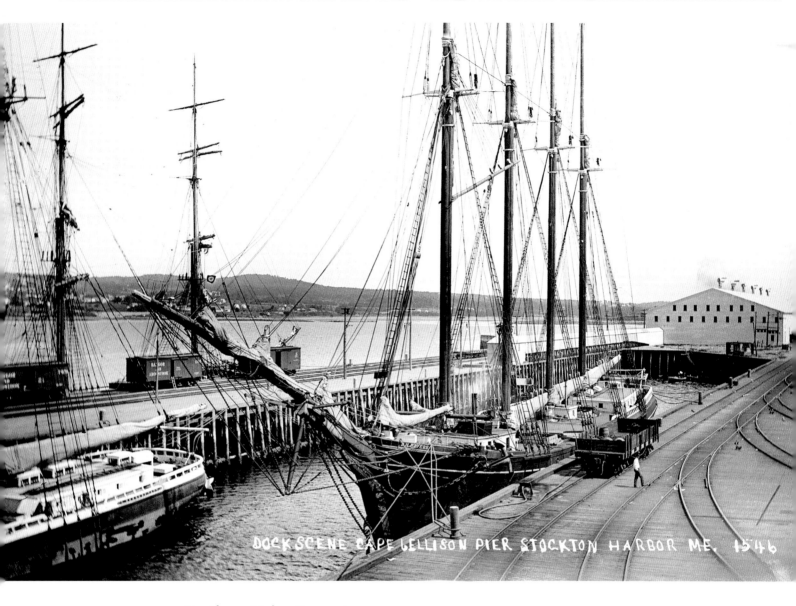

DOCK SCENE CAPE JELLISON PIER STOCKTON HARBOR ME. 1546

Northern Maine Seaport The Northern Maine Seaport, at Cape Jellison, an overly ambitious port facility, was built by the Bangor & Aroostook Railroad in 1905 as an ice-free outlet for potatoes, lumber, shook, pulp and paper, and for receiving fertilizer, coal, cement, paper-making supplies, and so on. A branch line connected with the main line at Lagrange. The white potato house measured 600 by 125 feet and could hold 240,000 barrels. Electricity from an on-site powerhouse moved the potatoes about and bagged them for shipment. Italian laborers built it all.

A great future for the new port was predicted, but after several busy years, shipments declined as timberlands were depleted, the potato boom slumped, fertilizer plants were built elsewhere, and freight transport by rail increased. In 1924 it all went up in smoke. At nearby Mack Point, in Searsport, where a coal pocket was built, shipping continues to this day.

The four-masters *D. H. Rivers*, at center, and the *L. Herbert Taft*, whose stern is seen at left, both hailed from Thomaston and were owned by the firm of Dunn & Elliot. Possibly they arrived with phosphate from Tampa. The square-rigger—she is a bark—may be Italian and loading hardwood fruit-box shook for Sicily.

Searsport Library, Interior The Carver Memorial Library was built in 1909 thanks to the generosity of members of the local Carver family, who by then lived in Brooklyn, New York, prospering in the chandlery business. (Brooklyn Heights was home to a number of transplanted Mainers engaged in maritime or related professions.) Librarian Mary McClure is believed to be on duty in this photograph.

Searsport, a town of 2,200 or so, was known far and wide for its many deep-water shipmasters. This was in good part a result of marriages that consolidated the ownership of vessels within the tribe. In 1885 Searsporters commanded thirty-eight, or 10 percent, of the 380 or so American-flag full-rigged ships. (Thirty-nine other sailing vessels were also commanded by Searsporters.) Full-rigged ships were called "ships," which abbreviation, being misunderstood, resulted in the claim that Searsport was once home to "10 percent of all American shipmasters." The actual record is extraordinary enough without erroneous embellishment.

With the demise of deep-water sail, a number of Searsport shipmasters went into steam, including seven who, in 1909, commanded freighters of the hugely successful American-Hawaiian Line, which was founded by New Yorkers of Maine descent. Seamen on American-Hawaiian Line steamers grumbled that on the Fourth of July, Searsporters saluted the American-Hawaiian house flag instead of Old Glory.

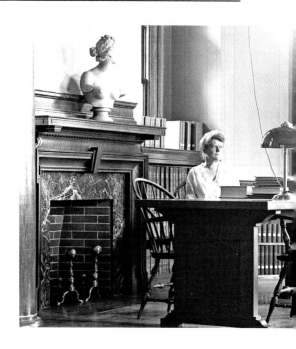

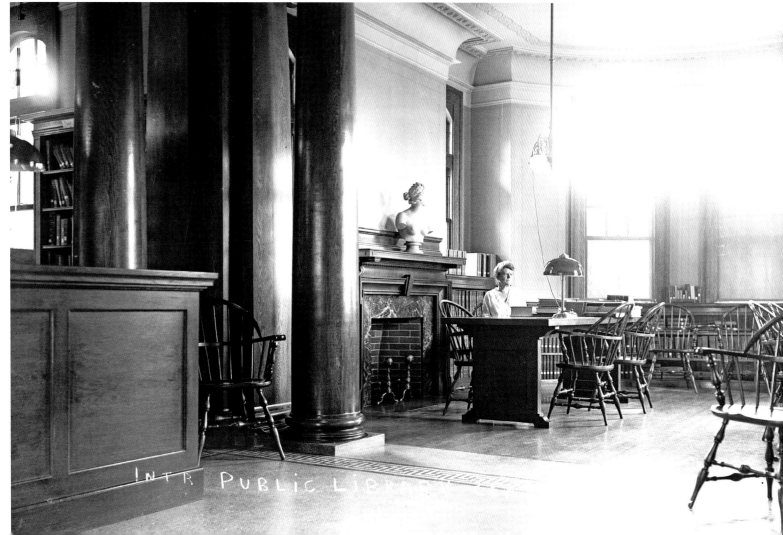

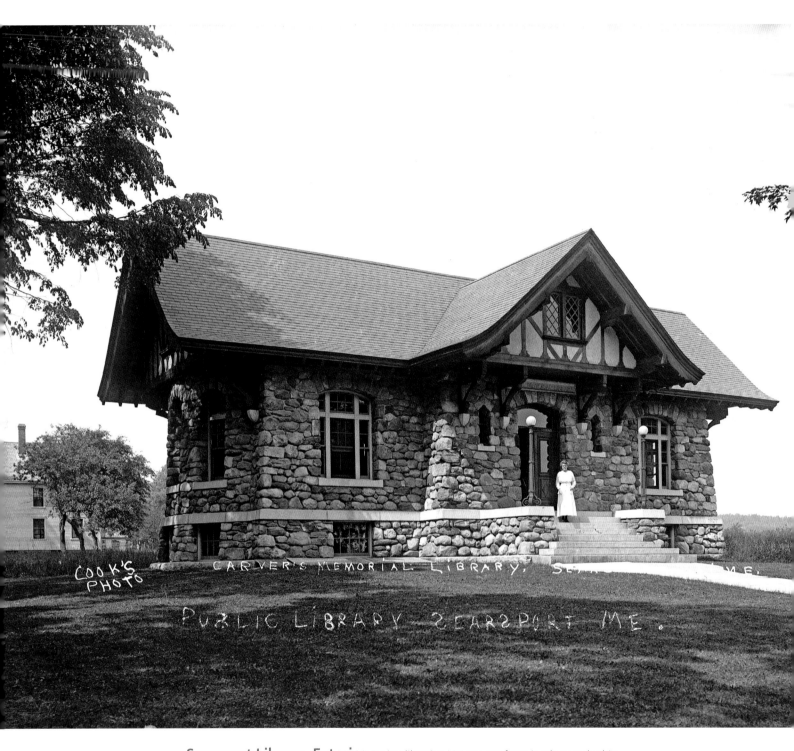

Searsport Library, Exterior Posing librarian McLure out front is what made this exterior view of the library a successful photograph. Designed by Boston architects McLean and Wright and built by a Boston contractor, at least the library's stones were native to Maine, coming from the Carver family's farm on what is today Moose Point State Park. The land for the park was another gift from the Carvers. The library was dedicated on October 13, 1910.

Belfast Tearoom and Camps The Boston-Bangor steamer *Camden* or *Belfast* enters Belfast Harbor. The view is from the Penobscot Bay Tearoom and Camps, sprouting on what had recently been a hayfield along US Route 1, circa 1920. In 1917 Belfast's Board of Trade promoted auto tourism with two hundred signs placed along Maine roads.

The northeastern shore of Belfast Harbor was then an open agricultural landscape, contrasting nicely with the compact brick-built city. The farmland with water views along Route 1 from Belfast to Searsport was ideally suited for the planting of camp grounds, and is today a motel strip development.

Kennebunkport author Kenneth Roberts, writing in the 1930s, had little regard for auto tourists or the changes they brought upon the land, including billboards, hot dog stands, and "unsightly nests of overnight camps that huddle in fields as though some debauched summer hotel, on the loose, had paused on a dark night and given birth to the result of a *mesalliance* with a sentry box."

However, beauty—and reality—reflect the perspective of the beholder. An Internet reviewer rating a present-day nearby motel/camp colony praised the "view of the lake."

The Penobscot Bay Tearoom and Camps fizzled out in the 1950s as the tastes of auto tourists changed. A number of the camps found new lives on the shores of area lakes and ponds.

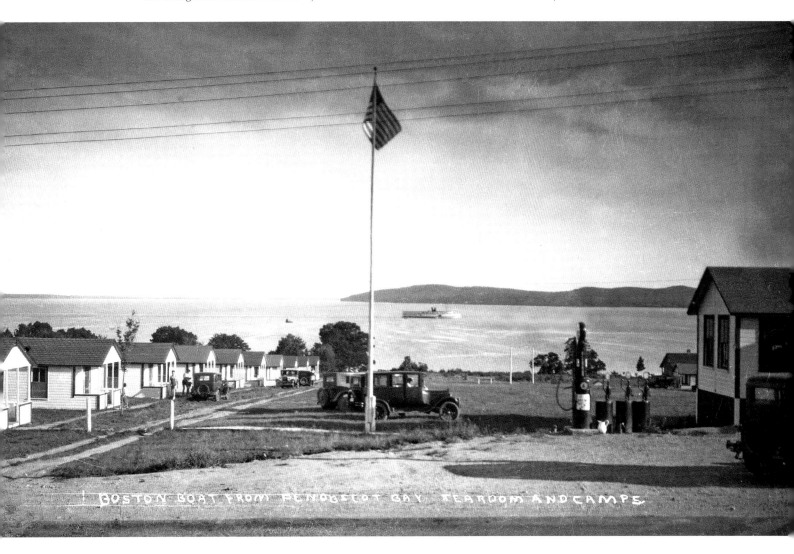

BOSTON BOAT FROM PENOBSCOT BAY TEAROOM AND CAMPS

Steamer Castine The smart little steamer *Castine* lands passengers at Smith Wharf, from which she ran to and from Belfast in one phase of her forty-one years of service. A crisp and brisk northwest wind furrows the bay with whitecaps and threatens to blow the ladies' hats off. Only the weary carriage horses appear unmoved by the stimulating scene.

Castine, and the smaller *Golden Rod*, were owned and operated by the colorful Coombs brothers, Leighton, Perry, and Fred. Leighton and Perry were captains, Fred was an engineer (as was Leighton also). The boats were among two dozen or so small steamers that ferried people about Penobscot Bay. None were better maintained. Nor was any captain more agile than Leighton, who could jump from one barrel into another, nor more saving of coal than Perry, who banked the fire as soon as the boat was alongside a wharf. And no boat had a longer career than did *Castine*, nor met such a tragic end as she did on a Vinalhaven ledge in fog in 1935, with the loss of four lives.

Islesboro had four steamer landings, reflecting both its long, skinny shape and the long-lived prohibition against automobiles, kept in force by the summer colony's threat to decamp and take their money with them if it was rescinded. Livery stable owners had difficulty recruiting enough horses and workers to meet the high demand for transportation in the short summer season.

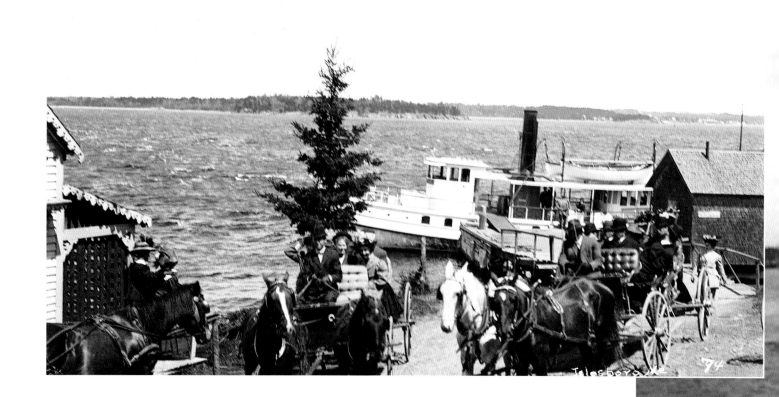

Schooner *Alice E. Clark* The four-masted schooner *Alice E. Clark* lies hard aground on Coombs Ledge in West Penobscot Bay, off Islesboro. Built at Bath in 1897, the *Clark* had enjoyed a career that, by the standards of her kind, was nearly unblemished. On July 1, 1909, however, she was headed up the bay for Bangor with 2,717 tons of coal when she went to the wrong side of the buoy marking the ledge—Captain McDonald blamed a low-lying haze. Although sailing slowly, she impaled herself, thwarting extensive and expensive efforts at salvage. Presumably these boatmen have legitimate reasons for boarding the *Clark*, and are not among those generally law-abiding coastal residents who were transformed into members of the genus *piraticus* upon the occasion of a bountiful shipwreck.

One might expect the coast of Maine to be littered with wrecks, but such was not the case. For example, of about 520 four-masted schooners built on the East Coast—over 320 of them Maine-built—only three were wrecked in Maine waters, all in Penobscot Bay. Explanations include the fact that big schooners spent most of their careers elsewhere; shipping along the Maine coast was much reduced in winter; unlike Cape Hatteras or Cape Cod, most of the Maine coast offered harbors of refuge in an easterly gale; and the Maine coast was well supplied with lighthouses. Many of the schooners wrecked on Hatteras were southbounders caught trying to slip by between the Outer Bank beaches and the north-flowing Gulf Stream.

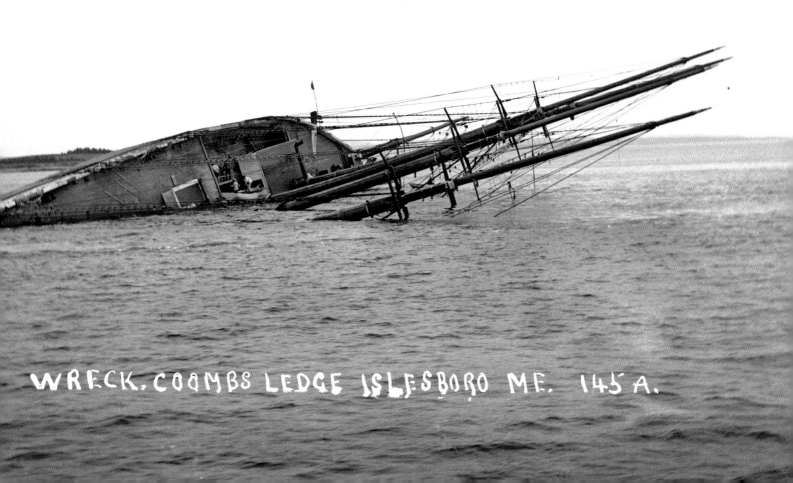

WRECK. COOMBS LEDGE ISLESBORO ME. 145 A.

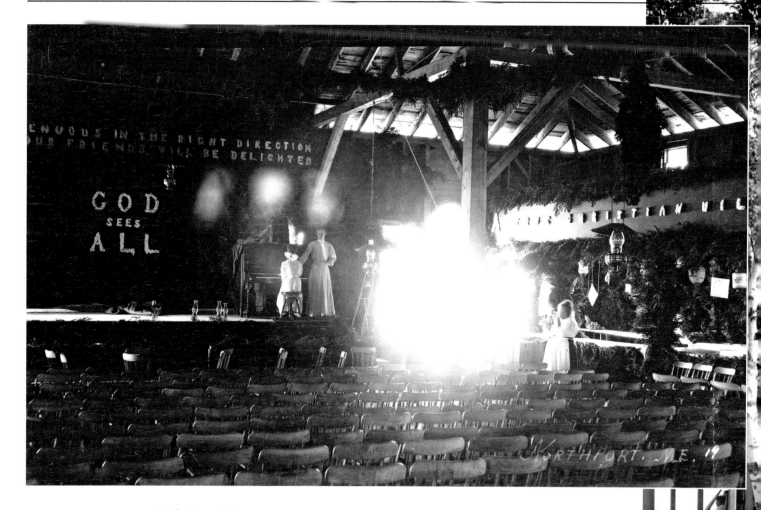

God Sees All An incorporated village within the town of Northport, Bayside had its beginnings in the 1840s as a Methodist "Wesleyan Grove" camp-meeting tent colony. The Auditorium, built in 1893 to replace an outdoor platform, was the center of community life, used for religious services, Chautauqua presentations, musical performances, and social occasions.

The Auditorium was located amid a gathering of large "Society Houses" built on the sites of tent platforms by residents of various towns. Many smaller houses sprouted up cheek by jowl on lots that had formerly been tent sites for individual families. By 1947 there were some 350 houses. Two successive hotels had also been built, both of which burned.

Farm families taking a week's break after haying comprised the core of the original camp-meeting goers, but after the Civil War the Northport Campground (Bayside was the post office address) evolved into a full-season summer resort. Along with the big Boston boats, small excursion steamers disgorged their passengers to picnic and play horseshoes among the camp-goers. The deteriorated Auditorium was pulled down in 1936, marking the end of the camp-meeting era. Bayside survives today as a unique, upper-middle-class, secular resort, still characterized by good fellowship.

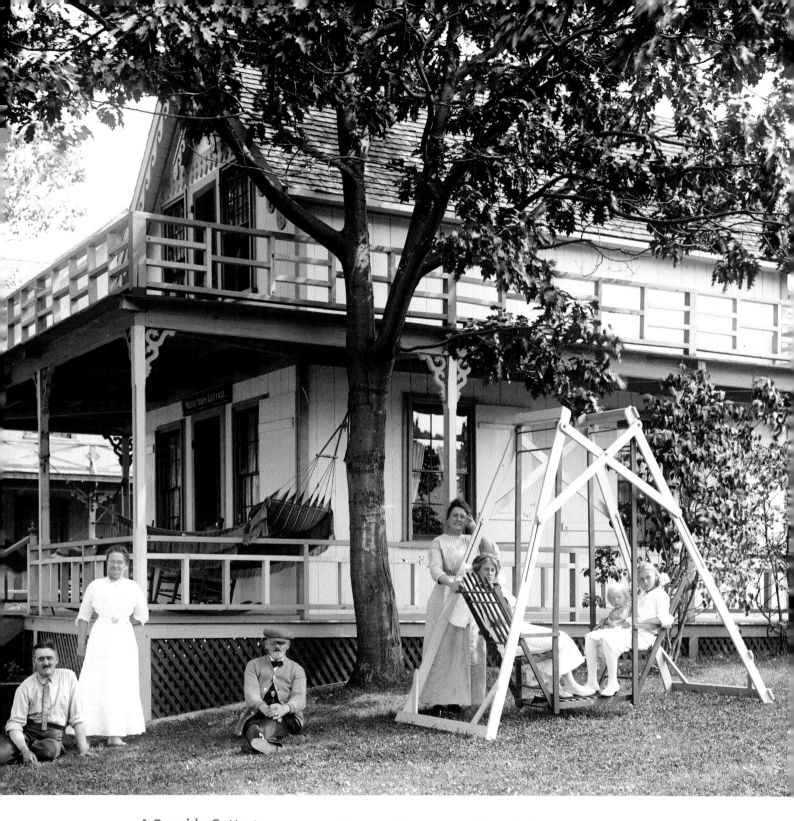

A Bayside Cottage Moose Horn Lodge, a Bayside cottage complete with the moose horns, embodies the American version of the idealized Edwardian, or post-Edwardian, era of innocent contentment and well-being. Of course, a photo of a miner's family gathered in front of its squalid shack in a West Virginia coal mining settlement—or, indeed, the families of many poor Mainers living hand-to-mouth, day-by-day—would present a very different tableau.

Bayside Carnival The first carnival at Bayside was held in mid-August 1914, and perhaps this is it. The list of activities dispels any notion that, although hazy, these were also the lazy days of summer.

Events included a greased-pig contest for men and boys; a rowing race; trial and final uphill male and female 100-yard dashes from the steamboat wharf; a boot-and-shoe race; a fat man's race (first prize was a humidor); canoe races; a diving contest; a sailing race; a sack race; a three-legged race; a tennis tournament; a tub race; various swimming races, including a one-miler; nail-driving contest; a baseball game; and the greased-pole contest, shown here. Winner Charles Mahoney was awarded seven dollars. The carnival closed with a concert by the Belfast Band, fireworks, and a ball.

The steam yacht lying off is the first (and much the smaller) of Philadelphia publisher Cyrus Curtis's two *Lyndonia*s. Built in 1907, she was taken over by the government for wartime service in 1917. A Portland native, Curtis was a leading summer resident of the Camden/Rockport area.

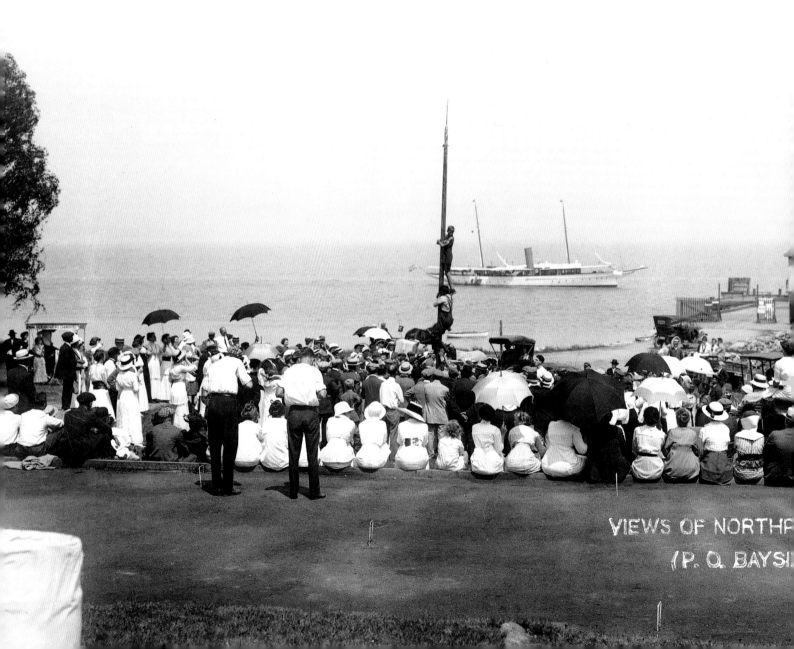

VIEWS OF NORTHP
(P. Q. BAYSI

HAWAIIAN GIRLS, LINCOLNVILLE, ME.

Lincolnville Grangers Elizabeth "Betty" Heald (née Connors), left, and Elizabeth Lucille Connors (née Heald), right, performing at Tranquility Grange. The Grange was very much a social organization as well as a political force. In the early 1900s Maine had the largest Grange membership per capita in the nation, with well over 400 Granges, each with its own hall. The Grange in Maine's archetypal agricultural town, Turner, in Androscoggin County, was said to be the nation's largest. The Grange reached its peak in Maine in the immediate post-World War II years, when there was still a vital small farm economy and no television.

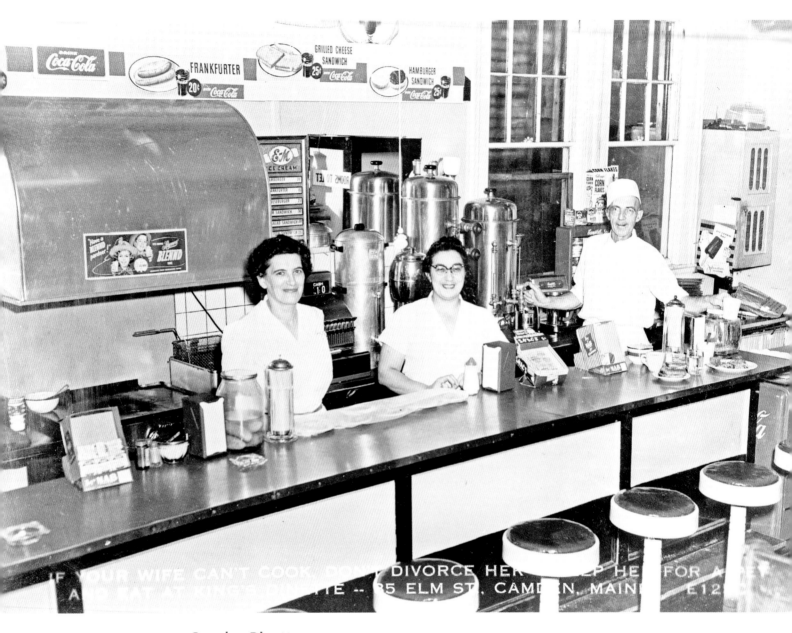

Camden Dinette Welcome to King's Dinette, 35 Elm Street, proprietors Grace Raffa King (right) and husband Charlie King. The woman at left is not identified. The prices on this eleventh day of June, 1956—20 cents for a hot dog and 25 cents for a hamburger sandwich—and the ash trays on the counter are as dated as the slogan, "If your wife can't cook, don't divorce her. Keep her for a pet and eat at King's Dinette." Maine's first minimum wage of a dollar an hour is three years in the future.

Speaking of fast food, one of Camden's claims to fame is that the inventor of the donut was native son Captain Hansen Gregory, 1832–1921. Gregory said that the idea to put a hole in what was then called a "fried cake" so that it would fry evenly came to him when he was the sixteen-year-old cook aboard a lime coaster.

The sticker on the range hood advertises Reymer's Blennd lemonade, a Pennsylvania favorite. "Have a Blennd pardner!"

Peyton Place Actors Diane Varsi and Barry Coe in a scene from the 20th Century Fox movie *Peyton Place*. Varsi's character, Allison MacKenzie, was the sensible, valedictorian daughter of a sexually repressed dress-shop owner (played by Lana Turner). Coe played Rodney Harrington, the smarmy, spoiled rich-kid son of the local mill owner.

To make a long story involving a half-dozen central characters mercifully short, Rodney ends up getting killed in World War II, and Allison leaves behind the white picket fences (and red hot scandals) of Peyton Place for the allure of New York City. The movie was adapted from the best-selling novel by Grace Metalious, a book which the Camden Library refused to stock.

Fearful Camdenites reportedly predicted that their town's association with the movie would forever tar its name, driving offended tourists away. Instead, it turned Camden into the tourist magnet it has been ever since. Nearly sixty years after Allison gave creepy Rodney the brush-off, fans from far and wide still come to Camden in search of Peyton Place.

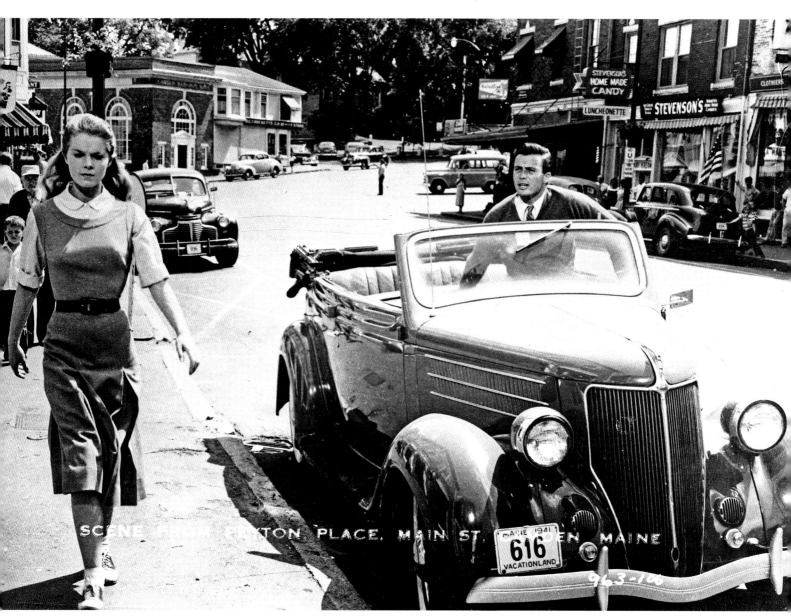

SCENE FROM PEYTON PLACE, MAIN ST. CAMDEN, MAINE

Schooner *James A. Webster* Under Sail The "dude schooner" *James A. Webster*, of Rockland, lazes along circa 1945. Built at South Brooksville in 1890 to carry general cargoes, the old schooner looks remarkably good for her advanced age. She is still carrying topmasts and setting a main topsail and a jib topsail.

In a final bid for survival, the *Webster*'s owner is following the example set by Captain Frank Swift of Camden. In 1936 Swift began buying up old "bay coasters," throwing up partitioned cabins in the cargo hold and hiring old captains out of retirement to sail them on protected Penobscot Bay with passengers.

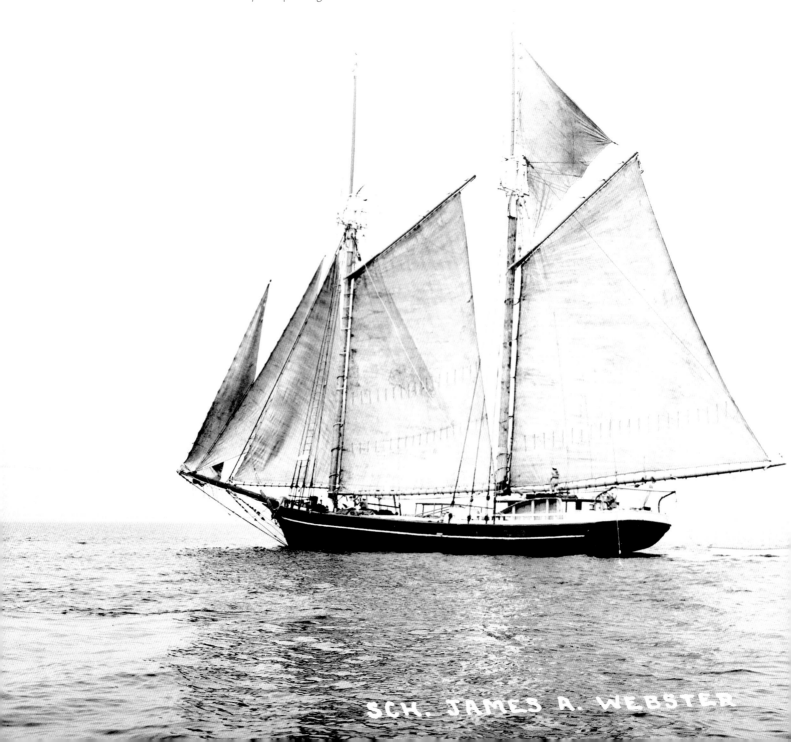

SCH. JAMES A. WEBSTER

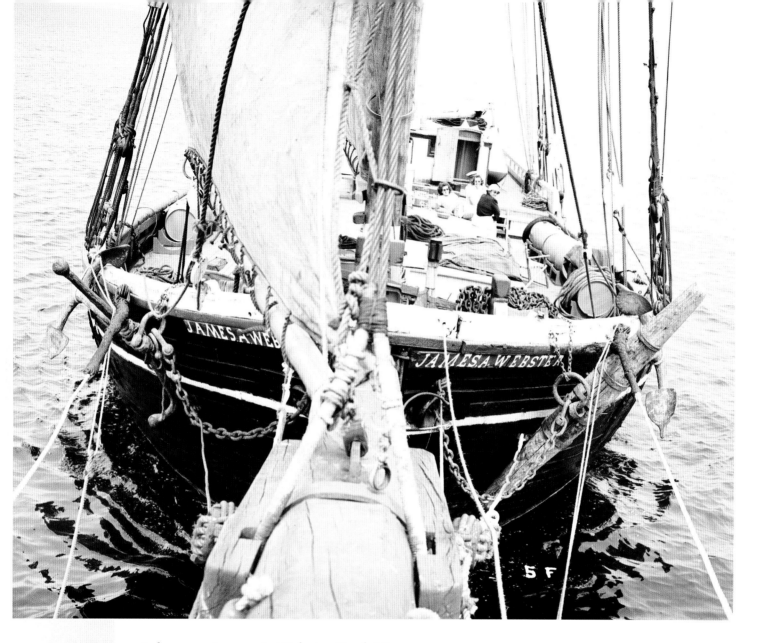

Schooner *James A. Webster* Deck View Passengers relax on deck. Living
conditions aboard the old schooners were basic—fresh water was carried in casks on deck—but
that was all part of the charm. For young single women, in particular, dude cruising offered an
economical taste of seagoing adventure without danger of seasickness or having to fend off the
obnoxious mashers infesting conventional resorts.

The business extended the active lives of a number of vessels, but as it was cheaper to buy
another schooner than to pay for major repairs, for most it was but a brief reprieve from the
final mudbank. The *Webster* was soon shifted to Long Island Sound, perhaps to be nearer to the
source of single secretaries and school teachers, but lasted in business there only a season or
two. The "windjammer" fleet on Penobscot Bay, however—the term "dude schooner" is passé—
not only survived but eventually thrived, both with rebuilt relics and, beginning in the 1960s, the
addition of several fine new vessels.

The *Webster*'s raised poop and stanchioned fly rail, a common feature of larger schooners,
was unusual for a two-master.

CARVERS HARBOR, VINALHAVEN

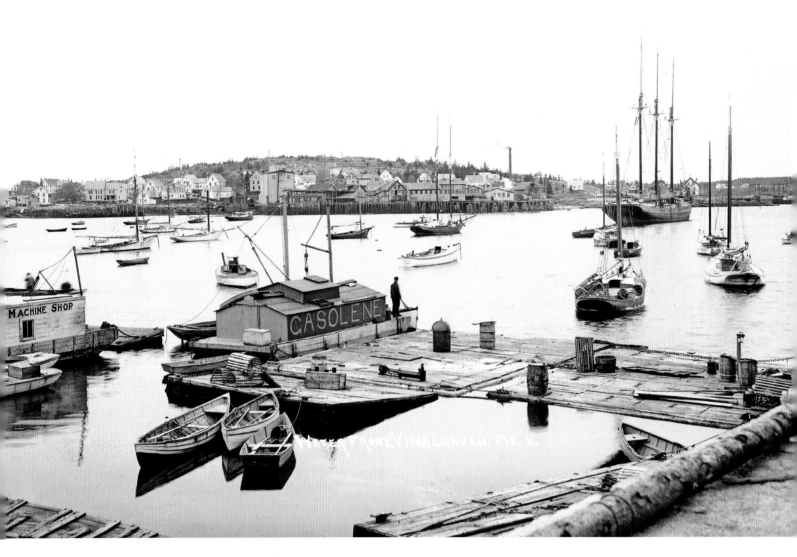

Carvers Harbor Vinalhaven Island was a busy place in the early 1900s, cutting granite, catching and curing fish, coopering, making glue, and knitting fly netting for horses.

 Across the harbor we are looking at the buildings of the Lane–Libby Fisheries Company, which annually cured six to eight million pounds of groundfish obtained from local boats and smaller dealers along the coast. Most was sold in the northeast states as boxed boneless fish, while large quantities of hard dried fish were shipped to South America and the West Indies. Fertilizer, glue, oil, and dried sounds (swim bladders, used to settle beer and make isinglass) were byproducts. Had the photographer arrived on another day, an Italian salt bark might have provided a picturesque centerpiece.

 We do see Friendship sloops, likely most now with motors. The floating machine shop and the gasoline barge are manifestations of the internal combustion revolution. The small, lofty schooner is a puzzler—she looks like a yacht-like pre-engine-revolution lobster smack. The three-masted schooner has likely come to load paving or salt fish. Dories ride on moorings, while two high-sided peapods and a skiff are tied to a lobster-storing "car" in the foreground.

GREEN'S ISLAND, VINALHAVEN

Heron Neck Light Looking south from Heron Neck Light's tower on Green's Island, all that the keeper sees, while technically the Gulf of Maine, is the open Atlantic.

Built in 1854, Heron Neck Light served as the southeastern gatepost of Penobscot Bay. Maine would become the nation's second-most-lighthoused state—Michigan ranked first—thanks to the infinite complexities of its coastal geography, the heavy marine traffic in its waters, and its influential powerbrokers in Washington.

To most mariners groping their way through pea-soup fog the sudden sound of a barking dog was disconcerting. In the early 1900s, however, Vinalhaven fishermen welcomed the deep, fog-piercing barks of Keeper Levi Farnham's Newfoundland, Nemo, who diligently answered the bleat of their foghorns.

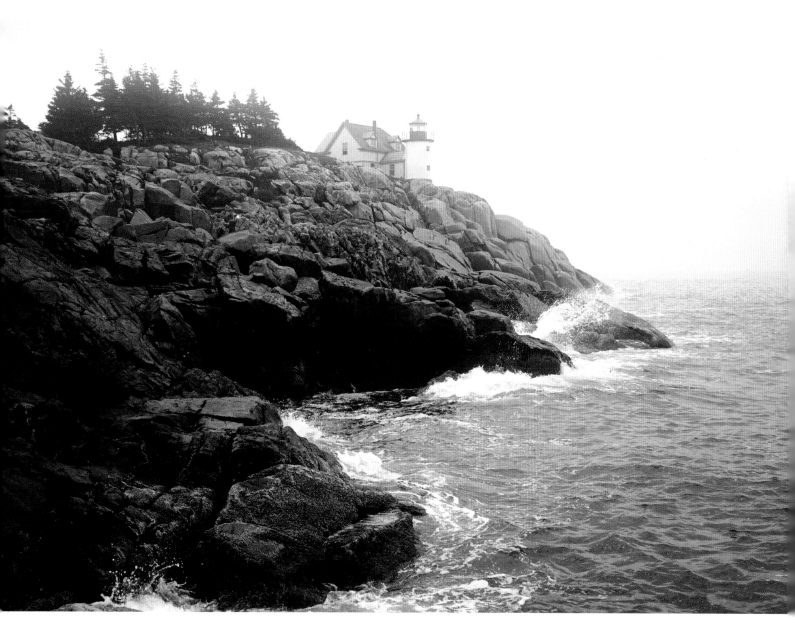

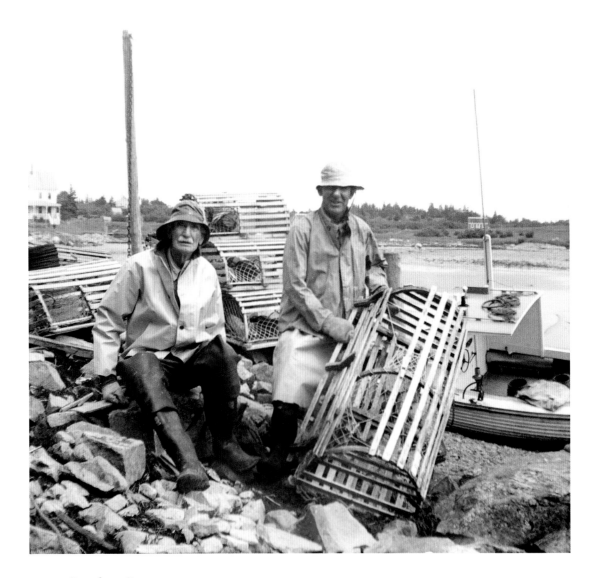

Gooden Grant The legendary Gooden Grant (left) is shown here with his sternman Minot Conary, of Deer Isle. Born in 1876, Gooden Grant began fishing at age nine and retired in 1961 at age eighty-four. He died in 1975. He spent many years lobstering in Friendship sloops. A "high liner," he set more gear than most and fished in winter in the dangerous waters off Seal Island, setting traps in seventy-five fathoms, hauling them by hand, and then beating home at five degrees above zero.

In the summer, when winds were fickle and the lobsters were in shoal water, he rowed from trap to trap in a peapod. He was an early convert to gasoline motors, even back when they had to be stopped and restarted by hand at every trap, risking a broken arm when spinning the flywheel. Said Gooden, "It was still better than rowing, although at times I didn't think so."

The turn-of-the-century decades were difficult times for most "shore fishermen," but in 1911 Grant built a fine new house at Head Harbor. He came from enterprising island stock—his father had owned a store that outfitted banks schooners, and also a large farm. Not long before his death Gooden remarked, "I've always found a good vessel and a good friend was better than money. . . . Makes me feel bad to lose them one after another."

Mirror Lake Mirror Lake looks as inviting here as it sounds in a July 1898 description in the *Maine Central*, a Maine Central Railroad publication promoting tourism:

> *Camden offers more varied attractions than any other resort on the entire coast. When one tires of the smiling, surging, shifting sea, he has but to turn for diversion to the mountains and the scores of charming lakes with which the place is surrounded. Within a distance of ten miles there are equally as many charming ponds where a summer day may be spent fishing, picnicking, or viewing the sylvan beauties of nature here so lavishly displayed. Mirror Lake is located high up among the mountains, at an elevation of three hundred and fifty feet above the sea. It is but six miles away, and its crystal water supplies the town.*

Today's view of Mirror Lake mirrors that of one hundred years ago aside from the fact that the sylvan lakeside lane has become roaring Route 17; a communications tower surmounts nearby Ragged Mountain; and no boats, persons, or dogs are allowed on or near the water. On the other hand, there are fewer telephone wires (upper left). With backup from Grassy Pond and a brook, Mirror Lake remains the water supply for several towns.

MIRROR LAKE W. ROCKPORT ME. 16.

APPLETON

Appleton Cemetery Photography is about surprise and mystery. What the EIC photographer saw that made him stop to take this photograph of an old cemetery is a mystery, and surely even he would have been surprised by the almost surreal image that resulted. Ghostly gravestones, many of them pushed akimbo by years of frosts, appear to have sprung from the corpses planted beneath. The orchard beyond, grown from scions grafted long ago onto hardy rooted stock, somehow provides the perfect backdrop.

In the 1840s some of the residents of this cemetery doubtless watched canal boats—called "gondolas"— being rowed, poled, and sailed the length of Appleton on the Georges River and Knox Canal. Connecting inland Searsmont to tidewater at Warren, and built with local funds and energy, the canal was intended to provide a better means for transporting ship timber and produce from the St. George River valley. Operations lasted but ten years.

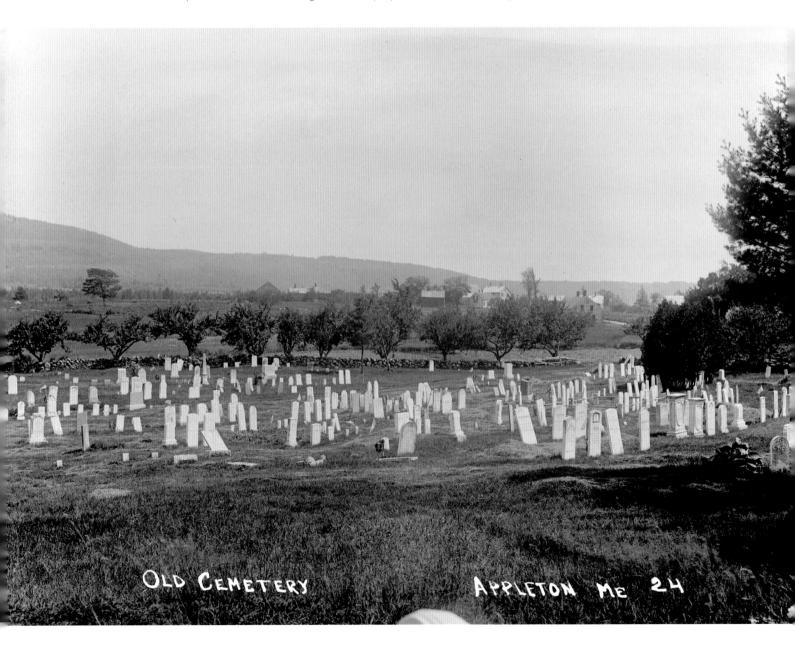

OLD CEMETERY APPLETON ME 24

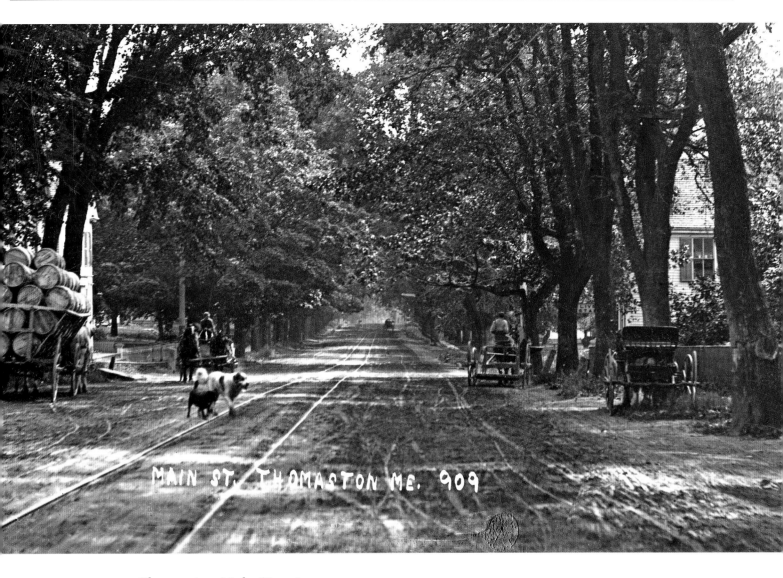

MAIN ST. THOMASTON ME. 909

Thomaston Main Street Photographs of Thomaston taken in the 1870s show an almost rigidly squared-away town of white-painted houses with nary a tree. During the American centennial year of 1876 it was decided to plant elm trees along the town's streets, and here—looking down Main Street (now US Route 1)—we see the delightful canopied result, one that was repeated in countless cities and towns across Maine and the nation before the Dutch elm disease denuded them again.

The two best pals are crossing the tracks of the Rockland, Thomaston, and Camden Street Railway. This image also demonstrates photography's ability to deceive and distort, for the overhead wire from which the streetcars received their electrical power is nowhere to be seen, although it is there.

The hayrack filled with empty lime casks represents the millions more, hove together in little cooper shops on countless hinterland farms, which traveled down this road. For decades the production and shipping of lime—along with the building and sailing of ships—was a cornerstone of the local economy. Most of the lime was shipped to New York to be used in plaster and mortar. In 1900 Thomaston still had over twenty operating lime kilns, but the industry had entered its final descent. Thomaston limestone is now used for making cement.

Barkentine *Reine Marie Stewart* The barkentine *Reine Marie Stewart* is berthed in Thomaston Harbor in this view across the Georges River from the Brooklyn Heights neighborhood, likely so-called because prominent Thomaston shipowners had moved to Brooklyn Heights, New York, by the East River, the better to oversee their ships and businesses. Stratospheric shipping rates brought on by World War I attracted both speculative plungers and the staid Thomaston firm of Dunn & Elliot, longtime sailmakers, shipbuilders, and shipowners. Not having built a vessel since 1904, their once-large fleet of schooners had dwindled to four, and so, in 1917, they went back to work. By 1920 they had built a four-masted schooner, twin four-masted barkentines, and a five-masted schooner. The five-master, the *Edna Hoyt*, built in 1920 for $200,000, sold four years later for $25,000 as the bottom fell out of the shipping business.

The twin 1919 barkentines, the *Cecil P. Stewart* and the *Reine Marie Stewart*, found cargoes as best they could, mostly in coastwise trades, although the *Reine Marie* made a voyage to Greece. In 1927 the *Cecil P* was lost on the New Jersey shore, and in 1928 the *Reine Marie* was laid up at Thomaston, awaiting better times that never came, becoming a mouldering photographic icon. In 1937 she was sold to Nova Scotian owners and rerigged as a four-masted schooner. In 1942, with tonnage again in demand due to war, she was purchased by Boston owners and sailed for West Africa. Off Sierra Leone she was sunk by an Italian submarine.

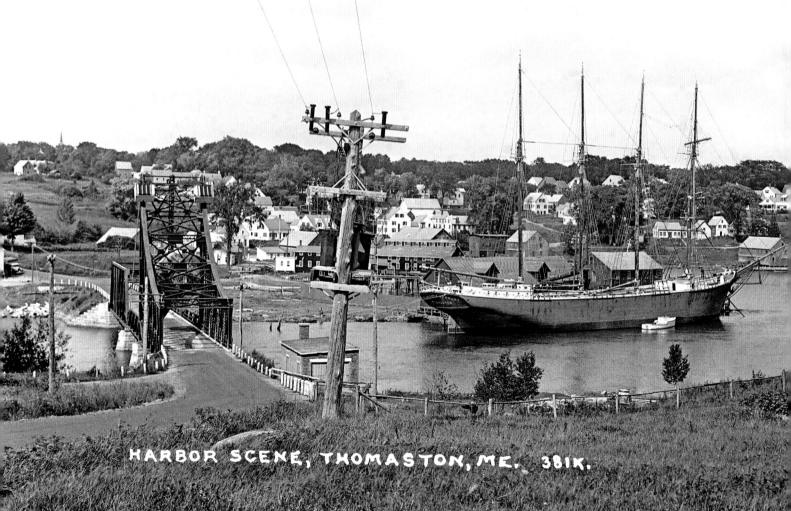

HARBOR SCENE, THOMASTON, ME. 381K.

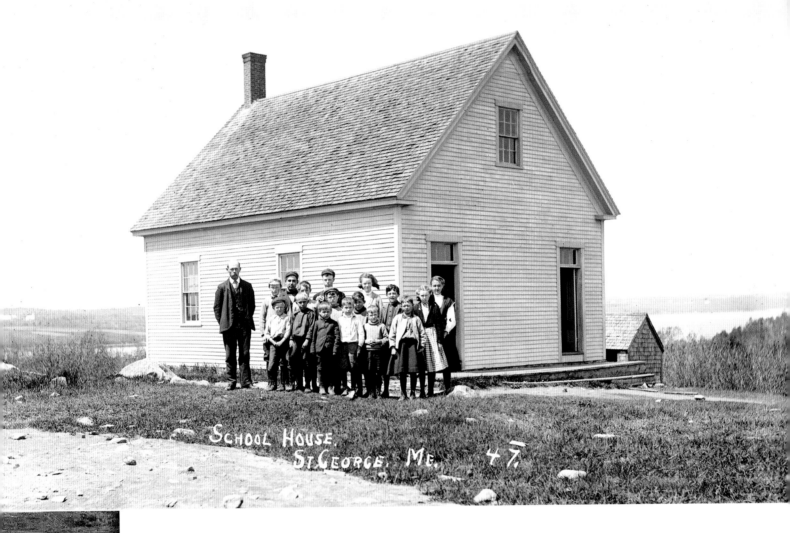

SCHOOL HOUSE,
St. GEORGE, ME. 47.

St. George School Students pose for a photo outside a district schoolhouse in St. George. In 1900 or 1901, in nearby South Thomaston, Wilbert Snow (the future poet) became the first high school graduate from Spruce Head Island. Taking a job in a quarry, he was soon fired for urging his fellow quarrymen to unionize like the better-paid stonecutters. He was then hired as the teacher of a district school, with about thirty "scholars," at six dollars a week.

The term began in August and ran for ten weeks. A second ten-week term began in the spring. Snow placed his pupils in three groups, rather than in eight grades, extended recess periods, and one day took the student body on a nutting expedition, arousing the ire of parents. He was then promoted to a larger school at Owl's Head, where, like the mate of a ship challenged by a belligerent sailor at the outset of a voyage, he had to lick the toughest of the older boys in a fistfight to win respect. Snow later wrote:

> *At the end of the term I said good-bye with regrets. I realized as never before the inadequacy of education in Maine—twenty weeks a year in a one-room schoolhouse; outhouses filthy, the boys' section jackknife-carved with obscene graffiti; potbellied stoves able in cold weather to heat only the front half of the room; underpaid and over- worked teachers trying to manage on six, eight, ten dollars a week—all this showed that people were giving lip service to education, and that was all.*

Long Cove Quarry At Booth Brothers' Long Cove Quarry in St. George, quarrymen on a waste pile reposition the inclined railway running from the cutting shed to the wharf while, above them, paving cutters cut street paving blocks. In 1891 the Booths' two quarries on Long Cove shipped 2,500,000 granite paving blocks in addition to 3,000 monument bases, making cargoes for thirty-odd vessels, while another two-dozen schooners served their nearby State Point quarry.

One of Long Cove's largest contracts came in 1891 for cut stone for a large office building in Philadelphia, estimated to employ 1,500 men for one year for the cutting alone. In a big quarry, most paving was cut from waste stone. The biggest market for Maine paving was New York, a New York paver measuring eight to twelve inches long, seven to eight inches deep, and three and one half to four inches wide. This provided far superior traction for horses than did larger blocks; ideally, granite for pavers was hard and brittle, else it became slippery with wear.

Paving cutters were specialists with their own union. Many were Scots and Swedes. Finns brought in as strike breakers soon became union men as well. Strength and endurance—a paving hammer weighed twenty-six pounds—and the ability to "read" the grain were prerequisites. Many cutters worked small "motions" located here and there.

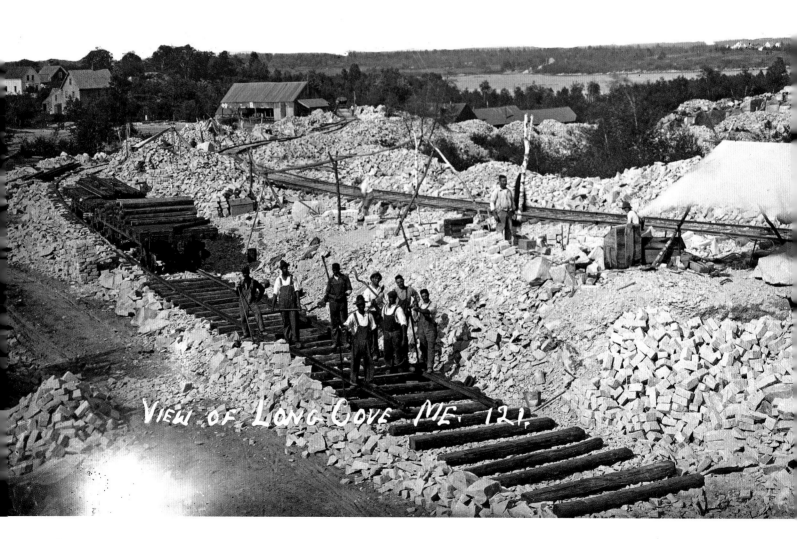

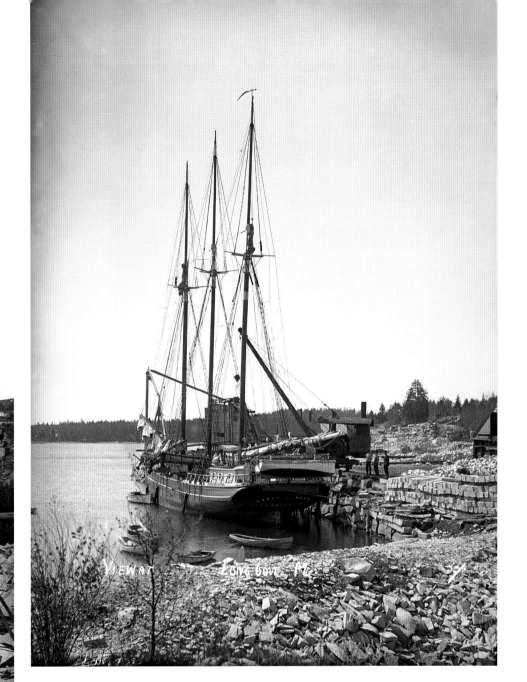

Schooner *Abbie Bowker* The three-masted schooner *Abbie Bowker*, of Thomaston, is loaded by the "Black Maria," which operated at the Booth Brothers quarry from the 1870s until 1942. Booth Brothers was one of several large quarries in St. George, in addition to numerous small, one-man "motions."

Maine's extensive granite industry after the Civil War was the result of many factors, including architectural styles, construction technology, stone qualities, the availability of water transport, the budgetary surplus of the federal government, and politics, crooked and otherwise.

Granite's grains, which permitted it to fracture along fault lines into sheets, made it both feasible to quarry and a valuable construction material. Long Cove produced "dark granite," a very closely grained stone which "hammered very light" but took a dark, high polish and fractured in thin sheets.

The *Bowker* was built at Phippsburg in 1890. A small three-master, in 1914 she loaded a cargo of 32,300 blocks at a Vinalhaven quarry, whereas the three-master *James Rothwell*, which preceded her there, loaded 77,000. In 1918 the *Bowker* stranded and was lost in the Bahamas.

Port Clyde Lobster In August 1914, Elbridge Stone shows off an eight- or ten-pound lobster measuring thirty-six inches from claw to claw. (A twenty-five-pounder landed at Dennysville, in Washington County, in 1905 measured forty inches long overall.)

Maine's first regulation regarding the minimum size of a legal lobster was passed in 1874. The first law stipulating a maximum legal size was passed in 1933, so Elbridge is safe from the law, at least in this instance. A "withy" jack-of-all-trades, Elbridge is said to have stood on top of a cornice of a five-story building and bent over at the waist to paint the underside of the trim. Well, it's a good story. He was also said to be a very enterprising rumrunner.

In the early 1900s lobster landings were very low, and likely there were relatively few full-time lobster fishermen. When the United States entered World War I, the lobster industry suffered from the idea that citizens should practice self-sacrifice. The big Rockland lobster dealer A. C. McLoon & Company countered:

<div align="center">

DO YOUR BIT
All those who are able and whose disposition is to
EAT LOBSTERS
and thus conserve the necessities of life for those who
are unable to afford the luxuries, and by so doing
HELP WIN THE WAR.

</div>

In the background we see a clam hod, the wooden basket in which clams are placed on the digging flats and then rinsed of mud with a rocking motion in shallow water.

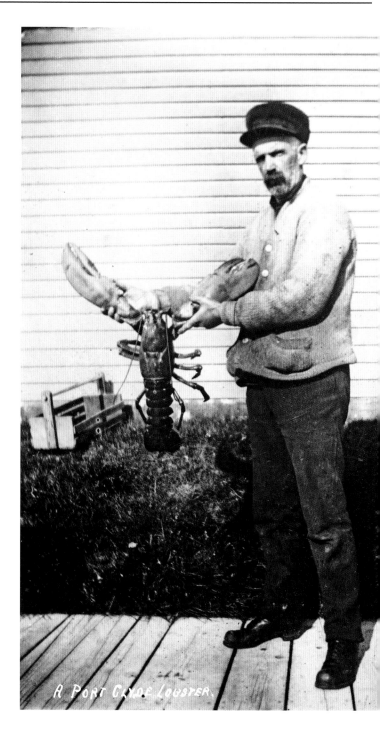

A Port Clyde Lobster.

Killer Whale A stranded orca, or killer whale, attracted much attention in 1956. The *Rockland Courier-Gazette* of December 15 reported: "Children and grown-ups alike took advantage to mount the killer whale's back while camera shutters snapped." The boy is Alan Hupper. The girl is Nadine Dowling. Nadine, understandably, looks ill at ease and perhaps is concerned for the whale.

The camera appears to be an iconic Rolleiflex. John Stilgoe has written: "The Rolleiflex caused users to bow toward subjects: most photographers not only bowed their heads . . . but also slightly hunched their shoulders and pulled in their stomach, bending their bodies at the waist." Viewfinder cameras, Stilgoe observed, capture a different perspective than do 35 mm cameras (or, indeed, cellphones).

The next morning at high tide, fishermen Hugo Lehtinen and Allison Morris, using a small outboard motorboat, towed the whale to deeper water, only to find themselves being towed by the still lively creature. That night the whale stranded again but had vanished by morning.

Sighting a killer whale today in the Gulf of Maine is a great rarity, although in the 1880s Cape Codders complained that they interfered with attempts to drive blackfish ashore.

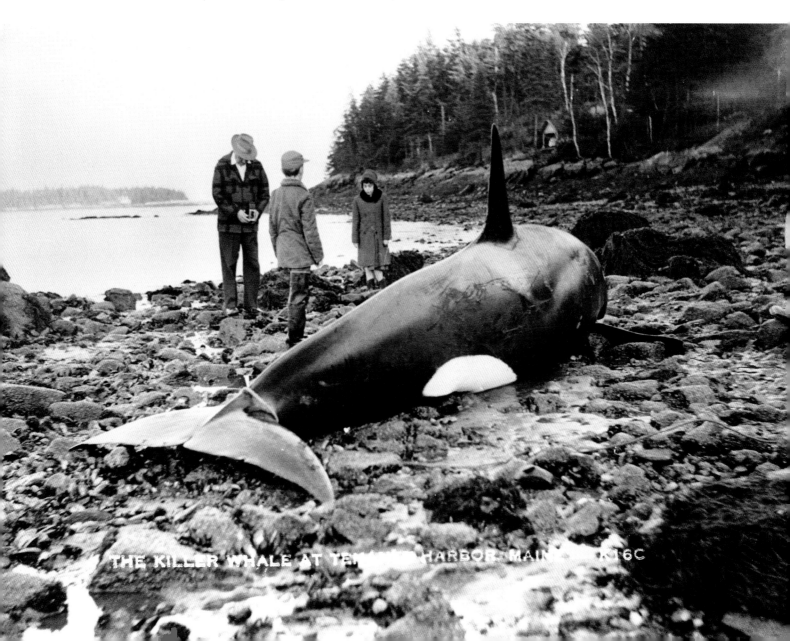

THE KILLER WHALE AT TE HARBOR MAIN K16C

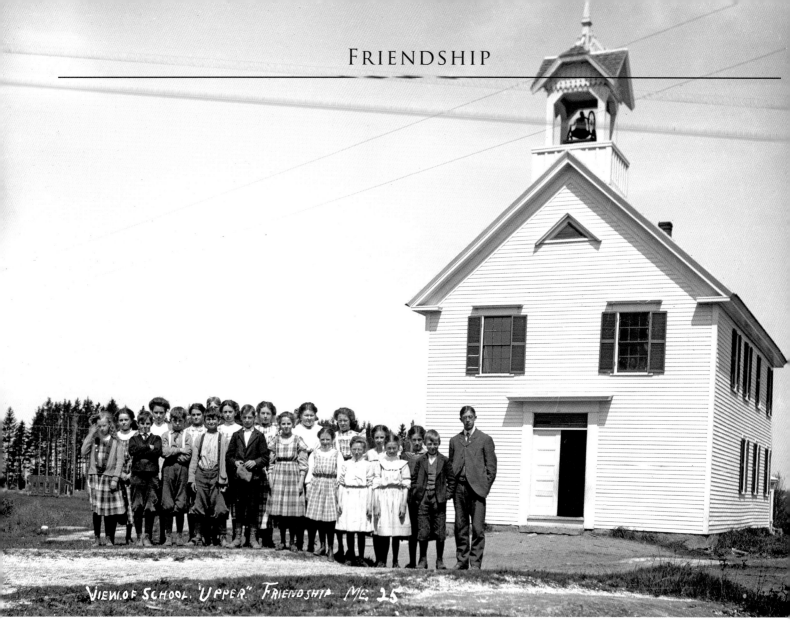

VIEW OF SCHOOL "UPPER" FRIENDSHIP ME 25

Friendship School Upper-grade scholars pose with their shipshape "Corner" school-house. Expanded from a single-room school, the lower floor was used for primary grades one to five, while the second floor was used for grade six to the first year of high school.

In the fall of 1924 a Nobleboro farm boy, Hudson Vannah, just graduated from high school, took the teaching job in a one-room district school at Back Cove, South Waldoboro, a community adjoining Friendship. Hudson found this to be a very different world from upland Nobleboro, although located less than ten miles away.

> *Almost all the men went lobstering in the summer. . . . In the winter most of the women braided rugs for Old Sparhawk Mills . . . the men cut and fitted their wood supply for the next winter, killed and processed their pigs, dug some clams for home use, and went hunting. . . . In the early evening, the kids all got together and visited for a few minutes at every house on the road. This went on almost every night. . . . It was a wonderful community, almost a country by itself.*

Hudson was less taken with the diet of sea duck and wild rabbit served at the home where he boarded, and he taught for only one term.

SWIMMING SCENE MEDOMAK LAKE WASHINGTON ME. 15.

Medomak Camp In 1904 Frank Poland and partner Walter Bentley established Medomak Farm Camp (later, Medomak Camp) on Washington Pond, on land of the Poland family farm, offering a hot-weather respite and rural living experiences for boys from big cities.

In 1946 Wetona Girl's Camp, established on the pond in the early 1920s, was purchased by Medomak Camp and renamed Med-O-Lark Camp. Closed in 1965, it soon after reopened as a co-ed, nonsectarian, noncompetitive alternative to traditional camps.

Frank Poland ran Medomak Camp until he died in 1964. The camp was then sold to Dick Larson of Sudbury, Massachusetts, who ran it until 1979, when it was bought by the Church of the Nazarene. In the 1990s, it was sold to a former camper who reinvented it as a secular family camp, with a retreat center, which continues. On a separate site there is a nonprofit camp for underprivileged girls.

Note the handsome pulling boats; EIC lake photos include many shapely water craft as pleasurable to contemplate as to row. Their motorized successors—including droning jet skis and high-powered dragsters—now endanger swimmers, rowers, paddlers, loons, and lakeside tranquility. Note also the not-exactly-natty robes, practical defense against sun, mosquitoes, and chills, if not the gibes of youthful fashion critics.

SHUFFLE BOARD COURTS – WILLOW BEACH CAMPS – CHINA, ME. 8173

Willow Beach Camps Willow Beach Camps, at the head of China Lake, in 1946. A new '46 Pontiac apparently is acting as referee for the thrilling contest taking place at the shuffle-board court.

An ancient game originally played on tables, court shuffleboard reached its peak of popularity in 1950s America. Florida, then viewed as an exotic land, was the sport's epicenter, and no newsreel or magazine photo spread about travel on luxurious ocean liners was complete without the obligatory photo of a game of deck shuffleboard.

Willow Beach had twenty-one cabins. In addition to shuffleboard, the camp offered a pitch-and-putt golf course and excellent fishing. It operated on the American plan, with three daily meals served in the central dining room. Cabins featured electricity, bathrooms, and fireplaces.

Owner and manager Nelson W. Bailey was the longtime principal of Lincoln Academy in Newcastle, and many of the school's students found summer employment at Willow Beach. Bailey was also a founder of Unity College. A devotee of unusual cars, Bailey once owned a Studebaker that looked as though it should have had a propeller at both ends.

Benton Creamery A Turner Center System receiving station, or "creamery," is shown in operation below the tracks of the Maine Central Railroad in Benton Station, a district of the town of Benton. Good rail service was key to the growth of the dairy industry.

In 1882 a cooperative butter factory was established in Turner Center, in Turner, and soon became the privately owned Turner Center Creamery. Under founder E. L. Bradford, the company grew rapidly and brought Maine into the Boston "milk shed." Innovative pricing encouraged year-round production, which led to single-purpose dairy farms and greatly increased the state cow herd.

By 1920 the "Turner Center System" had twenty-three receiving stations. Sources differ as to the range of functions performed at these stations, but at least initially stations tested for butterfat, then separated milk into 40 percent butterfat "sweet" cream for shipping.

After 1913, reflecting a growing market, increasing amounts of whole milk were shipped to the main plant in Auburn.

Even if shipping whole milk, apparatus for steam-cleaning farmers' milk cans was required. It appears that the Benton creamery received both three-phase "delta" electrical power, with two 120-volt wires and a ground, and a separate two-wire 120-volt service. Perhaps the three-phase power was required for mechanical refrigeration, as no icehouse is in sight.

In 1929, after having again become a cooperative, Turner Center fell victim to a takeover by Boston's H. P. Hood & Sons.

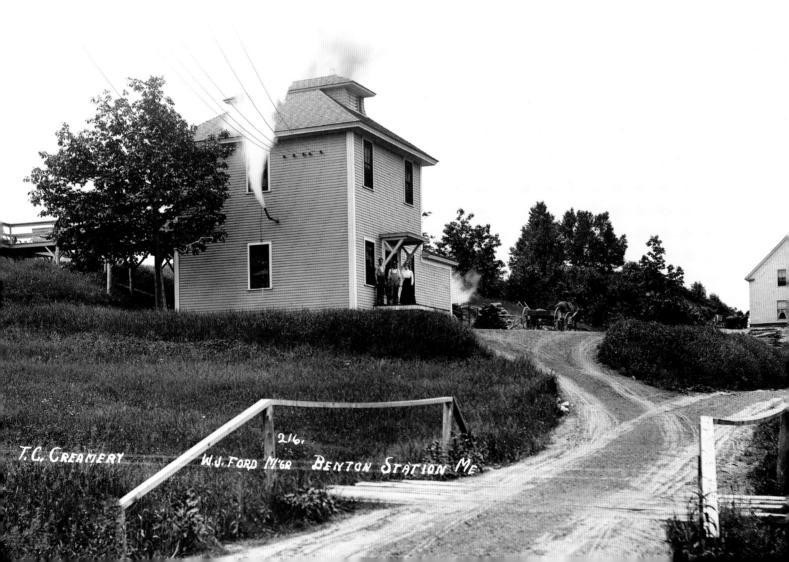

T.C. CREAMERY 216. W.J. FORD M'GR BENTON STATION ME

Social Hall A large social hall like this one at Davey's East Lake Camps in Oakland was a huge rainy day asset. The rockers make a more evocative image empty than if they were occupied.

Essentially, a sporting camp was an establishment, usually on a lake or pond, with a lodge where meals were served and cabins for guests. There were many variations, from classic wilderness camps devoted to serious fishing and hunting to family-friendly resorts, such as Davey's, in settled towns. Some camps, safely removed from public scrutiny, attracted pseudo-sports intent upon running wild with guns, rum, and freelancing chambermaids.

Camps capable of being accessed by an EIC photographer and desiring postcards included a number of the tamer variety, many being sited on former farmland in the Belgrade Lakes region, of which bodies of water East Pond was a minor member.

Davey's East Lake Camps had previously been called North and East Pond Camps, East Pond Camps, New East Pond Camps, and Clement's East Pond Camps. Ads in outdoor magazines boasted of fly and bait fishing ("50 to 100 bass per day"), boating, canoeing, tennis, bathing, dancing, and even "automobiling" (a 1915 ad noted that there were two camp automobiles), and "woody walks." The cabins had fireplaces and, eventually, hot and cold running water. The camp had its own garden and source of dairy products.

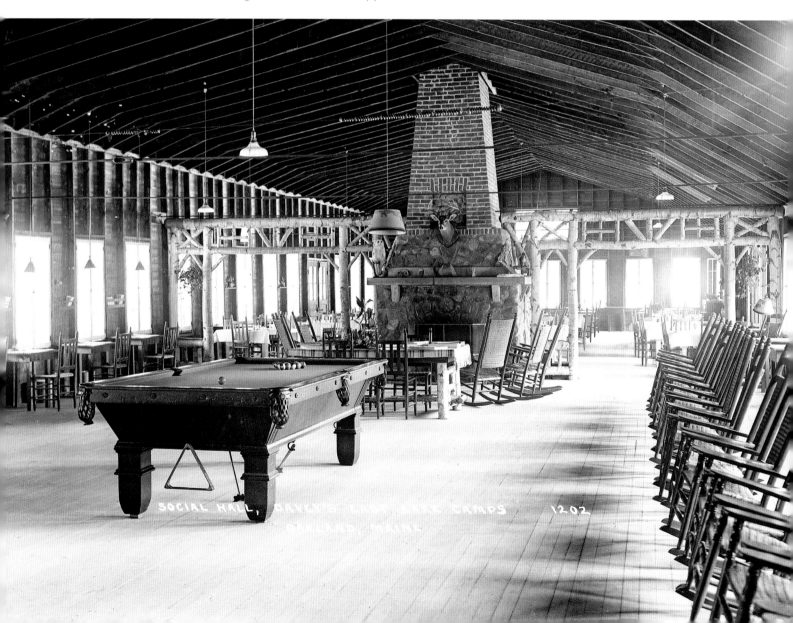

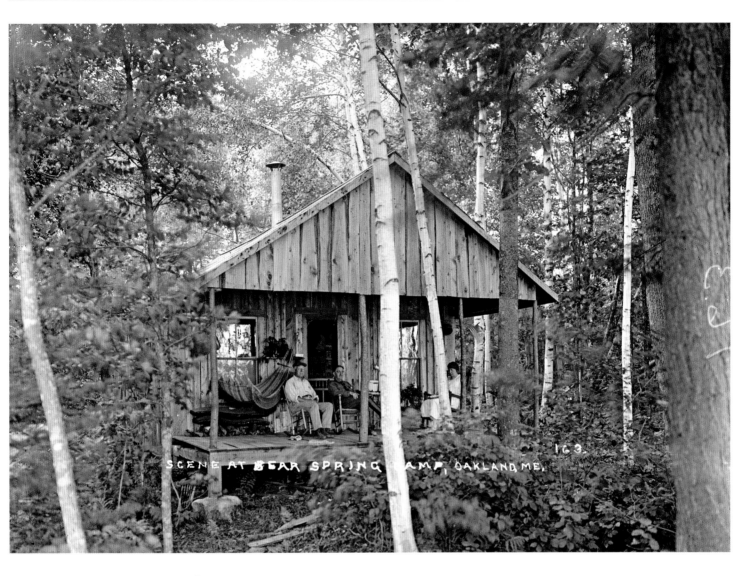

SCENE AT BEAR SPRING CAMP, OAKLAND ME. 163.

Bear Spring This cabin is at Bear Spring Camps, which, the photo label to the contrary notwithstanding, is in Rome—on Great Pond in the Belgrade Lakes region—not Oakland. The era is likely the 1920s. Bear Spring Camps was established by George and Alice Mosher in 1910 and is still in the family and very much in business. It was a cherished retreat for writer E. B. White from childhood on, and is the setting for his classic essay "Once More to the Lake":

Summertime, oh summertime, pattern of life indelible, the fade-proof lake, the woods unshatterable, the pasture with the sweetfern and the juniper forever and ever, summer without end.

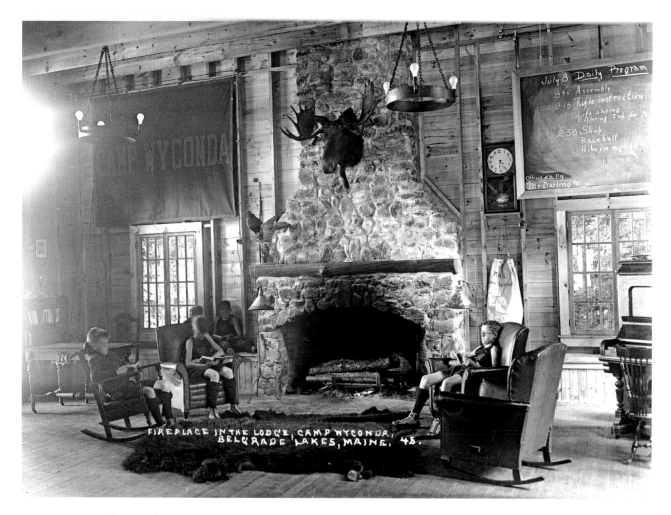

The Lodge According to the 1928 booklet of Camp Wyconda on Long Pond: "Camp life centers in the big, roomy lodge with its great stone fireplace." Charging $350 for the two-month session, Wyconda was clearly intended for sons of the well-to-do. Boys from Boston, New York, and Philadelphia boarded special cars bound for Belgrade.

Assuaging the fears of hovering mothers, Wyconda boasted flush toilets, artesian well water, and cots fitted with bedsprings and comfortable mattresses. "The daily supply of milk comes from a herd of tubercular-tested cows. . . . At eight o'clock every evening, boys who are under-weight and in need of extra nourishment are served eggnog and crackers."

Activities included swimming; canoeing and rowing; fishing; horseback-riding; rifle-range (under charge of an ex-army officer); shop (for building model yachts); nature study; orchestra; and various trips, including a trip to the coast to swim in salt water. Academic tutoring and also a coastal cruise (with camping ashore every night) aboard a chartered sloop were available at extra charge.

The template for Maine children's camps was Camp Merryweather, established on Belgrade's Great Pond in 1900 by Henry Richards and his wife, the popular author Laura Richards. The facilities at Merryweather were bare-boned. Extended canoeing expeditions were central elements of the program. With strong ties to Massachusetts' Groton School, campers included many future notables.

In the 1960s Camp Wyconda's 200 acres were subdivided into many small lots in a controversial development scheme.

Camp Maranacook Cabin This is one of the "junior bungalows" at Camp Maranacook, located on an island in Maranacook Lake. Founded in 1908 by William H. Morgan, the camp featured a "garden farm." Campers decamped in August for a second camp in Weld.

An ad for Grips Shoes in the July 1930 edition of *Boy's Life* magazine featured a plug for Camp Maranacook—"A Real Maine Camp for boys. . . . 'Sure footwork means safety,' says William H. Morgan, Camp Maranacook Director, 'That is why I want my boys to wear Grips.'" The page also featured ads for Big Bang carbide cannons and a flying model of a combat monoplane, two items surely of greater interest to the magazine's boy readers than shoes.

This cabin's interior decoration includes posters for Peanut Brittle and "Cooling & Refreshing" Rochester root beer. Pennants promote Massachusetts, Harvard, Atlantic City, and the Walpole Inn ("Quality First, Good Food, Refinement"). On the table at left sit a Brownie camera and a trumpet, the latter perhaps for reveille. The alarm clock sitting on a shelf may have awakened the trumpeter. An assortment of tennis rackets, baseball bats, and fishing rods line the walls. Note the knob-and-tube electrical wiring overhead.

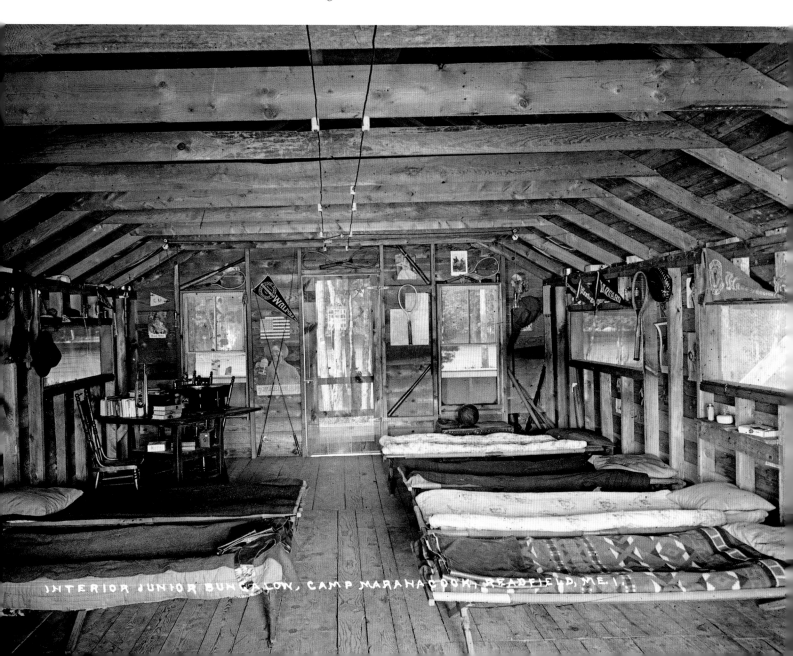

INTERIOR JUNIOR BUNGALOW, CAMP MARANACOOK, READFIELD, ME.

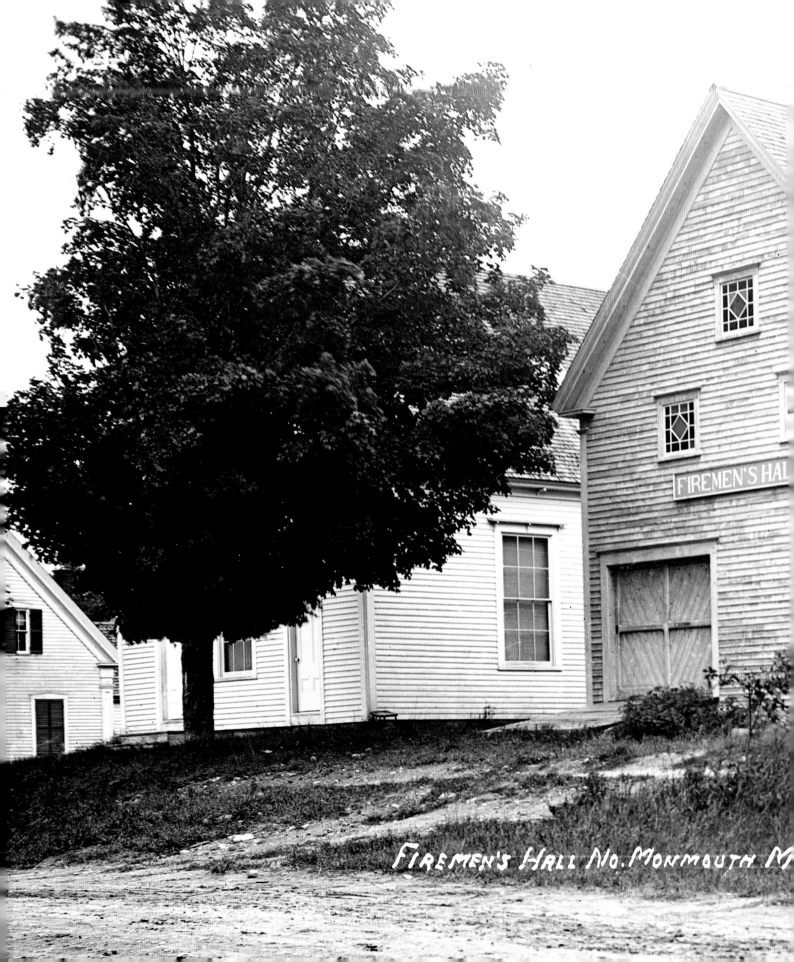

FIREMEN'S HALL

FIREMEN'S HALL NO. MONMOUTH M

Maxwell in Monmouth Herman Cassens' game little EIC Maxwell, shown here outside the Firemen's Hall, was equipped with chains on the rear wheels for better traction on muddy roads. The identity of the female fellow traveler, who appears in a number of images from far-flung corners of the State of Maine, is open to conjecture, but she evidently was a woman of fortitude and patience and a very good sport.

Monmouth, along with towns such as Winthrop, Turner, Bridgton, and Greene, was known for its apple orchards. In fact, it still is. In the late 1800s and early 1900s, Maine was a major exporter of winter apples to Great Britain via the ports of Portland and Boston.

After World War I, various problems beset Maine orchardists, including pests and competition from the West Coast and Nova Scotia. Severe winters in 1906–07 and 1917–18 were damaging, but the winter of 1933–34 was devastating. It caused the shift from the venerable Baldwin, long a New England standby, and the handsome but scarcely edible Ben Davis (a favorite apple for export, being second cousin to a cannonball) to the more winter-hardy red MacIntosh.

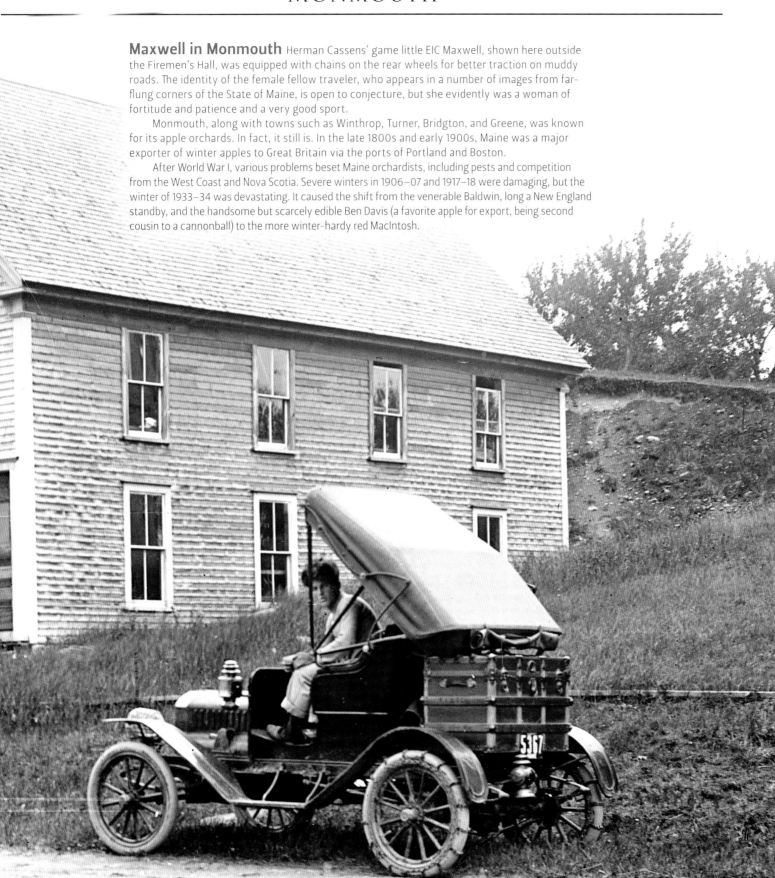

Water Street, Augusta Busy Water Street, likely in the nineteen-teens, would have looked very different before Augusta's Great Fire of September 1865 consumed all of these buildings' predecessors, save some at the far end. Set by an arsonist and spurred on by a southeast wind, the fire spread rapidly and deviously beneath the wooden sidewalks, which were elevated from the ground on posts. Eighty-one buildings, constituting the city's commercial center, were destroyed.

Aside from being Maine's capital city, Augusta could boast of the big Edwards cotton mill (manned—and woman-ed—primarily from the adjacent French-Canadian neighborhood of Sand Hill) and the national veterans' home at Togus. But the city's best-known claim to fame was as the source of more than a dozen magazines—the best known being Gannett's *Comfort*—produced by three publishing houses and circulated nationally, primarily to millions of rural housewives.

The magnificent 1890 granite post office, located behind the photographer's right shoulder, was a testament to the vast market for publications of minimal intellectual content functioning primarily as vehicles for mail-order advertising of items of little or no value, printed on the cheapest grade of paper, and best suited for a one-way trip to the privy.

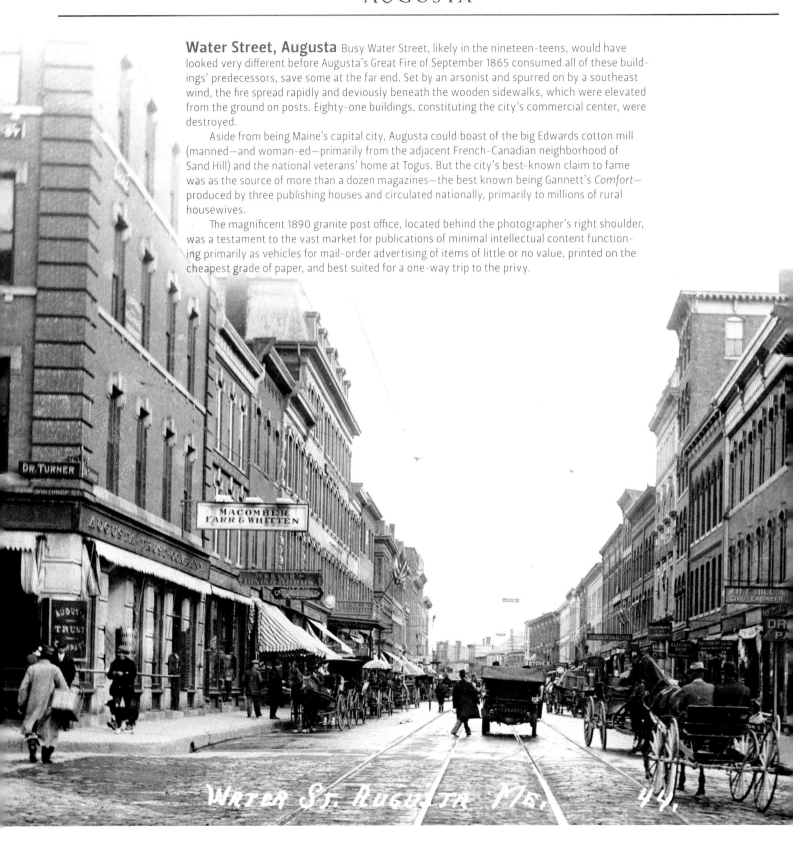

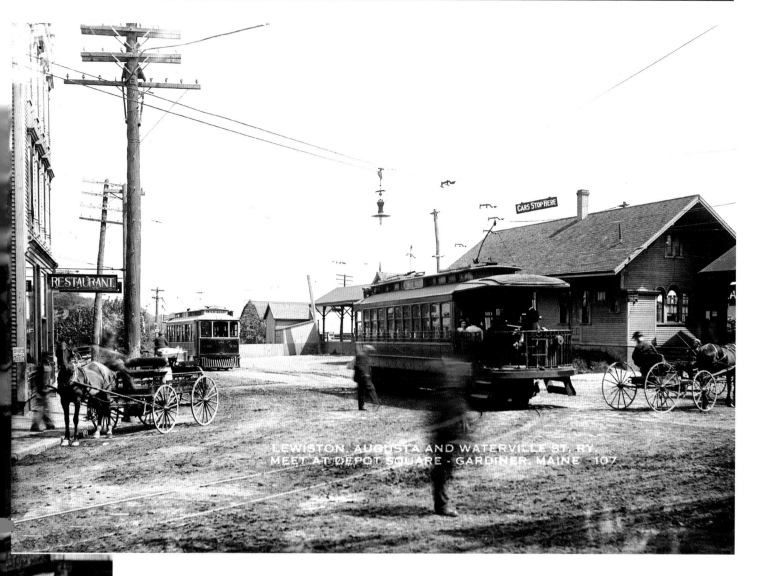

LEWISTON AUGUSTA AND WATERVILLE ST. RY.
MEET AT DEPOT SQUARE - GARDINER, MAINE 107

Depot Square, Gardiner Gardiner's Depot Square was a transportation hub. At right is the busy Maine Central Railroad station, while just to the south was the Eastern Steamship wharf, with daily seasonal service to and from Boston. At center, a Lewiston, Augusta & Waterville Street Railway interurban trolley car, bound for Lewiston, waits for the Gardiner-to-Augusta local to switch onto the sidetrack.

In the fifty-four-mile service between Lewiston and Waterville began in 1909 and ended in 1937. Gardiner-to-Augusta service—which would expand to Winthrop and Togus—began in 1889 and ended in 1940. During its brief heyday, "electric traction" began the move of city dwellers to the spreading suburbs, the liberation of rural housewives, and other profound social and economic changes to be compounded beyond all reckoning by the automobile.

In Randolph, across the Kennebec River bridge from Depot Square, the steam two-foot-gauge, five-mile-long Kennebec Central Railroad served the National Home for Disabled Volunteer Soldiers at Togus, delivering coal and weekend crowds of picnickers. The train was also patronized by thirsty and/or randy old bluecoats who wished to pay a visit to the little trackside hamlet of welcoming women in Chelsea, a feature not available along the competing trolley line from Augusta.

Commonwealth Shoe

The Commonwealth Shoe & Leather Company "shoe shop" is shown here circa 1920s, with curious workers looking back at the photographer from open windows just above the railroad crossing sign. The home of "Bostonian" shoes, the initial structure was built in 1897 by the city to attract a Massachusetts shoe company. Unlike cotton mills, which had to support heavy machinery, shoe shops could be of relatively light construction. In 1951 this by then inefficient firetrap was replaced by a new building, also city financed, and it was finally razed in 1970.

A bigger Gardiner shoe firm, the R. P. Hazzard Company, was established in 1906 by a superintendent at Commonwealth who joined forces with another Massachusetts shoemaker. In flush times, the two shops employed 1,300 or more workers.

Massachusetts shoemakers came to Maine seeking a low-cost, compliant labor force with which to check the demands of unionized Bay State shoe workers. In Maine, Yankee Republican anti-unionism and a strange bedfellow, the Catholic Church, suppressed significant outbreaks of labor unrest until the major strike by Auburn shoemakers in 1937, which brought out the national guard.

While relations between labor and management in Gardiner were relatively harmonious, dissension was discouraged by the threat of blacklisting. Voracious cockroaches, nurtured on leather dust, raided unguarded lunch pails in a matter of seconds and were a more immediate grievance.

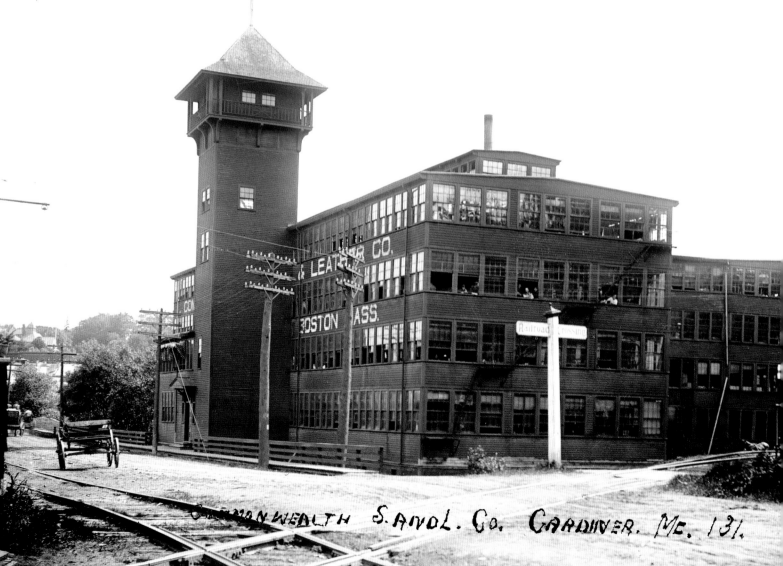

COMMONWEALTH S. AND. Co. GARDINER. ME. 131.

Gardiner Ice Cream The women's dress in this ice-cream parlor on Iron Mine Hill, Route 201, suggests the 1920s. On April 1, 1921, members of the Judiciary Committee of the Maine House of Representatives debated a bill regarding the labeling of ice cream made from "homogenized" cream, which was reconstituted from butter and skim milk. Windbag legislators expounded at length upon a subject on which all could claim expertise, all having eaten plenty of ice cream.

Representative Wing, from Auburn—home of the state's largest ice-cream manufacturer, the Turner Center System—opined: "I do not want to have every small boy and little girl in this State who takes a sum of money in one hand and a war tax in the other to go and buy a cone of ice cream and to have that child or elderly person have that cone labeled 'Homogenized Frozen Milk Product.'"

Representative Hinckley, of South Portland, also spoke in opposition to explicit labeling: "It is well known that during the great war there was a scarcity of fat in Germany, and . . . great wine presses were constructed . . . and the bodies of the dead men were thrown in and the fat abstracted from them, and butter and ice cream . . . was made from it. . . . Are you going to label this [homogenized frozen milk product] Homo. . . the oil of man?"

(On second thought, waitress, I'll pass on the ice cream.)

ICE CREAM PARLOR - IRON MINE HILL GARDINER ME. ROUTE 201.

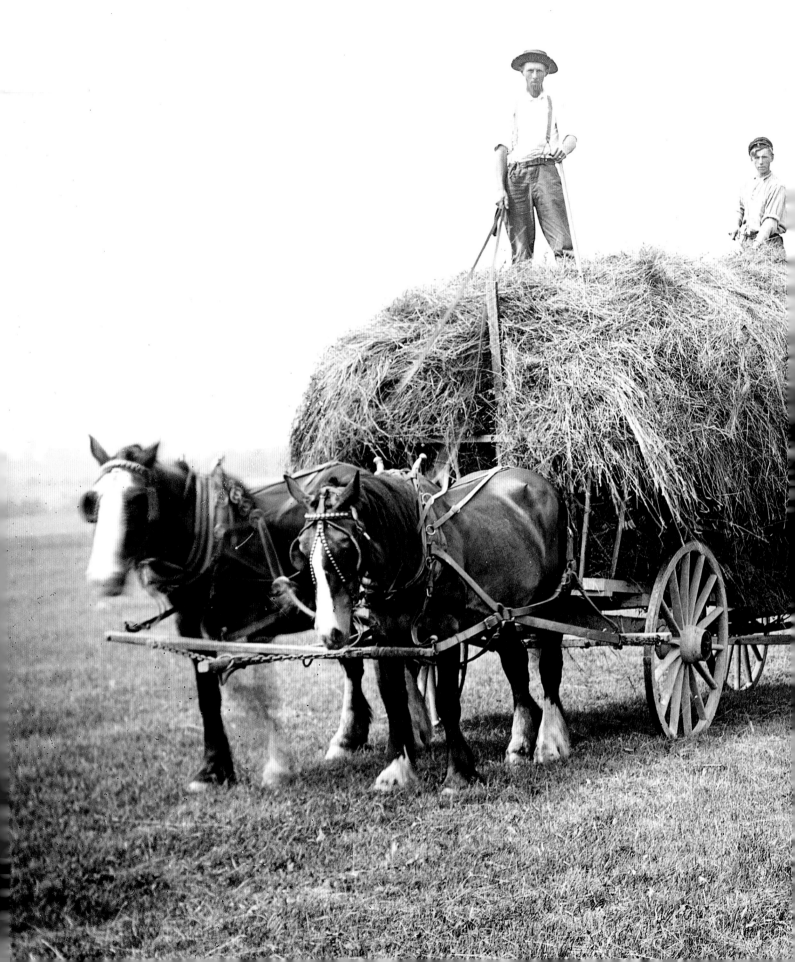

East Pittston Haying Pitching on the last of the raked-up scatterings. The boy on top is packing down the load, which is built up from the corners. Hay was Maine's biggest crop and also its most neglected, with the practice of selling hay rather than feeding stock blamed for a shortage of fertilizing manure. The abundance of semi-abandoned fields with grass free for the mowing was another factor.

Much Kennebec Valley hay was shipped to the Boston market, the Kennebec–Boston steamboat line being known as "the hay line." In winter, hay dealers traveled the valley from farm to farm with horse- or ox-powered presses, baling hay to be sold. "English hay," from upland hayfields, was largely composed of grasses of European origin.

These horses look to be Belgians, likely shipped by rail "green" from the Midwest and paraded from the cars to the dealer's stable in a string, tied tail to mane. The light horse pulling the rake also pulled the family buggy and cultivated the garden. Evidently the farm's dog is bossing the operation.

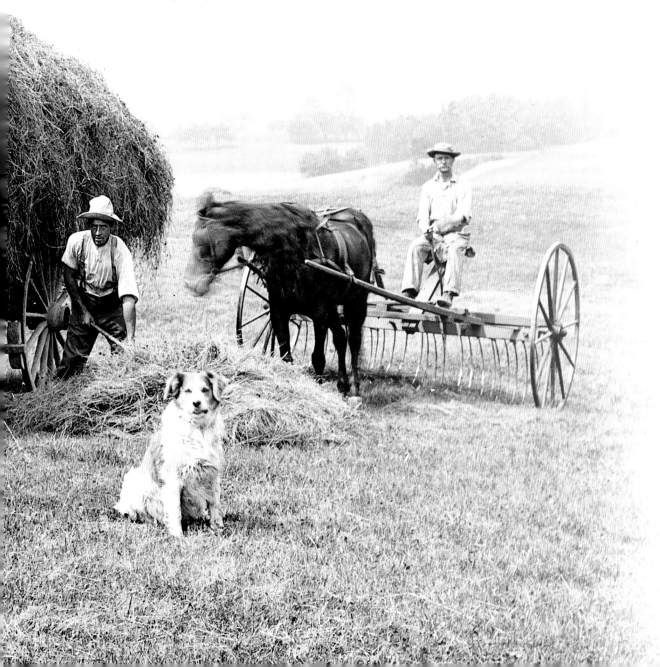

Bowman House The Bowman house on the eastern bank of the Kennebec River in Dresden was designed and built circa 1762 by Gersham Flagg, of Boston, for attorney Jonathan Bowman. The interior decoration included Dutch tiles.

The house still stands about a half mile below the 1761 Pownalborough courthouse. Bowman, a cousin of John Hancock, was register of deeds and would later become judge of probate. Bowman, Charles Cushing, and the Reverend Jacob Bailey were all members of the Harvard Class of 1755 and were all on hand at Pownalborough in June 1765 to welcome their classmate John Adams, who had come to argue a land case at the courthouse on behalf of the Kennebec Proprietors.

Instead of coming by water, which was then the usual mode of transportation in the region, Adams had come by horseback. During the journey he had been taken ill and also suffered from hunger. He described the journey in his autobiography:

> *In general it was a Wilderness incumbered with the greatest number of trees, of the largest Size, the tallest Height, I have ever seen. . . . The roads where a Wheel had never rolled from the Creation, were miry and founderrous . . . my Horses feet would frequently get between the Roots and he would flounce and blunder, in danger of breaking his own Limbs as well as mine.*

Dresden Ferry This image of the Dresden-Richmond ferry across the Kennebec River was presumably taken before circa 1916 when two new ferry scows were built. Although now powered by a motorboat, this scow still has a pulley fitted for the cable laid across the river bottom along which the scows previously ran, as well as the mast for the sail formerly carried.

Originally separate ferries ran from Richmond and Dresden, and from Dresden to Swan Island; later they came under one charter. Interviewed in 1904, retired ferryman Joseph G. Densmore, who had served from 1859 until 1897, calculated that he had voyaged 237,500 miles all while crossing the Kennebec—the equivalent of ten times around the world. The ferry season usually ran from early April, when the river opened, to December 1. The ferryman was obligated to transport passengers at any hour, although after 9 p.m. he could double his rates.

Mr. Densmore commonly made twenty-five trips a day. On one day he and his son ferried across the thirty-five teams of a traveling circus. After one horse panicked and took its rider and wagon overboard, the two Densmores were able to free it from its harness so that it could swim ashore. The wagon was salvaged later.

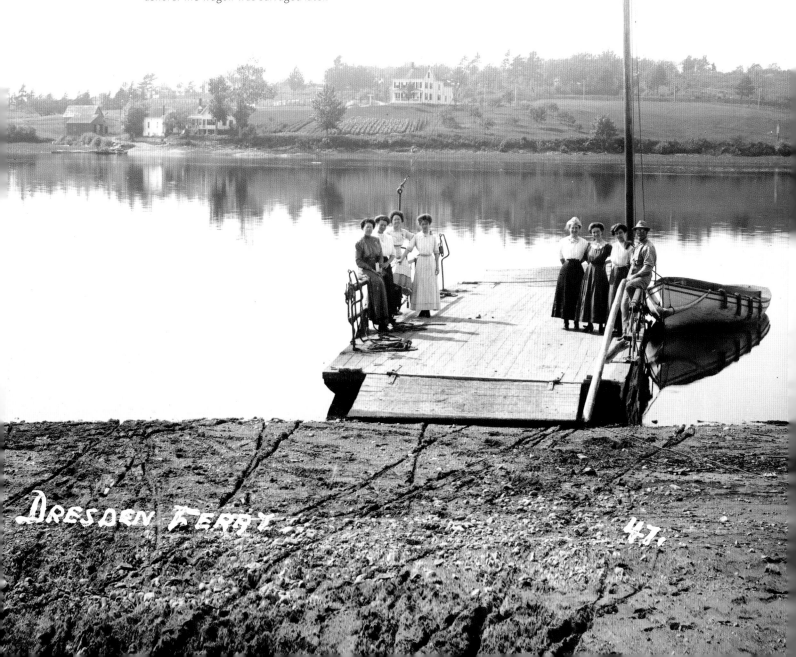

Bayville Bayville in East Boothbay was one of many post-Civil War summer colonies in the region, including Ocean Point, Murray Hill, Paradise Point, Christmas Cove, Squirrel Island, Mouse Island, Isle of Springs, and Capitol Island. Some were developed by—and for—inland Mainers, while Bayville's cottagers came in large part from the Boston area.

Colonies typically sprouted on thin-soiled shore land or islands formerly considered of small value; indeed, Bayville's site was called Hardscrabble. A local, Thomas Boyd, first attempted the alchemy of turning its ledge-rent lots into gold coin in the 1860s, but real development began in the 1880s. By 1904, a hotel was followed by about thirty-five cottages with seasonal piped water and electricity. In 1905 there were 574 non-resident taxpayers in the towns of Southport, Boothbay Harbor, and Boothbay, leading to agitation by the "summer complaints" regarding their taxation without representation. In 1911, following Squirrel Island's lead, Bayville became an incorporated village within the town of Boothbay.

The large edifice left of center was the hotel. At far left is a glimpse of the seal pen belonging to Captain Angus and Janet McDonald, who for years netted seals and sold them as public attractions all over the East, including Coney Island. In the forewater, a sloop awaits its mast.

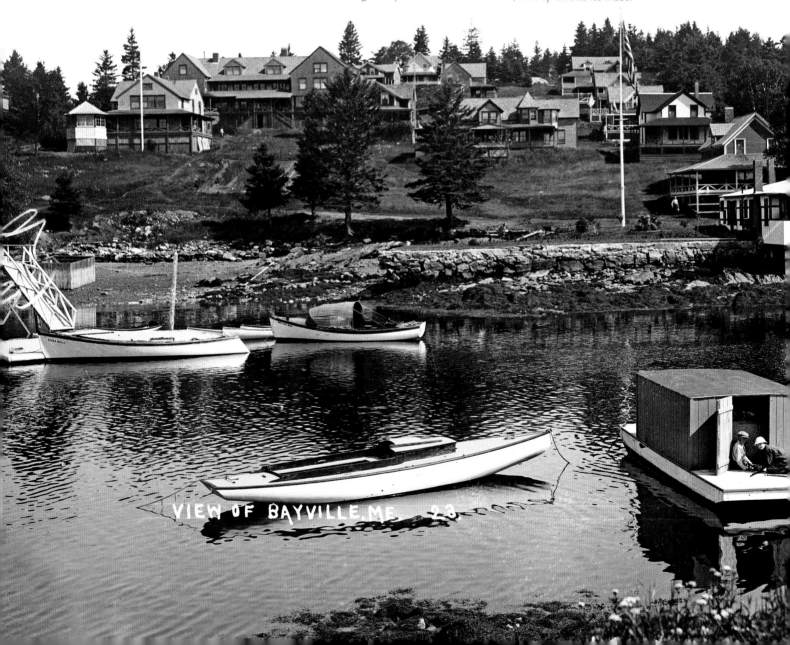

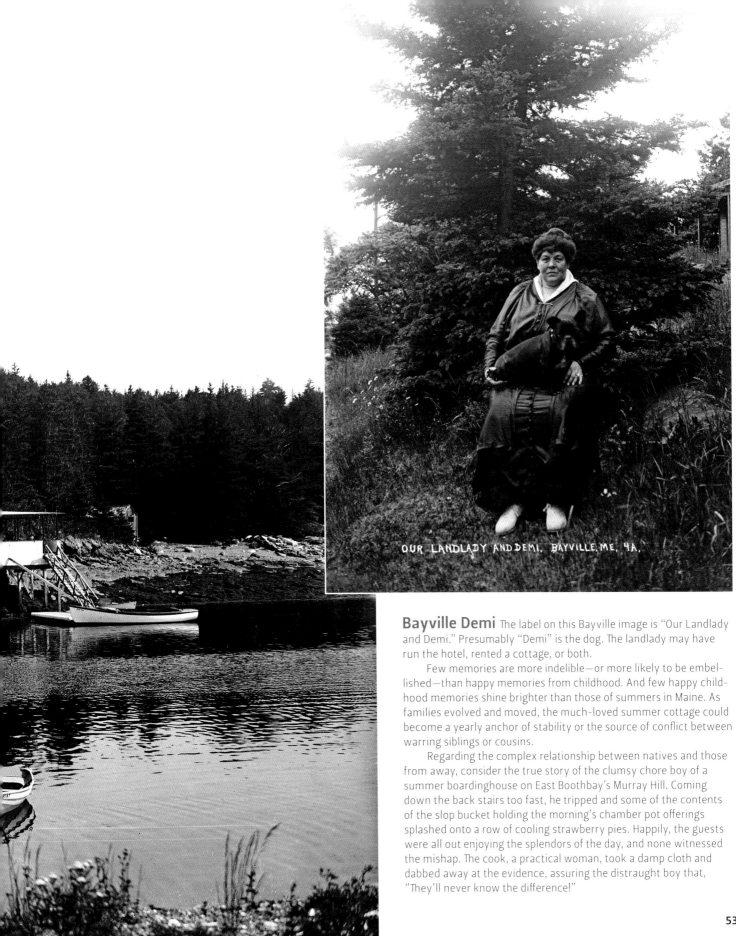

OUR LANDLADY AND DEMI, BAYVILLE, ME. 4A.

Bayville Demi The label on this Bayville image is "Our Landlady and Demi." Presumably "Demi" is the dog. The landlady may have run the hotel, rented a cottage, or both.

Few memories are more indelible—or more likely to be embellished—than happy memories from childhood. And few happy childhood memories shine brighter than those of summers in Maine. As families evolved and moved, the much-loved summer cottage could become a yearly anchor of stability or the source of conflict between warring siblings or cousins.

Regarding the complex relationship between natives and those from away, consider the true story of the clumsy chore boy of a summer boardinghouse on East Boothbay's Murray Hill. Coming down the back stairs too fast, he tripped and some of the contents of the slop bucket holding the morning's chamber pot offerings splashed onto a row of cooling strawberry pies. Happily, the guests were all out enjoying the splendors of the day, and none witnessed the mishap. The cook, a practical woman, took a damp cloth and dabbed away at the evidence, assuring the distraught boy that, "They'll never know the difference!"

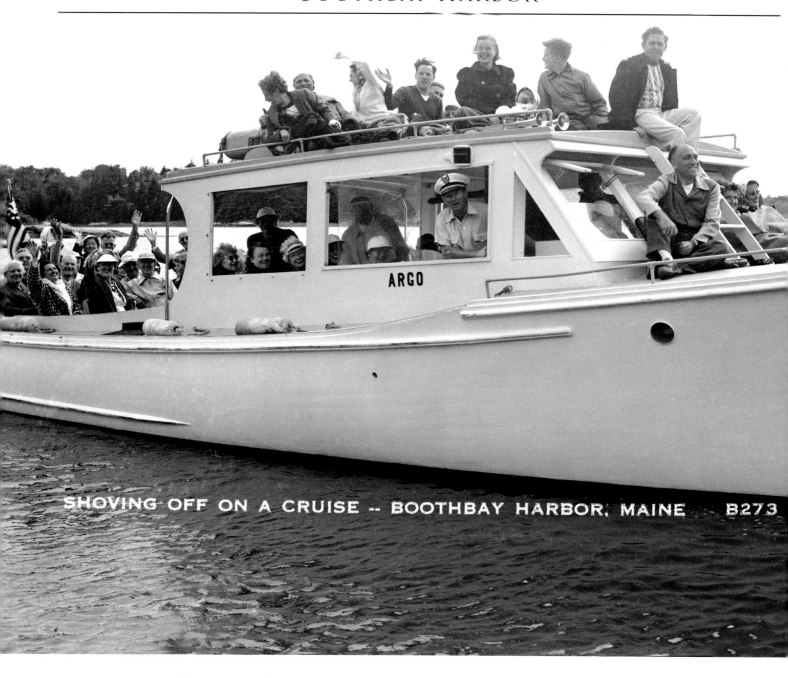

SHOVING OFF ON A CRUISE -- BOOTHBAY HARBOR, MAINE B273

Motor Vessel *Argo* Captain Eliot Winslow, leaning out the window, is at the helm of his *Argo*, member of a motley Boothbay Harbor tour boat fleet that included old familiar floating antiquities, a war surplus crash boat masquerading as a PT boat, and a salty seagoing Monhegan Island packet, all competing fiercely for tourist dollars.

Before World War II, Eliot Winslow had been a paint salesman. During the war he found his true calling as the very able commander of the Coast Guard cutter *Argo*. In the early 1950s he had the boat pictured here built at Friendship. A natural raconteur, his business flourished, and in the late 1950s he converted a 65-foot ex-army T-boat into a larger tour boat, also named *Argo*. In the winter Winslow picked up some odd work towing, which he enjoyed, and eventually a tugboat business replaced the tour boat business.

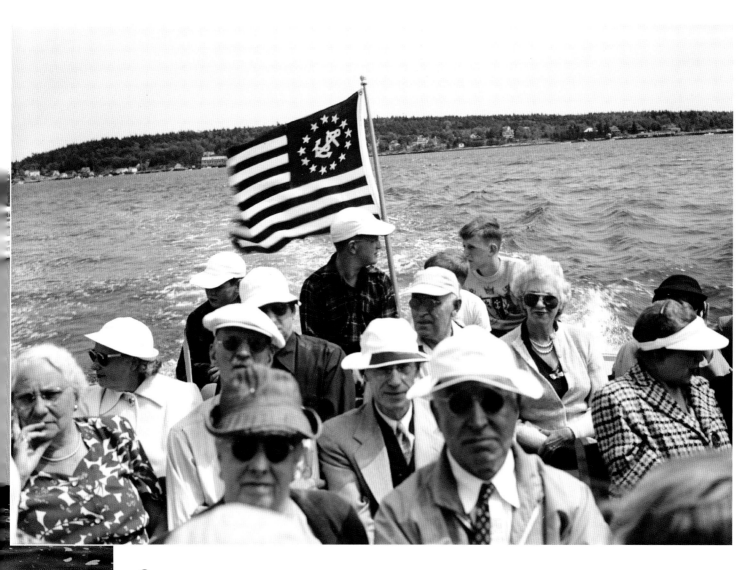

Grumps "Are we having fun yet?" Perhaps some in this grim-faced group of *Argo* passengers—"walk-on freight"—are worried about the efficacy of Dramamine, what with having to sit in the back of the boat smelling exhaust fumes.

The summer trade had long been important to the Boothbay region, but the lavish Hollywood spending during filming of scenes for the movie *Carousel* in 1955 is often cited as the tipping point in local attitudes regarding the separation of summer visitors from their money. That said, Eliot Winslow's reputation for giving his passengers a full measure of pleasure for their money—this load of crosspatches notwithstanding—was never questioned.

STEAMBOAT LANDING, S

Southport

Southport Steamers The Eastern Steamship Company's *Southport* calls at a landing in her namesake town while the smaller *Islander* (the second of this name on the route) steams west through Townsend Gut headed for the Sheepscot River, Goose Rock Passage, Knubble Bay, and the narrow Sasanoa River (where, at Lower Hell Gate, the tide pulls the spar buoys under) on the inside passage from Boothbay Harbor to the Kennebec River.

Southport will follow *Islander* to Bath, from whence *Islander* will continue up the Kennebec to Gardiner. *Southport* and her sister *Westport*, although built for this service in 1911, proved too big, and by 1920 both had shifted to the Rockland–Blue Hill line. The last of many steamers on the route was the *Virginia*, in 1941.

Small steamers serving islands and peninsulas long constituted a valued social and economic institution. They operated in watery realms unknown to rail or auto travelers, and the skill and nerve required to safely pilot them in fog and darkness were surely never fully appreciated by freight shippers or passengers.

Unlike barking locomotives or puffing harbor tugs, the little steamers, fitted with condensing engines, glided along with just enough noise and vibration to reassure the timid. Memories of the sound of their whistles and the sweet smell of soft coal smoke—if not the accompanying soot—were long cherished after motor vehicles and highways did the little steamers in.

MONHEGAN ISLAND MAINE. 1000

FROM MANANA ISLAND OF

Monhegan This view of the storied island was shot from a vessel on a day with a brisk offshore nor'west breeze. One doubts that the photographer quite expected this wonderfully evocative result, which imparts the seductive and forbidding natures of islands in general and of Monhegan in particular. Monhegan played an important role in the history of the first Europeans arriving on this coast, and thus, by extension, in the fate of the native inhabitants of the region.

While Monhegan islanders were separated from the mainland by water and weather, it would not be accurate to describe the community as isolated, since the island and its powerful lighthouse were important seamarks in heavily traveled waters, and passing vessels were frequently in sight. Also, it lay closer to rich fishing grounds than did mainland communities back when there were fish left to catch in coastal waters.

The aesthetically perfectly placed three-masted schooner is headed north toward Two Bush Channel, the western entrance to Penobscot Bay. Because she is having to tack, she is not setting her fore and main topsails.

Monhegan Harbor The steamer *May Archer* in Monhegan's harbor, such as it is, circa 1910. The *May Archer* was built at Rockland in 1906 for Captain I. E. Archibald. In 1907 she delivered building materials for the new Island Inn, the large hotel at center. In 1908 Captain Archibald instituted a summer service from Thomaston to Port Clyde to Monhegan to Boothbay Harbor, and return to Thomaston. The island became a great draw for visitors, with alarming sea conditions in the harbor often adding to the adventure, a case in point being this report from the *Brunswick Record*, reprinted in the *Belfast Republican Journal*, September 3, 1908:

> They had the first big blow of the summer out at Monhegan last Saturday as it was so rough that the steamer May Archer *could not make its landing at the wharf. There were half a hundred summer people anxious to get to the mainland, but they had to remain where they were, except six more venturesome persons who were taken out to the steamer in dories and pulled aboard at the end of ropes. Long before Boothbay Harbor was reached these six wished they had remained with the others, for the big waves had no end of sport with the steamer. However, she kept afloat and they suffered no worse fate than seasickness. Monhegan has hundreds of visitors this summer and the three hotels are all filled.*

From January 15 to May 28, 1910, island fishermen landed 58,500 lobsters, averaging $460 per man. Most of their boats were powered. The large vessel moored at right foreground has a seine dory astern and what appears to be a seine net flaked down aft; she is likely a herring seiner.

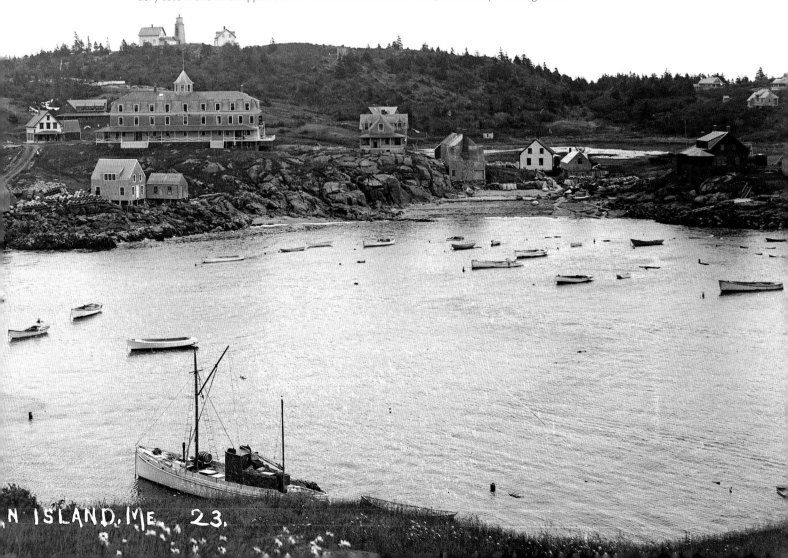

Woolwich Cow In the Day's Ferry district of Woolwich, across the Kennebec River from the north end of Bath, a cow poses while grazing along what is today Route 128. The house at left was that of Captain Edwin O. Day, whose career included fourteen years as master of the Bath ship *Dakota*. Retiring in 1895, Captain Day died in 1930 at age ninety. His house, built in 1885, remains with the family today.

The house atop the hill, belonging to Captain Andrew Blanch, had been built by William Preble. Captain Day and William Preble were both descendants of Ebenezer and Mary Preble, who were killed on their Woolwich farm by raiding Indians from Canada in 1758. The six young Preble children were kidnapped; a crying infant was quickly killed; one girl would disappear into France; two girls and two boys later returned. Five generations of Preble descendants included a dozen or more shipmasters.

The posing men may be Edward Crocker, Ernest Savage, and Samuel Ward. The cow's name has been lost. Motorists and roadside-grazing livestock were hazardous to one another. The telephone poles are likely those of the private line of the Morse Towboat Company, running from Gardiner to a Popham hotel, by which means the company's towboats were dispatched on the busy river. Plank sidewalks suggest considerable foot traffic. Today it is city folk who walk and stay fit, while country folk ride and get fat.

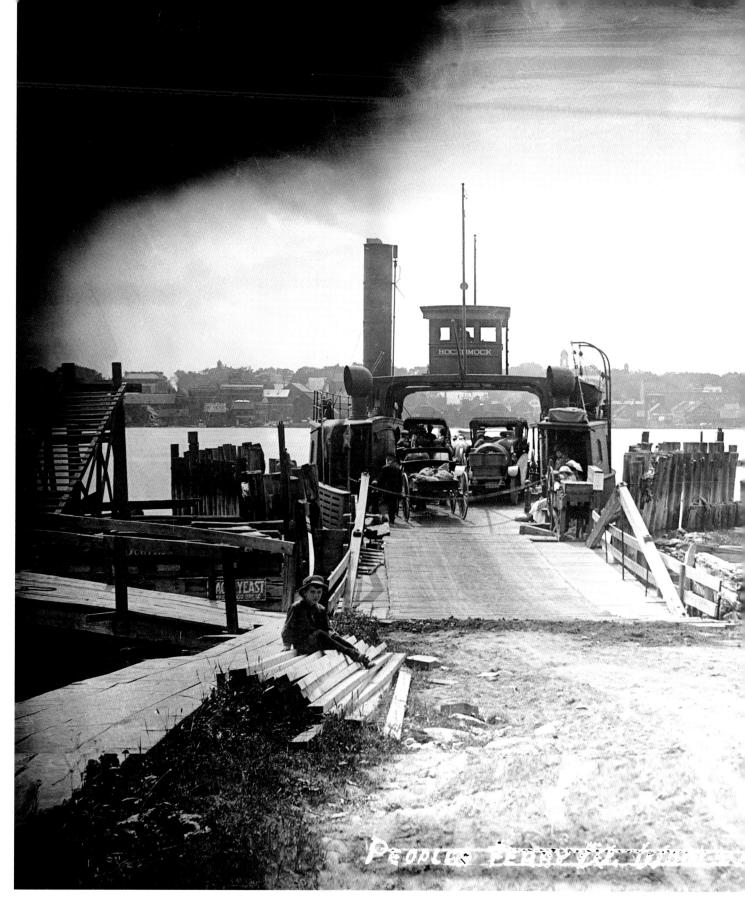

PEOPLES FERRY

Woolwich–Bath Ferry The ferry *Hockomock*, poised to cross the Kennebec River from Day's Ferry to Bath. She carries a mixed cargo of horse-drawn and motorized vehicles, and passengers. Pearline (see posters) was a laundry soap.

The history of ferry service between Bath and Woolwich is a tortuous saga of rowboats, scows (with swimming oxen tied astern), a horse-powered boat, and many years of frustration. The first steam-powered ferry was the 1837 side-wheeler *Sagadahoc*, which ran on no fixed schedule. Other boats followed, but after the Knox & Lincoln Railroad began its own ferry in 1871—a colorful saga in itself—there were years when steam service ceased on the old line. From 1876 until its end in 1927, the "People's Ferry" became a municipal (later, a state) burden.

The *Hockomock*—or "Hunky-Dink"—a double-ended propeller boat, was launched in 1901, joining the old *Union*, or, "Onion." In 1910 they carried 1,961 automobiles, rising to 15,000 in 1916. In 1920 the *Hockomock* and the *Governor King*, a secondhand New York Harbor ferry, carried 31,7347 passengers, 51,200 autos, and 10,021 horse-drawn vehicles, while the *Union* carried 54,000 passengers and 7,700 vehicles. Summer traffic delays of several hours were not uncommon, and in 1927, mercifully, the Carlton Bridge, which carried rail, vehicular, and pedestrian traffic, opened.

BATH

Front Street, Bath A view down Front Street in 1910. In 1895, the buildings between Elm Street—Swett's Drug Store is on the corner of Elm and Front—and the circus-poster-plastered Columbia Theatre were destroyed by fire, to be replaced by the buildings seen here. And despite the energetic work of their advance man, Forepaugh & Sells folded their tent for good in 1911.

The wires descending from the utility poles are electrical service drops. Presumably the telephone poles are in the back alleyway. The streetlight in the foreground is a General Electric AC arc light containing an ingenious mechanism that automatically adjusted the two carbon points at a proper distance apart.

From 1780 to 1910 Bath built about 4,000 ships, and in the late nineteenth century was the wooden shipbuilding capital of the world. In 1909 the Percy & Small yard built the 3,730-ton six-masted schooner *Wyoming*, the largest wooden commercial sailing vessel ever. In 1910, however, the only launchings were of two Bath Iron Works destroyers and a wooden forty-foot motorboat named *Yo Ho*. There was a modest improvement beginning in 1911, and during the World War I years Bath became a major builder of steel ships.

WASHINGTON ST. BATH ME. 46.

Washington Street, Bath Elm-shaded Washington Street, with its many large and notable homes, was but a few minutes' walk from strident Front Street. Both streets, in essence, reflected Bath's enterprising heritage.

Washington Street nabobs were not pleased when, in 1893, the first trolleys clattered up their "avenue," but worse was to come. The beefed-up rails and ballast seen here dates the photo circa 1917 to 1921, when the trolley track was upgraded to support the heavy loads headed for the Texas Steamship Company shipyard. A creation of the wartime shipping shortage, the yard built thirty-four tankers and freighters during its brief career. With Bath Iron Works building (mostly) destroyers full-tilt in the South End, wartime Bath was a boomtown bursting at the seams.

In the early 1900s the relatively modest white house, Number 973, was the home of Dr. William Rice. The brick mansion beyond, obscured by foliage, was built in 1853 by shipbuilder Captain William Drummond. John Hyde, Bath Iron Works president, lived in the next house, next door on the other side to the widow of diplomat Harold Sewall. Her house was a wedding present from her late father-in-law, shipbuilder Arthur Sewall. The sister of the notorious ice and steamship monopolist Charlie Morse lived at Number 942, while Isabella McDonald, at Number 958, was likely the widow of the great shipbuilder John McDonald. Schooner and steamboat tycoon James B. Drake, who, in 1888, for personal reasons never revealed, horsewhipped Dr. Rice of Number 973, lived at Number 972.

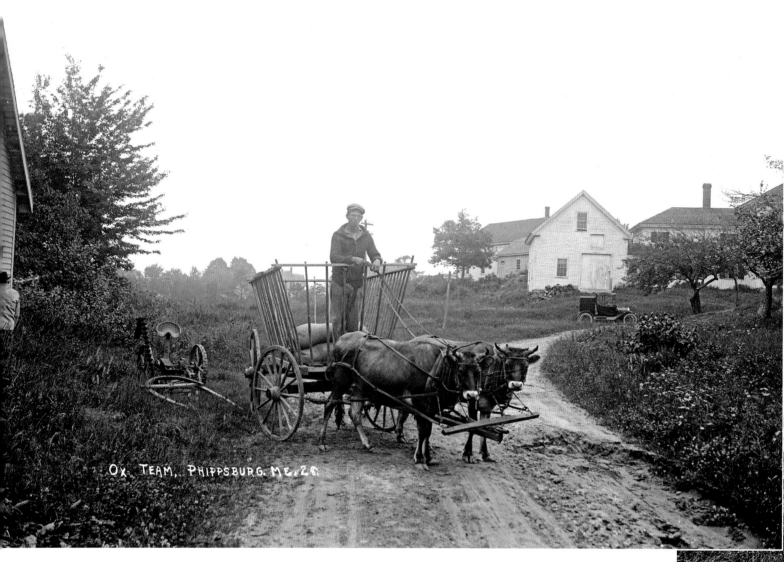

Ox. Team, Phippsburg. Me, 28.

Jersey Steers A pair of very small Jersey steers—even large Jerseys were relatively small—hitched to a hayrack. They are rigged-out with upside-down horse collars and harness.

An unorthodox arrangement such as this was commonly associated with cultural backwaters, such as might be found in the deep woods, on remote islands, and at the far ends of long peninsulas. And Phippsburg, a long peninsula of a town, did indeed feature pockets of old-fashioned fishing and farming folk considered quaint by the standards of nearby Bath. Residents of the insular fishing community of West Point were known for "rocking"—throwing stones at—carriages of sightseers from Popham Beach hotels who strayed into their territory.

Quite possibly the young teamster's mother makes butter from the cream from the two steers' mothers, to be sold to Popham hotels. The growing popularity of Jersey cows was the result of the high butterfat content of their milk, combined with the high price of butter. And in fact, Jersey draft cattle could do more work than appearances suggested, especially in hot weather that "pulled the tongues" of cattle of heavier breeds. At left is a single-horse—or steer or ox or bull—mowing machine. Machines favored for use with cattle were low-geared. At right, an EIC Model T holds a well-practiced pose.

Popham Popham Beach, at the mouth of the Kennebec River, beckons on a hazy day. Few locations in Maine had (or have) a stronger sense of place than Popham. In the early 1900s one could still get a sense of what the river was like in the late 1800s, when it was deemed the busiest in the nation, thanks to the booming summer ice-shipping business.

With a southwest breeze blowing away the mosquitoes, one could watch the Boston steamer, paddles thrashing, depart for the westward, while inbound ice schooners, gray sails filled and taut, headed in for the river and the anchorage at Parker's Flats. At twilight, the brilliant beacon atop the outlying sentinel of Seguin Island faithfully made its appointed revolutions. Very few resorts east of Scarborough could boast of a beach such as Popham's.

The little steamer lying at the Eastern Steamship wharf is the *Nahanada*. Built in 1888 for the Bath–Boothbay Harbor run, she remained in service in those waters until 1925. Here, she is likely awaiting the return of her excursion party. The rig of the schooner obscured by the wharf suggests that she is a small shore fisherman. Beyond, at left, are the granite walls of Fort Popham.

Balsam Pillows

Balsam Pillows The Whispering Pines, no doubt located on US Route 1, needs a new roof. The name was likely borrowed from a line in Longfellow's *Hiawatha* and may also refer to nearby Bowdoin College's famous grove of white pine, a remnant of the forest that once grew in the sandy-soiled region east of the college.

Automobile tourism gave rise to the roadside tourist trap, selling souvenirs to take back to the folks at home. Maine's equivalent to Florida's baby alligators was the fragrant balsam pillow, reputed to have both psychic and physical therapeutic value. Some were embossed with sentimental poetic ditties such as:

> I miss you in the summer
> I miss you in the fall, some
> But 'specially at Christmas time
> I pine fir yew and balsam.

Readers in their dotage will silently add a final line—"Burma-Shave."

DANVILLE JUNCTION, AUBURN

Danville Junction Girl This well-cared-for team no doubt has Percherons in the family tree. The little girl appears in another image showing a lumber wagon backed up to the door of a Grand Trunk boxcar. During World War I there was a ready market for almost any lumber delivered to a rail siding, with portable mills busily deforesting woodlands within range. Perhaps that is the backstory to the charming scene we see here.

The building in disrepair in the background is the second of three Grand Trunk stations at Danville. In 1911 it was replaced by a rustic stone edifice looking as little like the Maine Central station directly across from it as possible. The two were located just up the tracks from this scene.

Danville Junction Diamond Danville Junction is where the Grand Trunk and Maine Central's "back road" switched sides, as it were, on the diamond crossing shown here. It was also where the four-horse "tally ho" carriages of the Poland Spring House resort picked up and delivered guests arriving and departing by train. The old, unused Grand Trunk station appears in the distance at left. At far left, lumber is being transferred from a wagon into a boxcar standing on the siding.

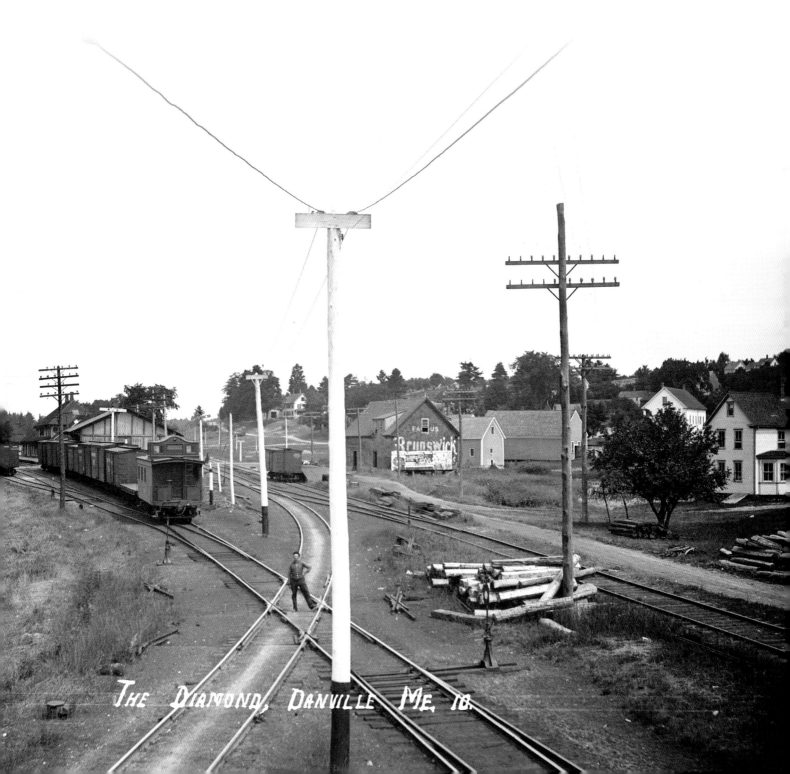

THE DIAMOND, DANVILLE ME, 10.

New Gloucester Intervale Here we look east across the Royal River intervale from the Maine Central Railroad bridge toward the J. C. Hammond farm, whose buildings command the upland ridge at center. Below, on the flat intervale, a Grand Trunk Railroad locomotive pulls a northbound train. The Grand Trunk connected Montreal with its winter ice-free port, Portland.

J. C. Hammond Farm John C. Hammond's residence and huge barn overlook the flat and fertile farmland of the Royal River intervale. These buildings burned in the 1930s.

Intervale lands along Maine rivers, first cultivated by Indians, were sought out by early settlers. In pre-mowing-machine times before the Civil War, big intervale farmers welcomed the seasonal invasion of scythers, who descended from small upland farms to help make hay and to be fed by the hard-pressed intervale farm women.

In the early 1900s the Royal River intervale farms were known for hay, sweet corn and beans for the local cannery, and dairy.

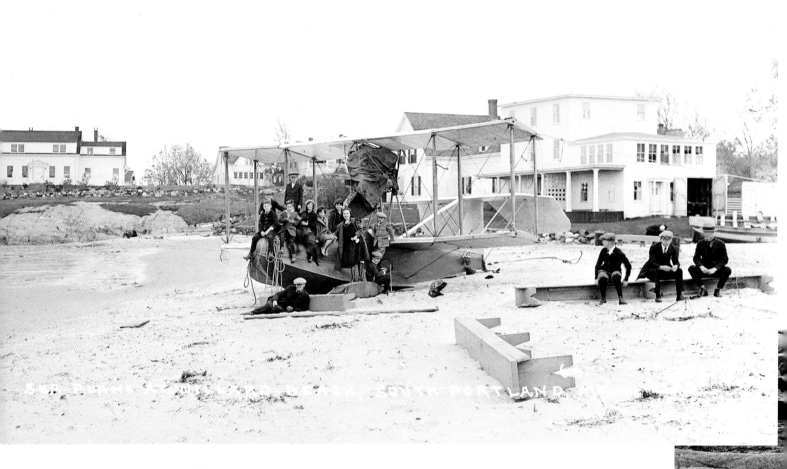

Flying Boat This Curtiss flying boat at Willard's Beach is very likely the *Betty V,* belonging to Victor Vernon. In the summer of 1914 Vernon brought his newly purchased flying boat (by land) from upstate New York to Portland to give exhibitions and take passengers on short flights from beach resorts. Vernon later wrote that contending with surf—his previous (very brief) experience had been on lakes—was when he really learned how to handle the aircraft.

That summer Atwater Kent—the auto ignition inventor and later a leading radio manufacturer—and his wife were successive passengers aboard the *Betty V.* On Mr. Kent's ride, after the landing, a wave soaked the engine and killed the spark. Kent immediately attended to the wet magneto, and the engine restarted just before the aircraft drifted onto rocks.

Offered $500 to show up for a 1914 Labor Day gala, Vernon and his mechanic took off from Kennebunk Beach for Bar Harbor. A leaking oil line forced them to land in an unknown cove, where, at the cottage of a prominent Chicago lawyer, they enjoyed a lavish luncheon clambake. Arriving at Bar Harbor, they found a number of Atlantic Fleet warships and the interned German liner *Kronprinzessin Cecilie* in port. (War having broken out in Europe earlier that year, a number of German liners were interned in still-neutral ports to avoid capture or destruction by the British Royal Navy.)

Vernon gave many prominent summer residents their first flight, and at a high-society party met navy secretary Josephus Daniels, whom he quoted as saying, "I see little future in flying, and doubt it will play much of a part in war."

BIDDEFORD POOL

The Basin Whether through artistry, serendipity, or both, this is a masterful image of fishermen's dories moored at The Basin. The brooding mass of the ledges contrasts with the fragility of the saucy floating dories, rugged craft though they may be. The permanence of the rock contrasts as well with the flaking emulsion from the bottom of the plate. If the author may be forgiven for quoting himself from another book, "Old glass plate negatives are but a thin emulsion over the dark void of eternity." So there

Frye's Place Frye's Place is a multipurpose filling station, restaurant, and campground on the shore road between Biddeford and Kennebunk—possibly on the Kennebunk side of the town line. The automobile resembles a late-1920s Dodge sedan.

No building is more emblematic of the past century than the filling station—or more likely to be overlooked. But there are folks who do notice them and study them as structures and cultural manifestations.

Basic filling station forms include house, house with canopy, box, box with canopy, oblong box, oblong box with canopy, oblong box with drum, commercial block, and shed. Architectural styles include bungalow/craftsman, Spanish mission, colonial revival, Tudor revival, art deco, ranch, modern, streamlined, international, and programmatic. The hip roof would place Frye's Place as a house with canopy.

Evidently Frye's sells both Texaco (Texas Oil Co.) and Tydol (Tide Water Oil Company) branded gasoline. Although the corporate history of the oil industry is as convoluted as the proverbial bucket of guts, there does not appear to have been any interrelationship between the two companies in that era.

The signs read, from left, "Tea, Coffee, Soft Drinks & Cigars," "Western Union Telegrams," and "Cement Blow Out Patches." Do not overlook the alert watch dog on duty.

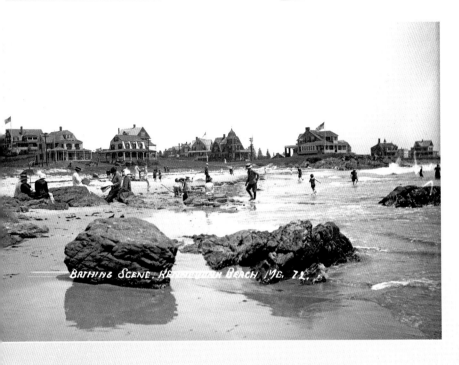

Bathing Scene, Kennebunk Beach, Me. 72.

Kennebunkport Beach Few swimmers brave the bracing water of Kennebunk Beach, which is sited to catch the southwest breeze. Kennebunk and Kennebunkport—glimpsed at far right—are divided by the Kennebunk River, which once produced many ships.

Large numbers of immigrants entering cities of the northeast at the turn of the century led to policies, even in Maine, excluding members of certain ethnic groups—especially "Hebrews"—from buying cottage lots or registering in hotels. By 1920 only one of the more than twenty hotels in the Kennebunks is said to have accepted reservations from suspected Jews (this despite long friendships between Maine farm families and Jewish peddlers).

The 1920s saw the rise and fall of the Ku Klux Klan in Maine, with Kennebunkport being termed a Klan "capital." Many Protestants—especially Republicans—alarmed by the influx of Catholic French-Canadians, joined the KKK as readily as Mainers had long joined other fraternal organizations.

But the KKK was not the Odd Fellows, and while marching in hoods and throwing baseballs at a picture of the pope might have seemed harmless, burning a cross in someone's front yard was an act of terrorizing. Briefly a political force, the Klan faced strong opposition—especially from old-line Republicans—and by 1930 had collapsed. As shameful as the flirtation had been, Klan activities in Maine never approached the horrors of the lynchings of black Americans in other states.

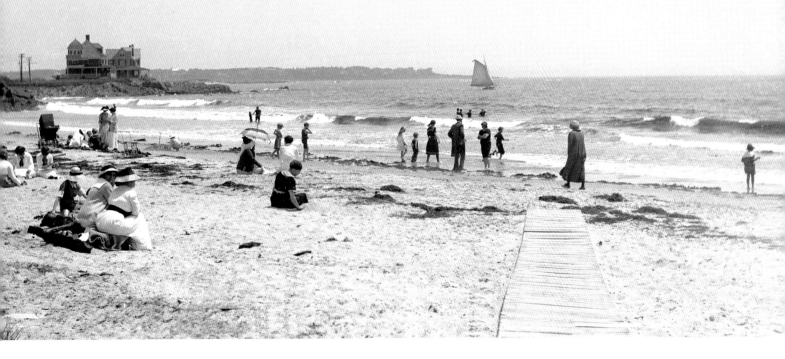

Limerick

Limerick A farmer with his team of "brockle-headed" oxen pulls an ox cart along Main Street through the elm-shaded village. For a small town, Limerick had an impressive village center, and village centers usually reflected the health of area farms and industries. (That said, one could safely nap in the center of this street, the only motor vehicle being the parked EIC Maxwell.) The EIC collection contains scores of similar images of elm- and maple-shaded village streets.

Limerick had a solid economic mix, with a cotton mill, a neighborhood of mill housing, and a strong farming community. When wool prices collapsed after the Civil War, many marginal Maine farms were abandoned, and in 1889 Limerick's neighbors—Limington, Parsonfield, and Newfield—contained fifty-seven abandoned farms, while Limerick had but one.

Brockle-headed cattle were usually derived from a cross of Hereford and Durham blood. A good brockle-headed ox was said to be as good an ox as could be, but those that took after the Hereford side of the family were often sulky and balky. An effective means to bring a balky ox to his feet was to urinate in his ear. The ox cart, although now forgotten, was arguably the most important land vehicle in the settling of America. And the ox, also forgotten, was even more important.

76

York Shingle-Style York Harbor was an incorporated village in the town of York, encompassing 150 or so cottages of well-off summer residents who had tired of being taken advantage of tax-wise and achieved a measure of self-rule. The Aldis cottage, shown here, was one of them.

Reportedly no community in the nation spent more money per capita guarding its health against impure drinking water, tainted dairy products, and other biological hazards. Nor was "the Harbor" subjected to invasions of annoying excursionists deploying from steamers or trains.

Built in 1884, the Aldis cottage was one of a dozen similar cottages in the Rockledge colony, a cottage colony within a cottage colony. Owner Bryan Lathrop of Chicago (whose wife was an Aldis) made a fortune in insurance and real estate and was a noted Chicago civic leader and a generous supporter of the arts.

The design of the cottage is attributed to William R. Emerson, a Boston architect with Kennebunk roots. He was the founder of the Shingle-Style school of architecture, which attempted, through flowing horizontal planes and the use of local materials, to blend structures with their natural surroundings.

Most Shingle-Style structures were summer cottages for the wealthy, and a great many were built in Maine. They remind us of how much employment summer people gave to local builders, to say nothing of Aroostook shingle sawyers. Many have been destroyed of late and replaced by edifices of the less self-effacing McMansion school of cottage design. Aldis cottage was demolished in 1980.

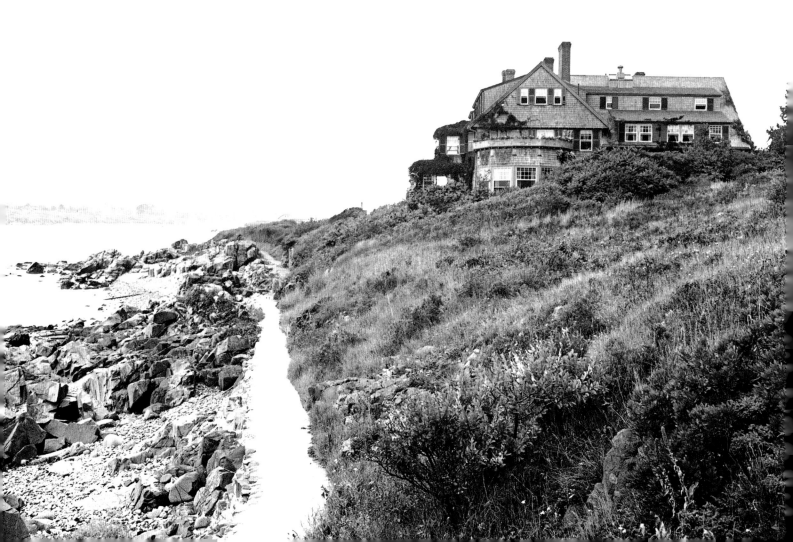

The Flee
Camp Wyone

Camp Wyonegonic The Camp Wyonegonic flotilla graces Moose Pond, beneath Pleasant Mountain. The camp (originally located on Highland Lake in Bridgton) was founded in 1902 by the Hobbs family and is today the oldest continuously operated camp for girls in the nation. (Camp Winona, for boys, farther up the shore of Moose Pond, was founded by the Hobbses in 1908.)

The proliferation of camps for boys and girls beginning in the early 1900s provided canoe builders with a welcome important market, the amusement park canoe craze having cooled off with the replacement of the livery canoe (for young couples' canoodling) by the back seat of the automobile.

Camp Wyonegonic's grand fleet features what appears to be a 34-foot Old Town war canoe with one adult and twenty-two paddlers aboard, double-ended guideboats, and two sailboats of inland lake heritage and pre-World War II vintage. It seems likely that this photo dates from the 1930s.

Narrow Gauge Locomotive No. 6, of the narrow-gauge (two-foot) Bridgton & Saco Railroad departs Harrison at the head of Long Lake for the road's connection with the standard-gauge Maine Central at Bridgton Junction in Hiram.

The photo obviously predates the abandonment of the portion of the line from Bridgton to Harrison about 1930. Locomotive No. 6 was built by Baldwin in 1907 and scrapped in 1935; however, happily, its twin, No. 8, survives with the Maine Narrow Gauge Railroad, presently located in Portland.

The Bridgton & Saco, which operated from 1883 to 1941, was the second of Maine's five narrow-gauge railroads. Although all were devised as a means to provide rail service cheaply, intended purposes varied—the B & S was intended to capture some of the tourist business monopolized by lake steamers.

Some, like the Sheepscot Valley's "Wiscasset and North Pole"— originally the Wiscasset & Quebec, later the Wiscasset, Waterville and Farmington — were general-purpose roads. Farmers, lumbermen, and storekeepers, in particular, benefited, even if the stockholders — some being the very same folks—usually did not.

Inherent disadvantages of narrow-gauge railroading included the inefficiency of transferring freight between the narrow-gauge and standard-gauge cars and, it must be admitted, the tendency of locomotives to derail and flop over without any great provocation.

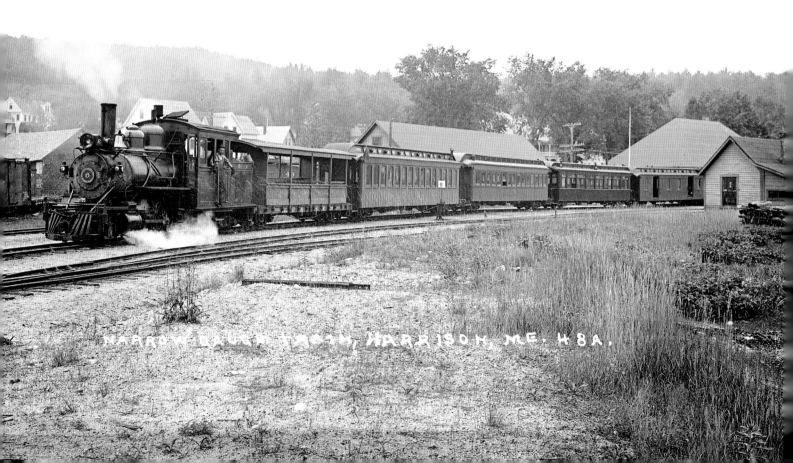

NARROW GAUGE TRAIN, HARRISON, ME. H8A.

E & B Spool In 1906 the E & B (Elliott & Bartlett) Spool Mill in the Lynchville section of Albany "turned" 700,000 feet of birch spool stock into No. 1 spools for Coats & Clark. Spools were precision machined to within the breadth of a single strand of thread, due to the precise requirements of thread-winding machines.

Maine's vast white birch belt included most of Oxford County and portions of Kennebec, Franklin, Somerset, Piscataquis, Penobscot, Aroostook, and Washington counties. Although birch was once considered practically worthless, beginning in the late 1800s its superior turning qualities led to the creation of a major industry producing a wide variety of products.

Birch is a common succession species after fire, and much of Oxford County was burned over by great fires in the fall of 1816, following the calamitous summer that never was, caused by the 1815 eruption of Mt. Tambora in the Dutch East Indies. (Five million acres of birch in forests east of Moosehead resulted from the fires of 1825, which burned fifty Maine townships before becoming what was known as the Great Miramachi Fire in New Brunswick.)

In 1916, after their Albany mill burned down, Elliott & Bartlett relocated to the town of Norway, where large stands of birch remained uncut. Most of their workers followed.

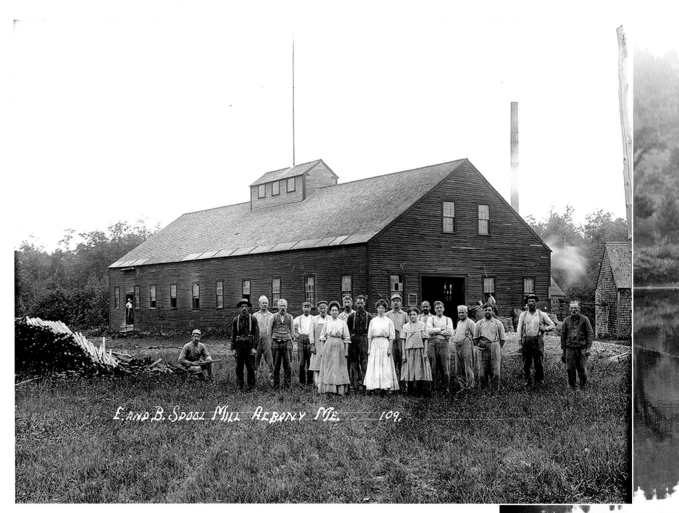

Rumford Center Ferry The Rumford Center ferry, one of a number of ferries once crossing the Androscoggin, here serves, in effect, as a prototype landing craft transporting members of the 5th Infantry Regiment.

We know that the river is flowing from right to left because the trolleys on the cable had to be rigged on the ferry's upstream side. Chains from the trolleys ran through a pulley on the deck and up to cranked winches. At the outset of a passage the chains were adjusted so that the "bow" was angled upstream, causing the current to propel the scow forward. Two leeboards lowered on the upstream side increased the water pressure. The cable was adjusted to the river height by a capstan.

As vital public conveyances, ferries were closely regulated, particularly when running between towns or counties, and were also protected from competition. Traditionally a ferry was summoned by the would-be customer blowing on a communal tin horn.

The 5th Infantry Regiment had been very active in the Indian wars but did not see combat in the Spanish American War or World War I. At some point, possibly right after the World War, the 5th was attached to the inactive 9th Division and relegated to garrison duty at Fort Williams, at Cape Elizabeth. Here, they appear to have captured the EIC Model T.

The last ferry to operate on the Androscoggin, at Rumford Point (upstream from Rumford Center), was replaced by a bridge in 1955.

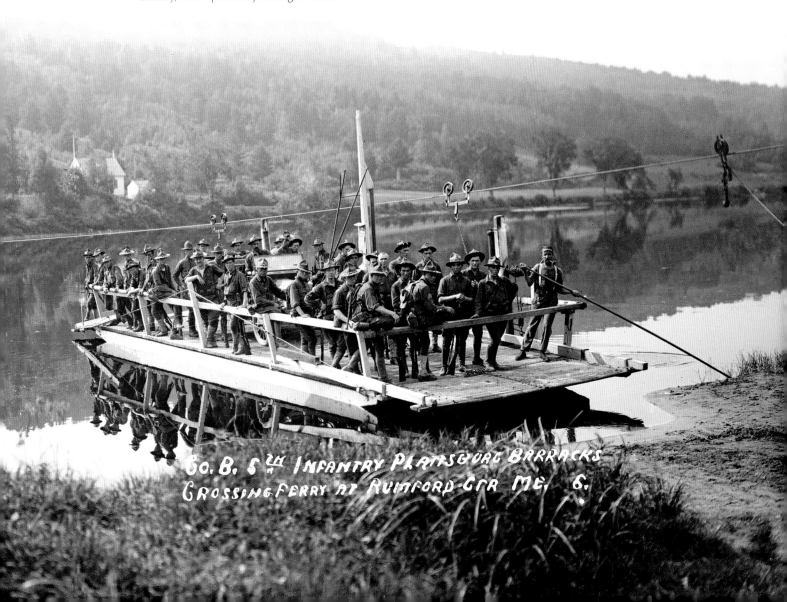

East Peru Ferry This private Androscoggin River ferry crossed between East Peru (foreground) and Dixfield. The owner and ferryman, William Paul, is paddling a river driver's bateau—perhaps it had been damaged during a drive, abandoned, and was then repaired by Paul. Paul's scow, used for his team and wagon, may be glimpsed across the river—the steel cable, which tethers the scow on its crossings, is seen at left. Paul owned a sawmill in Dixfield that produced spool stock, which he ferried across the river to the East Peru station of the Portland & Rumford Falls Railroad.

Baby Buggy A pair of fancy driving horses, standing square, as they were trained to, and with ears cocked back, either await a command or register unease with the unusual situation. Horses evolved to run first and reflect upon their actions later, and it would be a sensible precaution, in case the horses were camera shy, to have a large man stand in the road ahead to prevent them from dashing off with baby, buggy, and all.

Maine long enjoyed a reputation for its stylish, sound driving horses. Before being supplanted by autos, good driving horses were always in high demand. Summer resorts that attracted deep-pocketed and status-conscious visitors were prime hunting grounds for the higher class of horse dealer, whose shrewdness as a judge of both horse and human was veiled by a courtly manner.

One noted New York procurer toured Maine every summer, holding court on hotel piazzas while farmers drove by with their prize offerings. Only the best were chosen, while most were fated to become hard-worked farm horses, hard-mouthed livery horses, or some other such equine functionary. A farm horse surviving long enough to became a "haying horse" not worth wintering over ideally was humanely "laid away" in the fall, rather than sold off for a few dollars to no good end.

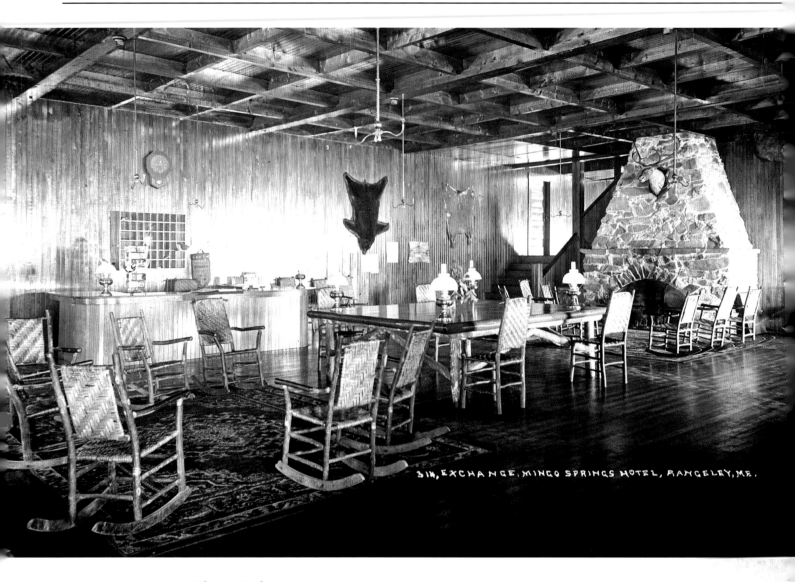

314, EXCHANGE, MINGO SPRINGS HOTEL, RANGELEY, ME.

Mingo Springs Rangeley historian Gary Priest has enumerated twenty-seven area "resorts" established prior to 1900 and thirty-three that began between 1900 and 1938. They ranged from single-cabin affairs to those with dozens of cabins or cottages, and to large hotels. The business was a fluid one, with many properties changing owners or names and going in and out of business with some frequency.

Among the early group was the Mingo Springs Hotel. Located on the western end of the northern shore of Rangeley Lake, Mingo Springs began with two camps built in 1896. Four years later there were five camps, a dining room, and a fourth owner, Philadelphian James Munyon, who, in 1906 built a large hotel. Tennis courts and a golf course followed. After Munyon's death in 1919, the resort was owned and operated by the Cottrell family until they closed it in 1964, at which time there were thirty cottages. In 1965 the furnishings were sold at auction, the hotel razed, and the cottages sold.

The great majority of the old Rangeley-area resorts are no more, many having burned or been razed, subdivided, turned into private residences, or had their cottages and cabins carted off to become private camps elsewhere. The fine distinctions between lakeshore camps, cottages, and cabins are instinctively (and subjectively) understood by owners.

Rangeley Lake Hotel The roaring speedboat with its bored-looking passengers, viewed against the backdrop of the luxurious Rangeley Lake Hotel, creates a Gatsbyesque scene. The speedboat was as far removed from the classic Rangeley Lakes rowboat as was the sprawling hotel from an old-time Rangeley sporting camp.

The Rangeley Lake Hotel originated in 1877 with the construction of the fourteen-room Rangeley Lake House. In 1895–96 the hotel was moved, in two sections, closer to the lake's shore and a twenty-room annex added. By 1908 another twenty-five rooms, guest cottages, a 350-seat dining room, a golf course, a gas plant for lighting, and a steam plant for late-season heating had been added. New ownership in 1928 would change the name to Rangeley Lakes Hotel. Closed during World War II, in 1946 the hotel was purchased by the Sheraton Corporation, which, after 1953, attempted to get clear of what had become an outdated facility. In 1958 a buyer sold the furnishings, razed the buildings, and subdivided the property.

From about 1891 until 1935, the Rangeley Lake House/Hotel enjoyed a symbiotic relationship with the Sandy River and Rangeley Lakes Railroad, a narrow-gauge (two-foot) operation that connected with the standard-gauge Maine Central at Farmington. In 1902 a standard-gauge line (leased by Maine Central in 1908) connected the MCRR at Rumford to Oquossoc, on the western end of the lake. (This line was extended to Kennebago in 1908.) All rail service ended in 1936.

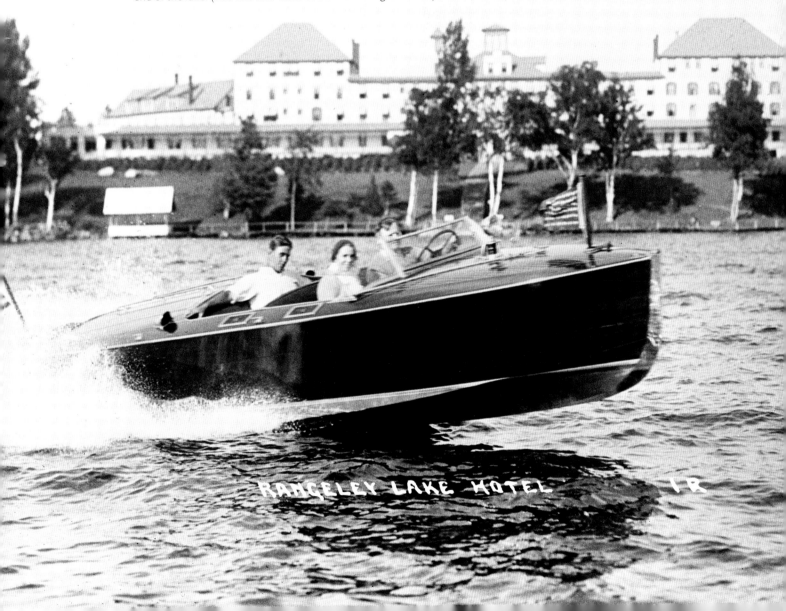

RANGELEY LAKE HOTEL

Kennebago Falls A guide assists his "sport" fishing for trout or landlocked salmon in the pool below the Kennebago Falls on the Kennebago River.

The tradition of guiding was an old one, but beginning in 1899, guides had to be approved and registered by the commissioner of the Department of Inland Fisheries and Game. Most guides, when not serving sports, were local farmers, loggers, or other outdoorsmen. Ideally, a guide was not only knowledgeable about wildlife and woodcraft but skilled in human relations, often having to walk a fine line between being at once servant, instructor, and, theoretically at least, enforcer of game laws.

A 1903 statute forbidding non-residents of Maine from entering "the wild lands" with the intent to "camp and kindle fires thereon, while engaging in fishing or hunting" during the months of May through November without having engaged a registered guide was a boon to the guiding business. Backed by big landowners, the prime intent of the statute was the protection of timberlands from forest fires.

In 1916 a dam and hydroelectric plant to supply electricity for Rangeley were built at the crest of the falls.

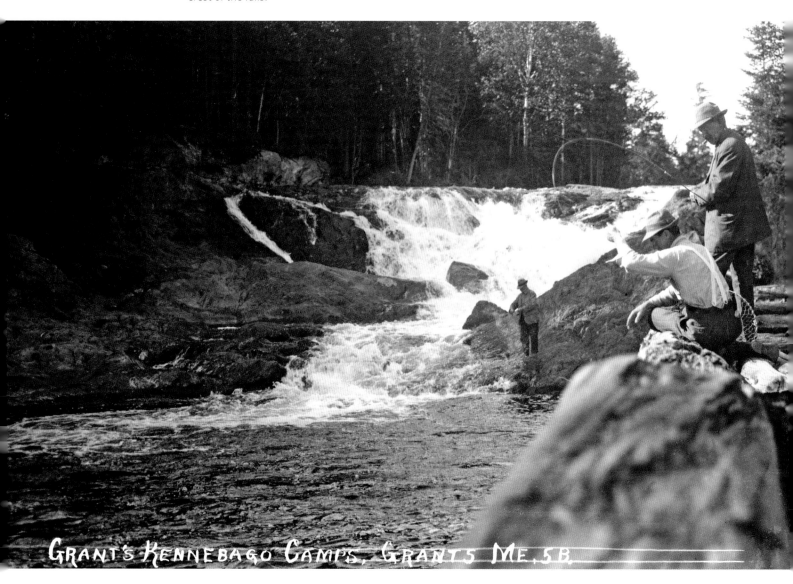

GRANT'S KENNEBAGO CAMPS, GRANTS ME. 5B.

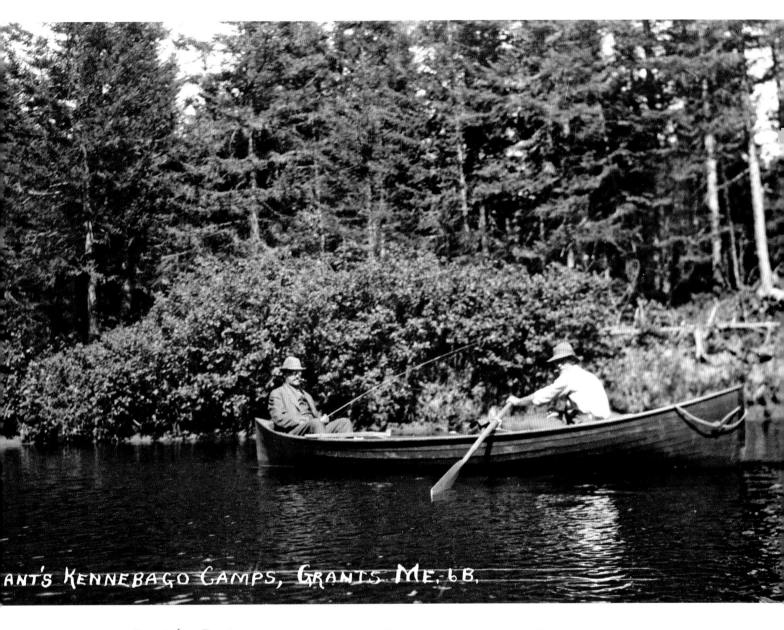

ANT'S KENNEBAGO CAMPS, GRANTS ME. 6B.

Rangeley Boat A guide on Kennebago Lake in the Rangeley Lakes region rows his "sport"—a guest at Grant's Camps—in a double-ended Rangeley boat. Rangeleys were an adaptation of the St. Lawrence skiffs imported from New York by the Oquossoc Angling Association in 1885. Ideally suited for guided lake fishing, Rangeleys became popular on Sebago, the Belgrade Lakes, and elsewhere.

The first fly rod wielded at Rangeley was carried through the forest from Phillips in 1829 by the Reverend Zenas Thompson and an English sportsman named Ware, the rod's owner. The two men were attracted by loggers' tales of the fantastic catches (with poles and worms) of huge "speckled" brook trout.

In the early 1860s avid sportsman (and future coal tar tycoon) George Shepard Page caught eight trout weighing a total of almost fifty-two pounds. After word got out, Rangeley eclipsed the Adirondacks as the trophy-trout fisherman's promised land.

In the late 1800s the image of the Rangeley Lakes region as the sportsman's all-around paradise was successfully publicized with cleverly staged displays at New York City sportsmen's expositions, which included the notable outdoorswoman and guide "Fly Rod" Crosby and Penobscot Indians in traditional dress.

Grant's Pasture The hillside in the foreground of this view of Kennebago Lake from behind Grant's Camps is pasture—it is fenced, and there is a hovel and water tub for horses and very likely a cow at lower right. Many sporting camps had extensive gardens for supplying the kitchen with fresh produce; given the "boney" terrain, if Grant's did not, they deserve a pass.

BIRDS EYE VIEW GRANT'S CAMPS, G

Grant's Camps Founded in 1904 by brothers Will and Hall Grant, Grant's Camps, on the northwestern end of Kennebago Lake, provided guests with excellent fishing on what was virtually a private lake. It was located just far enough from Rangeley, via a ten-mile buckboard ride and a steamboat ride up the lake from the Kennebago Lake Hotel, to impart a sense of adventure and remoteness without inflicting any real hardship on guests.

Owners of the hotel, which dated from 1884, had been granted exclusive rights to most of the lakeshore by two lumber companies. In 1912 a railroad spur, built to serve lumbering interests, reached within two miles of Grant's. The rails were removed in 1933 and replaced by a gated road, which remains today. Grant's Camps, after a number of ownership changes, remains very much in business.

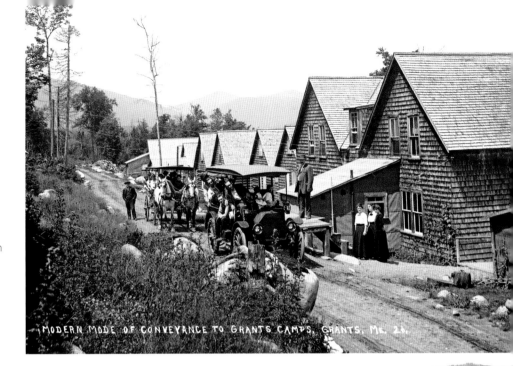

MODERN MODE OF CONVEYANCE TO GRANTS CAMPS, GRANTS, ME. 26.

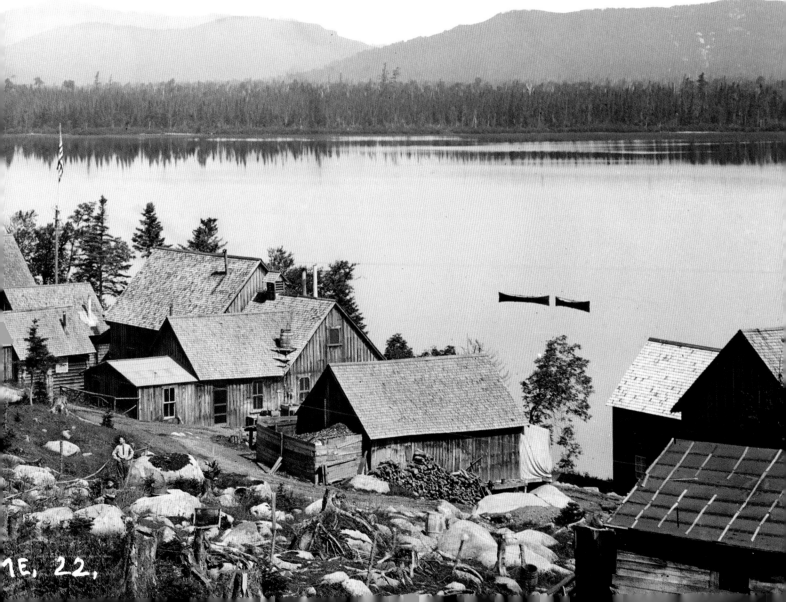

ME, 22,

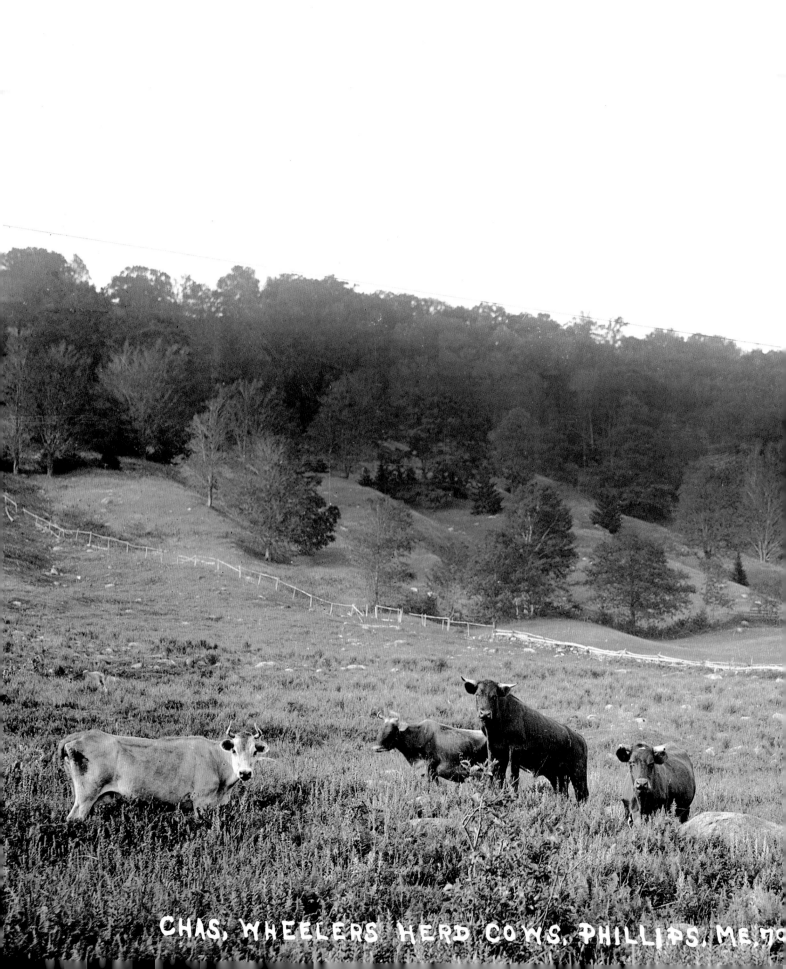

CHAS. WHEELERS HERD COWS. PHILLIPS. ME. 70

Charles Wheeler's Cattle These are Charles Wheeler's cattle, and Mr. Wheeler is glimpsed standing beyond the skinny cow at right of center. EIC photos of cattle are few—evidently neither cows nor farmers bought many postcards—but given how many cows and farmers there were in the state, they deserve some notice here.

Farmer Wheeler's herd is a motley one, motley as in of many colors. The two steers at center are probably "handy," meaning that they are trained as draft animals. They are dark "red" Shorthorns, or Durhams, although to a clueless city person they may look brown. Durhams can be white, red and white (or "sparked"), roan, or all red except for a touch of white somewhere, although dark red was and still is the favored color.

The light-colored cows are of Channel Island, or Jersey and/or Guernsey, breeding. They are supposed to look half-starved. Specialists in the production of butterfat, their presence indicates that either Mrs. Wheeler makes butter or Mr. Wheeler sells cream to a creamery.

In 1900 there were 173,592 "milch" cows in Maine. There were 11,442 steers of age three or older, indicating that they were kept for draft purposes—at age four a steer became a "four-year-old," and at age five a four-year-old became an ox. The sheep population—for which rocky upland pastures like this had originally been cleared—although much reduced from the 451,577 head of 1850, still amounted to 252,213.

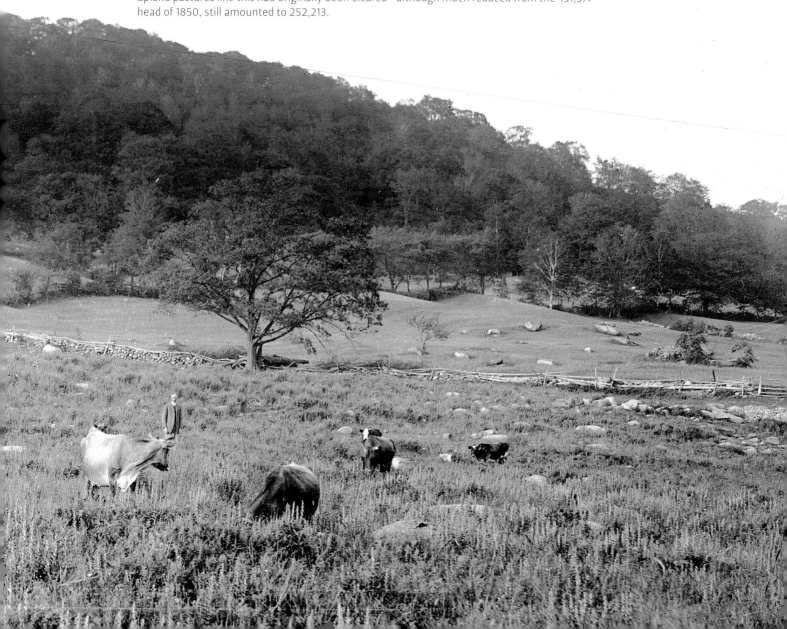

Blue Mountain Camp It was not often that an EIC photographer posed subjects in what was presumably considered an artistic manner, as with these counselors at Blue Mountain Camp in Weld. While the date of the photo is unknown, and with no reflection upon anyone concerned, this is reminiscent of photographs from fascist Germany in the 1930s.

Blue Mountain Camp (later changed to Lawroweld Camp) was founded for boys from the New York–New Jersey area by Joseph Stagg Lawrence, who taught economics at Princeton University. The intention was to use Princeton students as counselors. The camp opened in 1927 with fifty boys on 200 acres at Weld Pond. In 1947 the camp property was sold to the Northern New England Conference of Seventh-Day Adventists, which now operates the facility as a family camp.

No doubt an important factor in the founding of the numerous waterfront camps in Maine in the early 1900s was the low price of rural land. In 1900 the average value of farmland in Franklin County was $4.31 an acre, the lowest of any county in Maine and not much above half the statewide average. By 1910 both had nearly doubled (surely reflecting, to some degree, sales to rusticators) but were still relatively inexpensive.

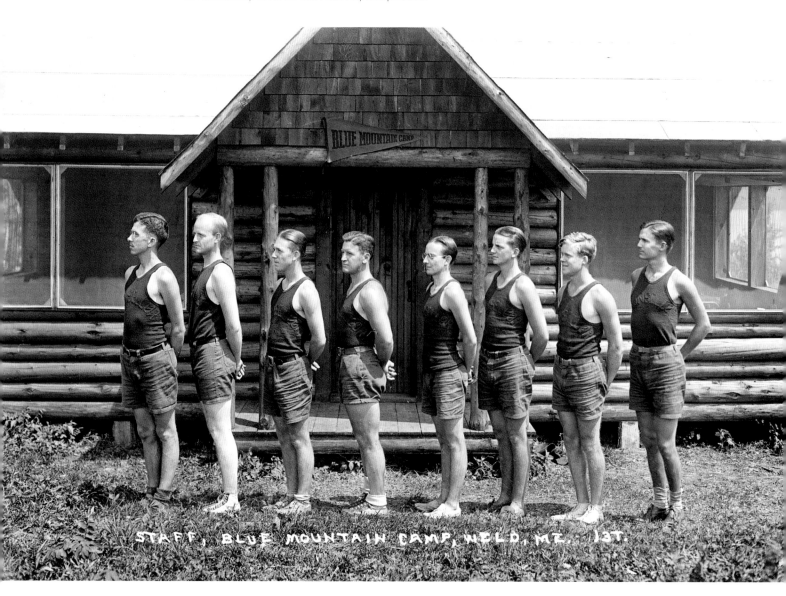

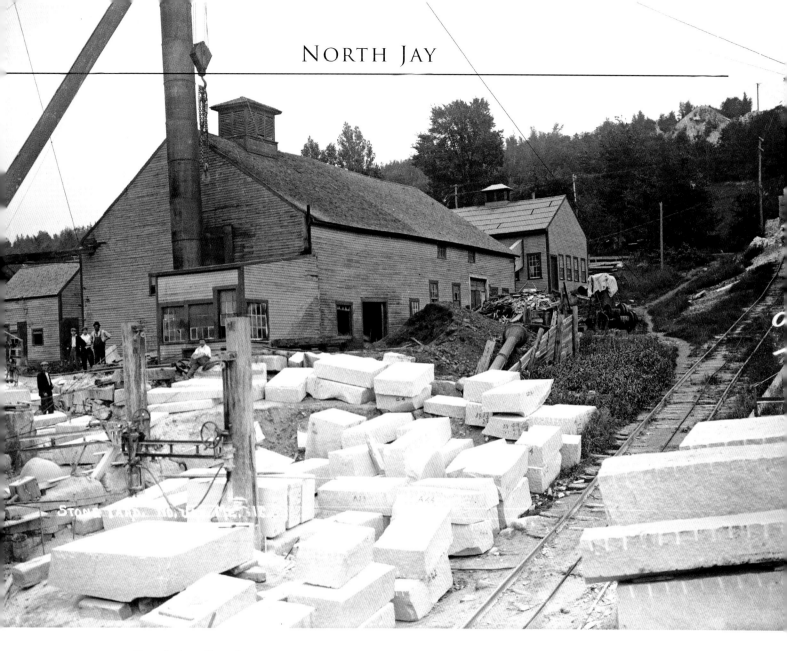

North Jay Granite At the stone yard below the Maine and New Hampshire Granite Company's ridge-top quarry in North Jay, a 1,300-foot tramway, at right, lowered rock to the yard. The white granite was easily worked, and in the 1890s the quarry produced as many as one million paving blocks annually.

The company was founded by officers of the Maine Central Railroad, and it was no coincidence that the railroad's tracks lay close at hand. The company also owned quarries at Redstone, in North Conway, New Hampshire.

Among the many notable structures built of North Jay granite were Grant's tomb in New York; the Penn Mutual Insurance building in Philadelphia; and post offices in Pittsburgh, Philadelphia, Cincinnati, Chicago, St. Louis, and New York. In 1907 thirty cars a day commonly left the quarry's siding, and the workforce of 300 was to be increased to 500 for the two-year job of supplying stone for the fourteen-story Marshall Field department store in Chicago.

The cutter in the foreground is air-powered. The big cutting shed, where the air was filled with lethal dust, is out of sight at left. The finished products were works of precision that would last for the ages, while the quarry buildings were anything but. The sad irony is that many grand granite buildings occupying valuable real estate have already ended up in landfills.

Chisholm Flat This "triple decker" tenement—those with flat roofs were also called "flats"—in Chisholm, a village in Jay, was built for paper or pulp mill workers, who were likely French Canadian or Italian immigrants. The village was named for Hugh Chisholm, the visionary Canadian-born Portlander who, in the late 1800s (with Greene's Alvin Record), built pulp and paper mills along the Androscoggin in the neighboring towns of Jay, Livermore, and Livermore Falls.

Chisholm went on to build Oxford Paper, with its planned town, at Rumford Falls, and combined seventeen northeastern pulp and paper mills into International Paper, the world's largest paper producer. He helped turn the Androscoggin into one of the most industrialized (and polluted) rivers in the nation, and in the process helped to create an explosion of newspapers and, indirectly, the era of "yellow journalism."

The ubiquitous triple-decker, built from about 1880 to 1920 in many variations, from stark no-nonsense to bay-windowed aspirational, was standard worker housing in New England mill towns and industrial cities. To this day they so dominate some cityscapes as to become individually invisible. Cheap to build, they offered tenants relatively roomy apartments, with porches for relaxation and laundry drying. The owner/builder/landlord, himself an immigrant, might live on the first floor, the better to monitor staircase comings and goings.

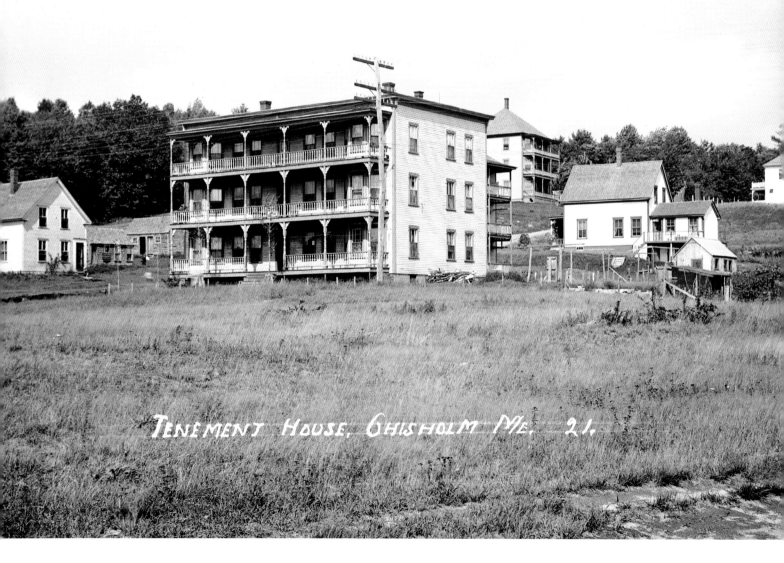

TENEMENT HOUSE, CHISHOLM ME. 21.

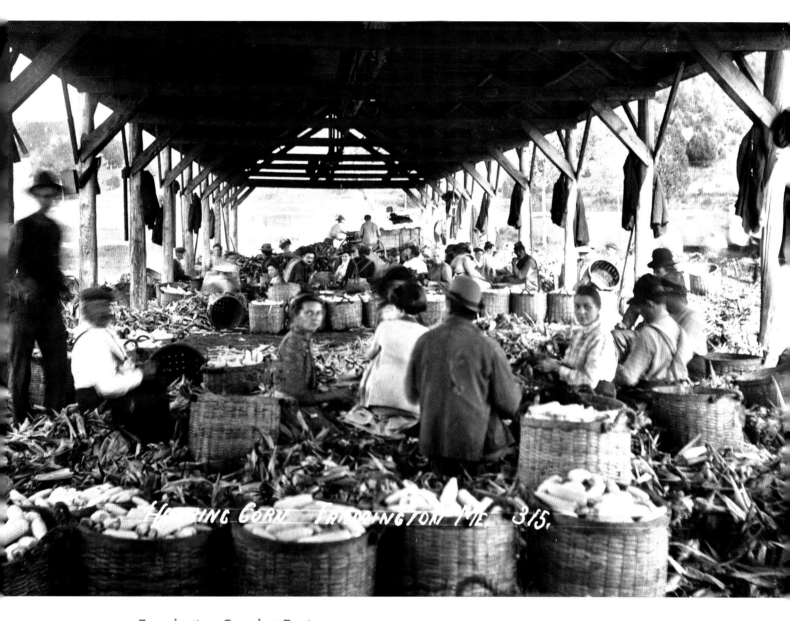

HUSKING CORN FARMINGTON ME. 315.

Farmington Canning Factory Husking sweet corn at one of several area canning factories, or corn shops. While Oxford County was the heart of Maine's sweet corn belt, the Farmington area, featuring deep intervale soils along the Sandy River and warm inland nights, was a heavy player in the industry. After about 1930 the northern New England corn-canning industry—it had spread from Maine to New Hampshire and Vermont—began a slow decline. The last corn canned in Maine was from a Farmington factory in 1968.

Local women and also children supplied important labor for corn factories. The month-or-so canning season, in September, was a social occasion as well as an economic opportunity for workers, especially for shuckers. A good shucker might fill twenty-five to thirty-two bushel baskets in a day, perhaps for five cents a basket. Shucking machinery was introduced about 1920. The brown ash baskets were made by Maine Indians who traveled about from customer to customer, making baskets from local ash trees. Cans were manufactured at the shops during the off season.

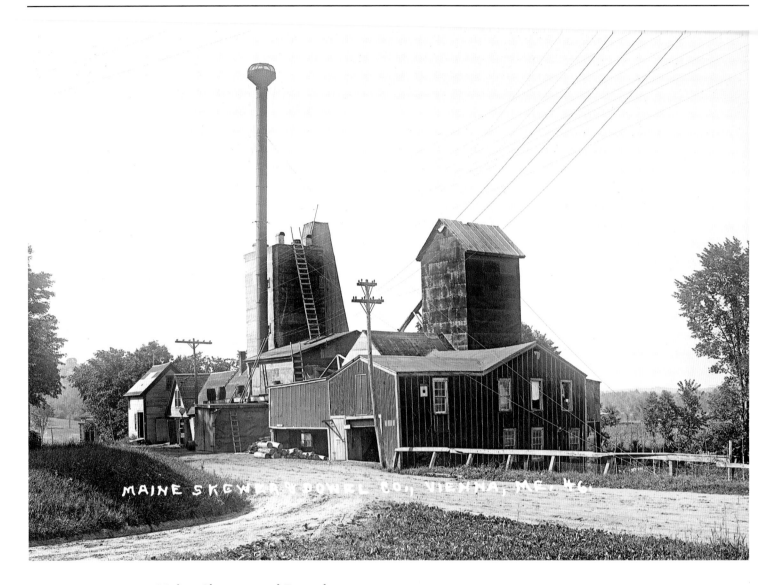

MAINE SKEWER & DOWEL CO., VIENNA, ME. 46

Maine Skewer and Dowel The Maine Skewer and Dowel mill is seen on Mill Stream, circa 1920, in the town of Vienna, or "Vy-anna." John Allen, company founder, invented a ball-bearing arbor and a pointing machine for pointing skewers—Maine's extensive white birch wood-turning industry was built by clever mechanics and inventors mothered by necessity. About fifteen men, and a dozen or so women who packed the skewers, were employed at Skewer and Dowel. The output was trucked to the depot at Readfield and from there shipped worldwide. A mill turning out—no pun intended—handles for shovels and hoes stood on the opposite bank of the stream.

Camp Norridgewock Setting-up exercises at Camp Norridgewock, on Miller Island, East Pond (one of the Belgrade Lakes), circa 1921. Counselors included "trained physical directors." Arthur M. Condon purchased the thirty-acre island from farmer William Miller for the site of a boy's camp. Facilities included six cabins, a dining hall, lodge, boathouse, infirmary, and power house. A "camp mother" was provided for younger boys. Alas, a few years later the bank fore-closed on the whole island.

Mr. Condon's misfortune notwithstanding, in 1921 there were in Maine about fifty-five boy's camps and thirty-eight camps for girls. Many drew campers from particular regions or schools—many directors were school administrators or teachers. Some camps were religiously oriented. Children's camps were of significant economic and social importance; not only did they help support local farms and postcard publishers, but many former campers returned to Maine as adults.

SETTING-UP EXERCISES, CAMP NORRIDGEWOCK, OAKLAND, ME, 33.

Madison Library The Madison Public Library was built in 1906, a temple of civilization protected against the forces of ignorance by a Civil War "Boy in Blue." The library is one of eighteen public libraries and two academic libraries in Maine built with grants from the Carnegie Foundation between 1901 and 1912.

Andrew Carnegie, 1835–1919, was the Scottish-American industrialist who led the huge expansion of the American steel industry in the late 1800s and then gave away, to good causes, the majority of his fortune of over $300 billion—yes, billion—in today's dollars.

Local architects Snow and Humphries were obviously not going to let this opportunity for immortality pass them by, and their energetic efforts were rewarded posthumously when the building was included in the National Register of Historic Places.

To crib from the Register, the library is a structure of brick and stone, with Classical Revival features. It is roughly triangular in shape, with two rectangular sections joined by an angled main façade. The rectangular sections are interrupted by an octagonal tower, with diamond-pane windows, which is encircled by a band of decorative brick corbelling. The front facade has a recessed entry section with stone columns and brick pilasters flanking, and a band of corbelled brickwork below a stone balustrade. Quite a building.

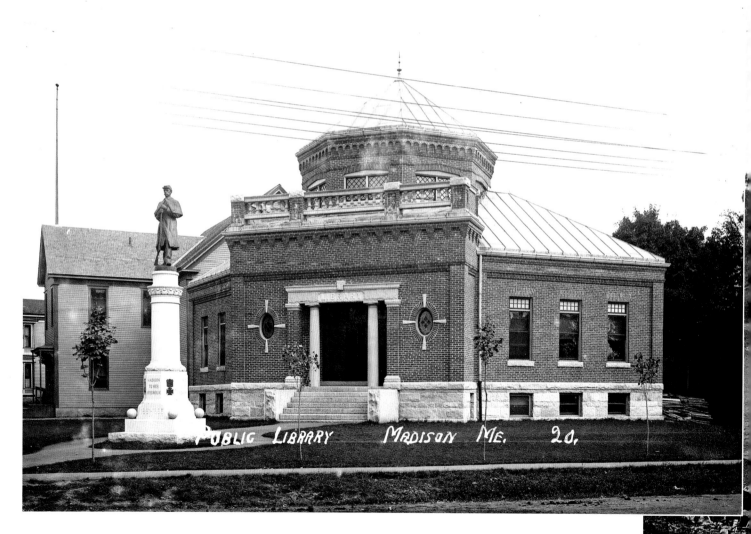

New Solon Bridge The "new Solon Bridge" between Solon and Embden is shown under construction in 1910. (The old bridge was presumably the railroad bridge upstream at Caratunk Falls.) With the rapidly increasing numbers of autos and trucks, agitation for better roads reached a head in the early 1900s. The establishment in 1913 of the State Highway Commission, with power of eminent domain, was the beginning of today's highway system.

Situated at an ancient and important crossing, the bridge was funded by the two towns and by the state, the state having begun to aid main road improvements in 1907. The designing engineer was from Skowhegan; the contractor for the piers was from Fairfield; and the iron or steel truss bridge itself was supplied by a big Pennsylvania bridge works. This bridge was replaced in the 1950s.

After the 1915 Bridge Act, the cost of state highway bridges was shared between counties and the state. Also in 1915, the legislature appropriated $1,000 to compensate Jotham Stevens, the Solon ferryman, for the loss of his charter, a budget item that had been overlooked.

From 1860 until 1898 the ferryman was Theophilus Hilton. A cousin, said to be of a "poetic temperament," wrote an "extended epic" about the old man, several selected lines of which follow:

> Perhaps Theophilus was bluff
> And had his faults like other humans.
> Altho his hand was hard and rough
> His heart was tender as woman's.
> The boat had but twelve inches draft
> And no one knew who did design her
> He was as proud of that old craft
> As though she were an ocean liner.

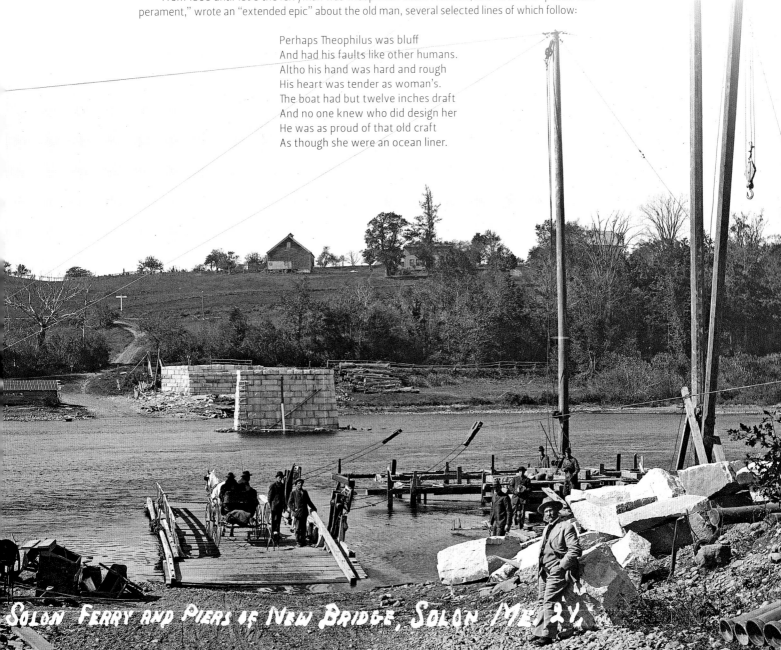

SOLON FERRY AND PIERS OF NEW BRIDGE, SOLON ME. 24.

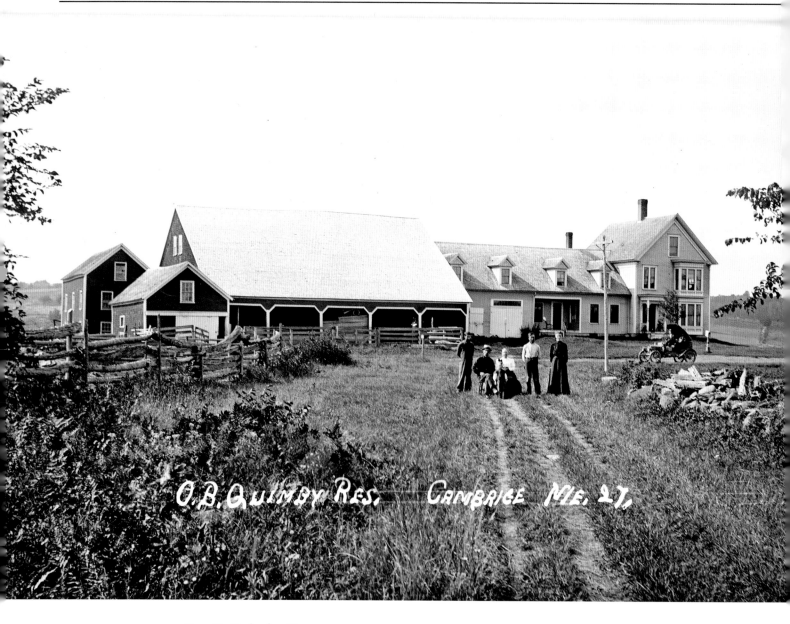

O.B. Quimby Res. — Cambridge, Me. 27.

Ora B. Quimby Farm This is the farm of Ora B. Quimby, Cambridge, Somerset County.

Although the 1910 Census counted over 60,000 Maine farms, relatively few merited a visit from an EIC photographer. Most that were photographed were in resort areas and no longer cultivated much or at all, having, in effect or in fact, hung out a sign reading, "Tourists Taken Here."

Despite the surplus of moribund or abandoned farms—many were bought up by summer people—there still were a great many active farms with good soil and able people which were productive and successful. Ora Quimby was a progressive dairyman, and his farm, located on the shore of Cambridge Pond, lay in a belt of good soil that supported a number of dairy farms, some belonging to other Quimbys.

Today, only one large dairy farm remains in Cambridge, and of the handsome set of buildings that were once the Quimbys' pride, only the house now stands. The rugged barnyard fence, at left, looks to be horse-high and bull-strong. Few fences were also pig-tight. At right, by chance or by design, the EIC Maxwell balances the composition.

RIPLEY

Ripley Village Ripley Village, the commercial center of an agricultural town, is shown circa 1920. (Ripley bounds Cambridge to the north.) The little girl standing at the intersection of Main Street (now State Route 23) and Water Street is in no imminent danger, as the only vehicle in sight—parked at Ramsdell's General Store—is the trusty EIC Maxwell.

Ramsdell's store, the low-roofed stable beyond it, and Hamilton's dry goods, beyond the stable, are all gone now. However, the building then serving as Hanson's General Store, glimpsed at far left, still stands, as does the United Methodist Church, now minus its steeple. The second floor of Hanson's store was one of two dance halls in town; once there had been three. Ripley boasted its own telephone company and the Crocker Free Library, with 2,339 volumes, located for a time upstairs at Hamilton's.

In 1925 the five district schools held contests for sighting and identifying the most birds, flowers, and automobiles. In 1927 students at the Mills School, all under age twelve, raised $1.85 from a corn roast to buy rope for swings and then went into the woods with sharp tools and cut the poles for the swing frame.

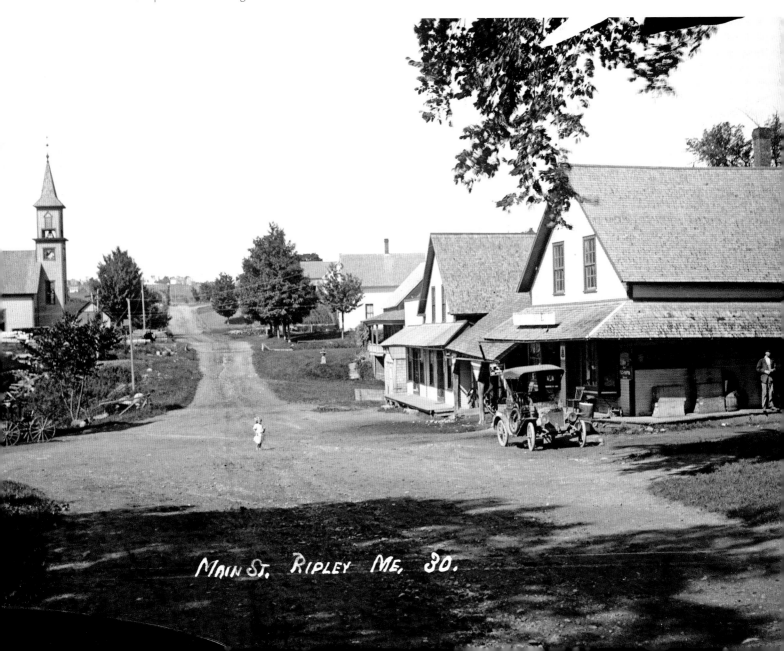

East Dover Brickyard At Crocket's brickyard in East Dover, it is presumably Mr. and Mrs. Crockett who are posing at left. An endless supply of suitable clay, ample firewood, and ready access to shipping made Maine a major burner of brick. While inland yards served local demand, often for mill buildings, coastal yards shipped their product far and wide, and to Boston in particular.

At center we see a Hobb's mud machine. Another machine is out of sight at right—we glimpse part of the well-trodden circular trail of the horse that, hitched to a sweep, powered the shaft that revolved the blades that mixed the clay with water to the right consistency to be molded, or "struck." Long days hitched to a mud machine sweep was the thankless fate of many a blind horse; a pause in its journey to nowhere often invited a lobbed gob of clay.

Bricks-to-be were "haked up" in stacks to air-dry. In due course they will be built into kilns under a temporary roof. Wood fires in tunnel-like "arches" will do the baking. In a small town, the burning of a kiln was an occasion for a gathering and at night even imparted a touch of romance to the otherwise dreary and tedious process. East Dover was a village in Dover; in 1922 Dover was united with neighboring Foxcroft.

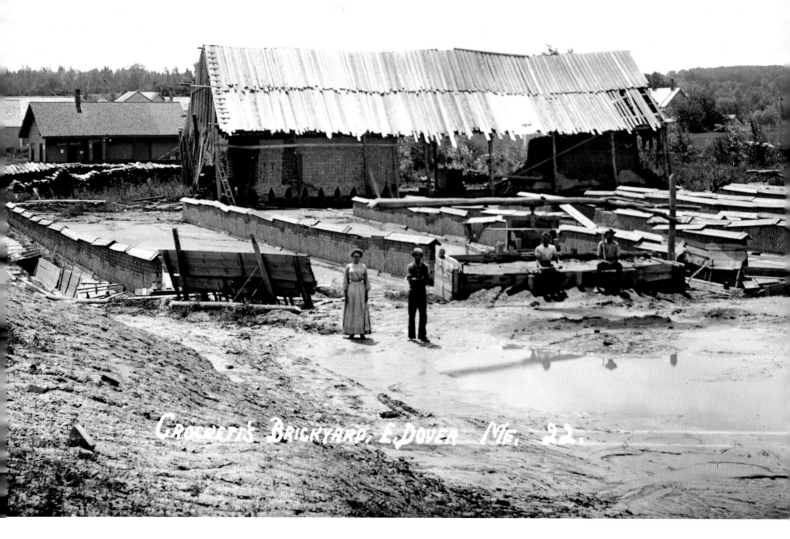

SECOND STREET, DERBY ME. 28

Derby Village In 1905, with the growth of traffic for the Bangor & Aroostook Railroad from the Great Northern Paper Company's mill at Millinocket and the great expectations underlying the construction of the seaport at Stockton Springs, the railroad decided to build itself the second-largest complex of railroad shops in New England at sleepy little Milo Junction. It was comprised of six very large brick shop buildings along with a turntable, a store, and office buildings.

To house the expected workforce of about four hundred, a company town was created. Fifty "model" rental houses were built by an Old Town contractor, along with a forty-nine-room hotel or boardinghouse. Construction of a school and casino (or social hall) was contemplated. About 1913, by a vote of the town, Milo Junction was renamed Derby.

One suspects that it will be regretted that the attractive maple trees were planted so close to the model houses and that the street was not made wider.

Milo was then a very busy place. The big American Thread Company spool mill annually consumed 10,000 cords of birch bolts plus lumber for box wood, much of it arriving by rail. ATCO, a combination formed from a number of thread companies, was itself part of a vast trust headquartered in Scotland.

W.D. SCOVILL RES. ABBOT VIL. ME. 104

Abbott The auto in Abbott Village, a Maxwell, belongs to EIC founder Herman Cassens, who presumably took the photo (that is not Herman Cassens at the wheel). The derby-wearing gentleman sitting at left with the five children—the three kneelers look very close in age—is presumably Mr. W. D. Scovill, whose residence provides the backdrop. The "Blue Bell" ceramic signs on the porch indicate that long-distance pay telephone service is available here; perhaps the local telephone exchange is located in Mr. Scovill's house.

The Maxwell was a notable early automobile, being the first to use a drive shaft rather than chain drive. It was promoted as a very durable machine, having performed well in various endurance contests, thus making it a logical choice for use by EIC photographers traversing rough Maine roads.

Founded in New York, the Maxwell-Briscoe Company migrated first to Indianapolis, and then, circa 1913, to Detroit. Along with Ford and Buick, it became one of the top three American automakers. By 1920 the company was overextended in the post-World War I recession, and it was bought by Walter Chrysler. The Maxwell disappeared as a brand in 1925, but the design would live on as the four-cylinder Chrysler, introduced in 1926, and again in 1928 as the Plymouth.

Monson Slate These slate workers are probably at the Monson Maine Slate Company. Slate is compressed clay laid down in horizontal beds over time—the slate at Monson is 400 million years old. In time the beds tilted about 180 degrees, appearing in Maine's slate belt as veins varying from a few inches to twenty feet in width. Monson's black slate was of very high quality. Originally primarily split into roofing shingles, by the 1900s it was being used for many products, including sinks and electrical panels.

Mines were narrow and deep. Waste rock was dumped in piles, which became hazardous nuisances. When the mines reached depths of 350 to 400 feet, the sides began to bulge in. Around 1910 horizontal shaft mining was begun at the bottoms of the pits. Slate was then removed from the shaft ceiling, leaving the waste rock as fill for the ever-rising floor. Some shafts extended out 900 feet.

The first miners were Welsh, to be joined by Swedes, French Canadians, Prince Edward Islanders, Irish, Yankees, and Finns. But only the Welsh were said to be born shingle splitters. The widow of Albert Anderson, killed in a Monson quarry in January 1916, received Maine's first workman's compensation widow's benefit, $7 for 300 weeks. Monson Maine quarried its last slate in 1943.

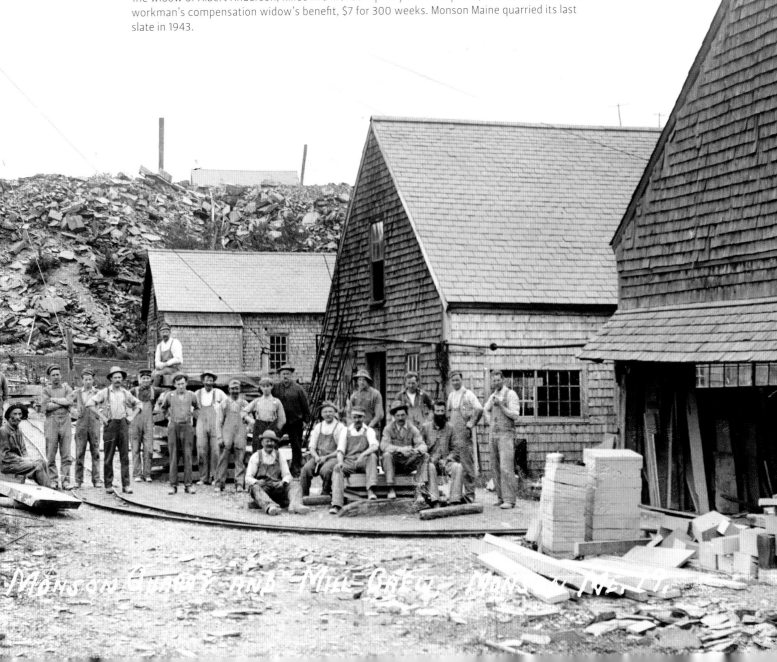

MISERY GORE

Somerset Junction The stationmaster and his family pose at the Canadian Pacific Railroad station at Somerset Junction in Misery Gore. This was where, circa 1905, the Maine Central's Kineo Branch crossed the "CP." The Kineo Branch dead-ended at Rockwood on the shore of Moosehead Lake. From there passengers were ferried across the lake for the final leg to the big Kineo Mountain resort.

The CP crossed into Maine from near Lac Megantic, Quebec, and dove into the remotest of forests. Connecting with the Maine Central at Mattawamkeag, it crossed into New Brunswick at Vanceboro, headed for the ice-free winter port of St. John. Begun in 1886, it was completed in 1889.

In 1914 a petition from Dr. Humphries and thirty-four other citizens of Jackman to the Maine Railroad Commission requested that the CP be directed to maintain a station at Somerset Junction and to either add stops to the eastbound express train or the eastbound mixed-train so that passengers wishing to connect to the Maine Central would not be forced to wait at Somerset Junction from 2:20 in the afternoon until 9:34 the following morning. The CP complied without being compelled. The last regular rail passenger service in Maine ran on the CP line, ending in 1994.

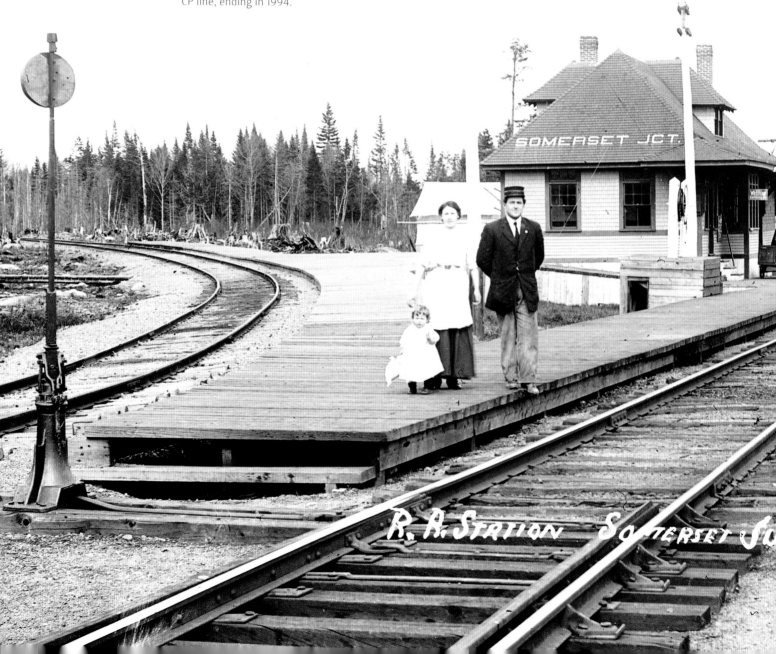

ROCKWOOD

Moosehead Salmon A sport at Maynard's Camps, located in Rockwood Strip Township at the outlet of the Moose River into Moosehead Lake, shows off his string of landlocked salmon.

In the United States, "landlocks" were originally found only in Maine's Sebago, Green, Sebec, and Grand Lake systems. It was long thought that these populations had been marooned after the last glacier. However, before their outlets were dammed, these lake systems were open to salt water, and apparently the ancestors of the "landlocks" for unknown reasons simply gave up migrating to sea. Today, the salmon from those four lake systems have been transplanted to water bodies throughout the state, across the country, and around the world.

The passion that so many already well-fed humans attach to the pursuit of fish, which often go uneaten, and often at great expense, suggests that there is at play an evolutionary link to ancient hunting and fishing practices. (Perhaps golfers, searching in the rough for errant balls, are the descendants of ancient gatherers.) Whatever its origins, the fishing compulsion has greatly benefited the State of Maine, which by the late 1800s had developed fish hatcheries and stocking programs to keep sports and their money coming back. Maynard's, another beneficiary, continues in business today.

Pulp Boom At Ripogenus Dam, on the West Branch of the Penobscot at the lower end of Chesuncook Lake, we see a boom of pulpwood, which will be sluiced over the dam. Built in 1916 by the Great Northern Paper Company, Ripogenus was one of the world's largest reinforced concrete dams.

The turn of the century saw vast changes in the North Woods as the fast-growing pulp and paper industry, backed by massive out-of-state capital, rolled over the old long-log establishment. The Great Northern, from its newly built city of Millinocket, ruled some two million acres of forestland with remarkable organization and ability.

Unchanged was the reality that wood harvesting was primarily a transportation business, and water was the chief mode of transport in Maine. The postcard caption not withstanding, the boat, *GNP No. 3*, is not towing the boom. The boom was towed down the twenty-eight-mile-long lake by the splendid 91-foot-long diesel tug *West Branch No. 2* or its side-wheel predecessor. Both, of course, were built on the lake shore. (Transporting *West Branch*'s thirty-ton engine to the lake was a major task.)

In 1927, from May 21 to July 27, *West Branch*, in its first season, delivered fifty-one booms—a boom contained up to 5,000 cords—of pulpwood cut the previous winter. Most pulp was driven to the lake by way of streams; some traveled 120 miles by water to Millinocket.

GNP No. 3 may be one of the larger diesel-powered members of GNP's fleet of "boom jumpers," which, at flank speed, slid over boom logs on their flat bottoms. The propeller was caged.

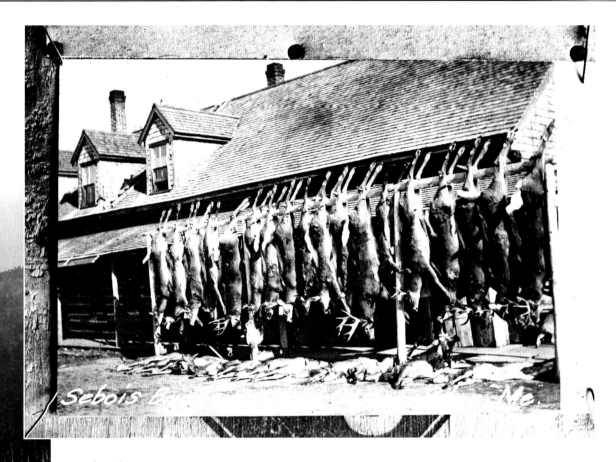

Seboeis Deer T6 R7 WELS means Township 6, Range 7, West of the Easterly Line of the State, one of Maine's unorganized townships. Obviously Seboeis has been the scene of a white-tail deer massacre. Note also the smaller carcasses lying beneath. An advertisement in the 1914 Maine Road Book read:

Seboeis Bridge Sporting Camps
Private Log Cabins Patten, Maine Telephone

These camps are situated on Seboeis Stream just north of Patten Village. . . . There is a good road from Patten to Shin Pond where cars can be stored. My teams will meet all parties at Shin Pond and carry them to the camp seven miles distant, free of charge. Good moose, bear, deer and partridge hunting in the season. . . . LUTHER HALL Proprietor, Patten, Maine.

The camps were evidently located on a main logging camp tote road, thus the telephone connection. One wonders how many of these deer were shot by the "sports" and how many were shot by guides on behalf of their sports.

In 1914 Maine's big-game limits per hunter were one moose and two deer, except in Androscoggin, Cumberland, Knox, Kennebec, Lincoln, Sagadahoc, Waldo, and Hancock counties, where the limit was one deer. Lumber camps were limited to six deer—in theory, of course. Out-of-staters could export two deer; Mainers, one. Today, deer are suburban pests in many southern and central Maine localities and are greatly reduced in the North Woods.

The negative evidently having gone astray, an earlier postcard was photographed to produce more postcards. Likely the original image was supplied by Mr. Hall.

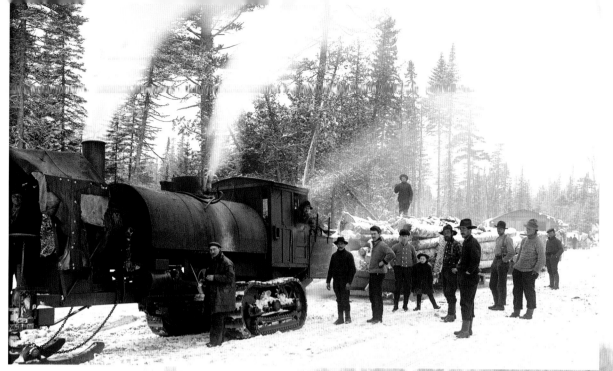

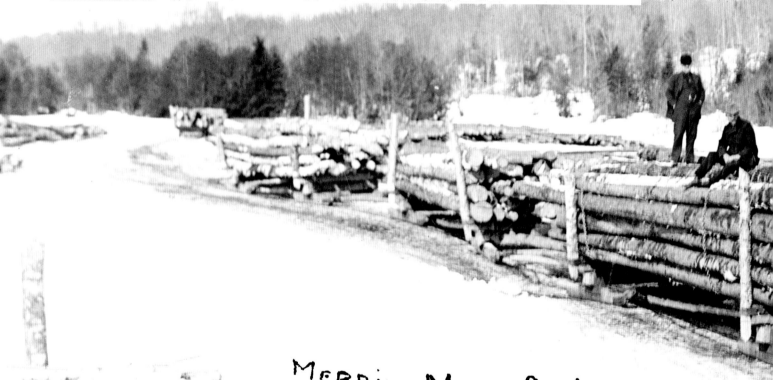

MERRILL MILL CO'S.
LOG HAULER
PATTEN ME.

Lombards The Lombard steam log-hauler was invented and manufactured by Waterville's Alvin O. Lombard. Patented in 1901, it was the first commercially successful track-laying vehicle. Lombard was motivated by the heavy losses of woods horses, laid in part to the increasing demand for birch bolts, which do not float and had to be hauled long distances. Despite the inevitable problems, especially when operating in sub-zero temperatures, Lombards quickly gained favor — one big woods operator claimed that three log-haulers did the work of sixty horses. A 20-ton Lombard could haul 175 tons of birch bolts.

Lombards required improved roads, iced nightly by horse-drawn sprinklers. There were no brakes, and the steersman—or two steersmen, as seen here—was sitting in a very poor place if a train of heavy sleds jackknifed. Log-haulers operated around the clock, their shrill whistles echoing from distant hills on cold, still nights. More than eighty steam Lombards were built at Waterville through 1917. A gasoline-engine version was introduced in 1914.

The story of the bitter patent wars between Benjamin Holt, founder of the Caterpillar Tractor Company, and rivals is too involved to be related here. Perhaps all that Mainers need know is that when the kindly Alvin Lombard was approached to be a friendly witness in a suit brought against Holt by another competitor, he reportedly responded, "By God, young man, I'm glad to see you. If God Almighty could charter me to kill a man, I'd get on the train and go to California and kill old Ben Holt."

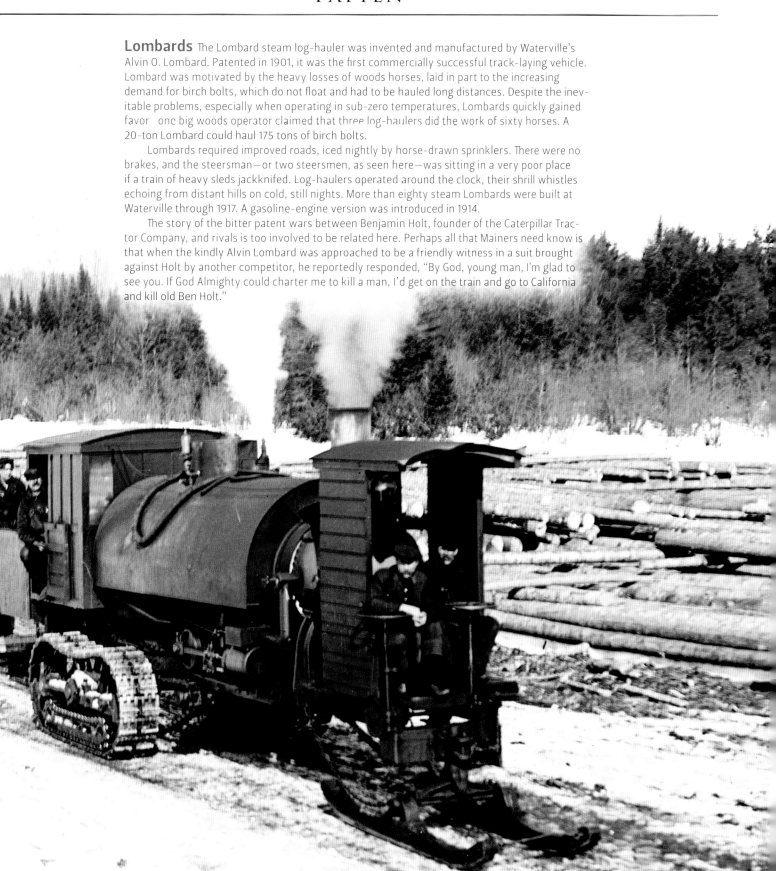

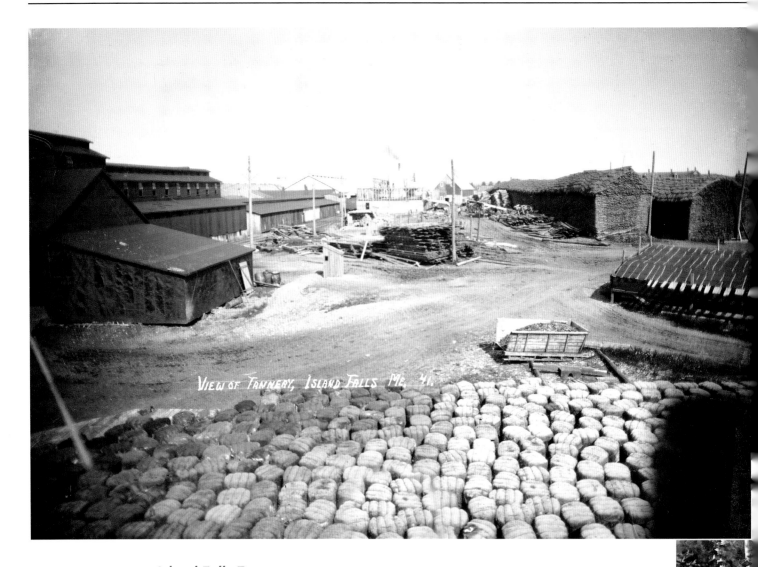

VIEW OF TANNERY, ISLAND FALLS ME, 41.

Island Falls Tannery The Fred W. Hunt Company tannery in Island Falls was an interesting but odoriferous facility built in 1896 after the arrival of the railroad. Leather was a vital component of civilization, but, like laws and sausage, easier to appreciate in its finished form than its creation. Anthrax was an occupational hazard for workers, as was missed compensation from skinflint absentee owners. Most tannery workers, housed in tenements, were recent immigrants.

Large-scale tanning of thick sole leather required copious quantities of tannin derived from grinding huge amounts of hemlock bark. This led to the creation, in the late 1800s, of big tanneries, owned in Boston, amid the vast stands of hemlock in eastern Maine. Bark peeling was warm-weather work; bark hauling was a winter job. Hemlock lumber was long scorned, and the logs were left to rot. This changed in the 1900s, and Hunt's lumbering operations may have included salvaging the peeled logs. Only peeled hemlock logs floated.

Two thousand hides could be processed at their Island Falls tannery daily, requiring 12,000 cords of bark annually. Two great peaked bark stacks are seen at right. Ten thousand cord of firewood fueled the furnaces. Bales of hides are in the foreground, Hides were of both foreign (especially South American) and domestic origin. Revolting refuse flowed freely into Mattawamkeag Lake.

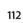

Birch Point Pavilion The Birch Point Dance Pavilion on Pleasant Lake is shown about 1925. The pavilion was built in 1922 during the Big Band era and for many years was a major local attraction. Playing tonight is Fogg's Famous Dance Band from Brockton, Massachusetts.

After the 1893 arrival of the Bangor & Aroostook Railroad, the population of Island Falls quadrupled by 1900 as it was transformed from a small farming community to a teeming tannery, sawmilling, lumbering, and agricultural center. By 1930 the tannery and the sawmills had shut down, the population had declined, and catering to visiting sportsmen and campers became increasingly important.

The man in the white shirt is likely William Edwards, a local potato broker who, with his wife, Melvina, beginning in the 1920s with overnight log cabins, developed Birch Point into a recreational destination. Birch Point Campground, still owned and managed by members of the Edwards family, thrives to this day, although the pavilion collapsed in the winter of 1955.

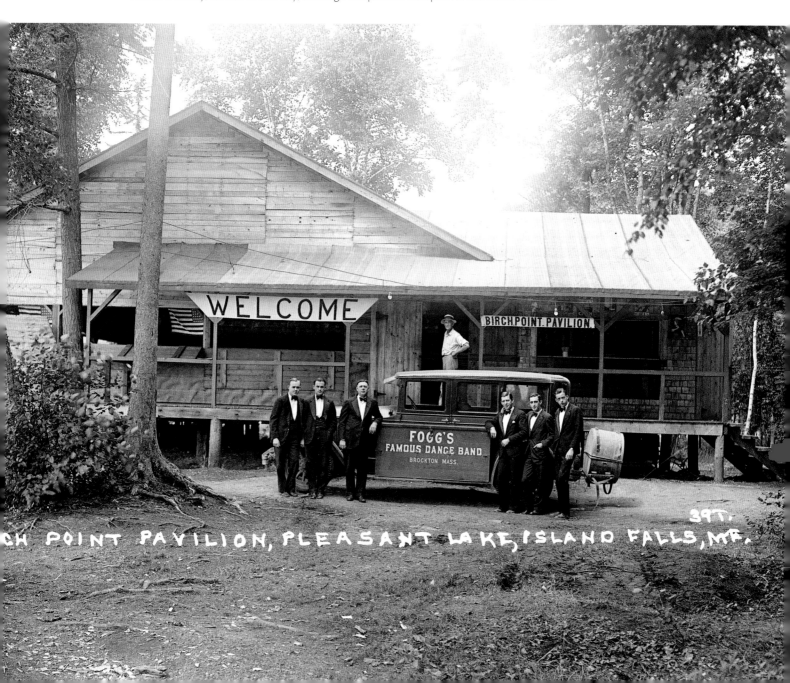

MASARDIS

Haywood Post Office Haywood—the incorrect "Haymock" label to the contrary notwith-standing—Post Office, Masardis, Aroostook County. Masardis lies at the confluence of the St. Croix and Aroostook Rivers, which join to create an enhanced Aroostook flowing north to the St. John.

In 1895 the Bangor & Aroostook Railroad reached Masardis, greatly expanding agricultural and lumbering activities. A Houlton woman, Miss Clara Stimson, who had taken over her late father's lumber business, shrewdly secured the deeds to three islands and nearly a mile of front-age on the Aroostook downstream (that is, to the north) of the village of Masardis at its junction with the Squapan River, where she established valuable log-holding booms and built a sawmill.

Miss Stimson's mill was bought by brothers Charles and Avon Weeks, local lumbermen, who built a second mill. The Haywood Siding Post Office—Haywood Siding was later renamed Squapan Junction by the railroad—was originally the log cabin home of Charles and Gertrude Weeks. Gertrude became the postmistress.

At far left is a pile of heavy boom chain. A bateau oar stands at left of the doorway.

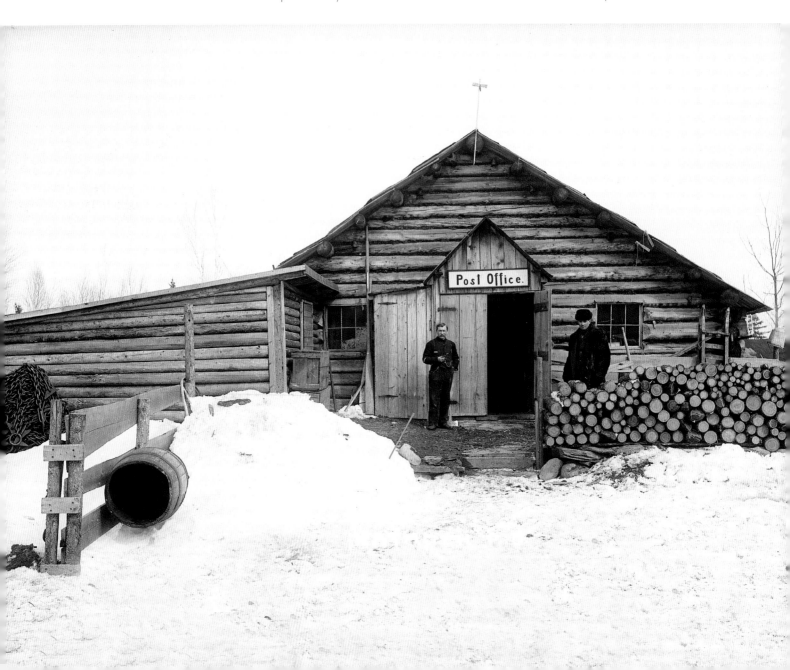

ASHLAND

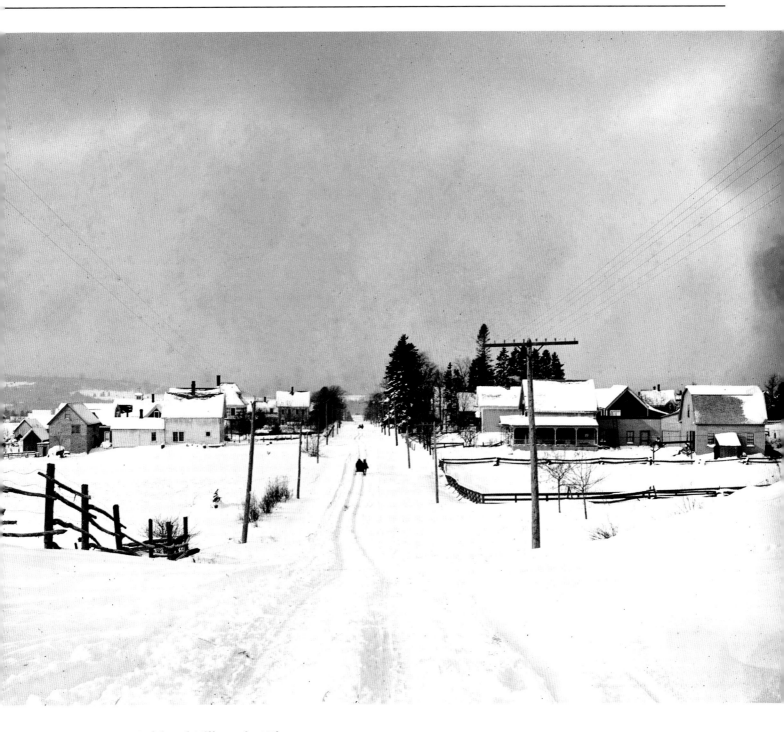

Ashland Village in Winter This is a wonderful image of the season in Maine that rules all others, yet rarely appears in EIC photographs. Despite Mainers' very rapid adoption of the automobile, for a good part of the year it was of no earthly use. Winter was the prime season for rural travel by horse, provided there was a firm snow cover on the roads and not too much ice or drifting. Shortcuts over fields—"across lots"—became seasonal thoroughfares.

Here we see the electric line on one side of the road, and telephone lines on the other.

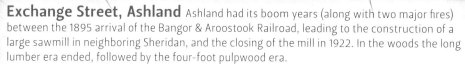

Exchange Street, Ashland Ashland had its boom years (along with two major fires) between the 1895 arrival of the Bangor & Aroostook Railroad, leading to the construction of a large sawmill in neighboring Sheridan, and the closing of the mill in 1922. In the woods the long lumber era ended, followed by the four-foot pulpwood era.

Local telephone service began in 1896. An electric light plant, powered by the Aroostook River, was completed in 1910. Also in 1910 the town acquired three large two-ton snow rollers, drawn by four or six horses, to pack the roads. These were considered a great advance over the old, narrow "triangle" plows. Here, it appears that a roller has done its work on Exchange Street. In 1915 the post office was moved to the false-fronted and rather shabby building at left, at which time the building was spruced up. The Exchange Hotel appears in the middle distance.

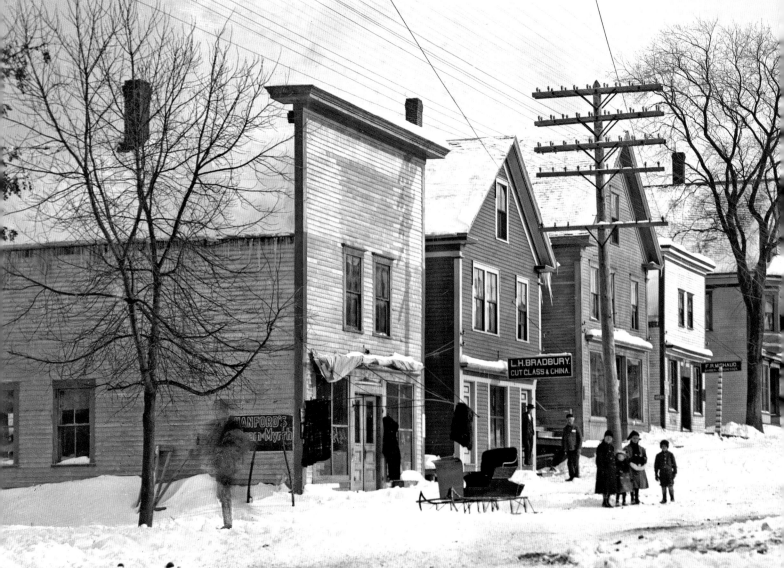

5 EXCHANGE ST. ASHLAND

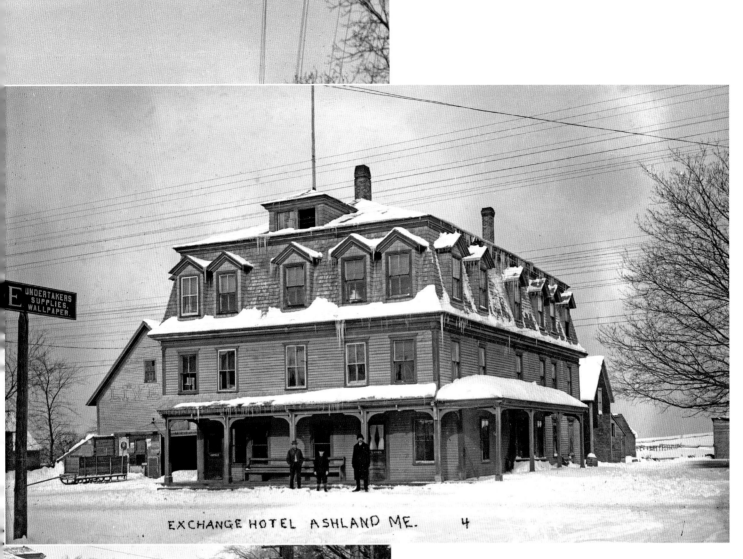

EXCHANGE HOTEL ASHLAND ME. 4

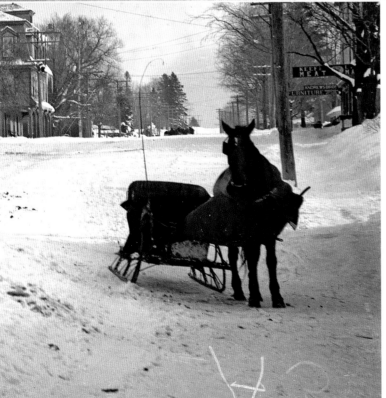

The Exchange Hotel The Exchange Hotel's "connected" livery stable is seen at left. There were two types of hotels in a lumbering town—those that put up with rowdy loggers and even rowdier river drivers, and those that did not. The Exchange was of the latter class, where salesmen and members of the public need not fear finding themselves in the middle of a drunken fracas. The rival Ashland House maintained separate facilities for the two classes, the woodsmen sleeping sixteen to a room in double-decked bunks.

Despite its airs, the Exchange does not appear particularly inviting, and in the dead of winter it likely featured cold rooms, colder sheets, and a skim of ice in the water pitcher. At least the cluster flies would be dormant, if not the scurrying rodents in the walls. There is the story of a man checking in to a northern Maine hotel, snow caking his hat and coat and icicles hanging from his beard, who is asked by a fellow guest, "And what room do YOU have?"

The sign in the foreground advertising undertaker's supplies at Andrew's furniture store does nothing to improve the dreary ambience. Furniture store proprietors were commonly the local undertakers, or the other way around.

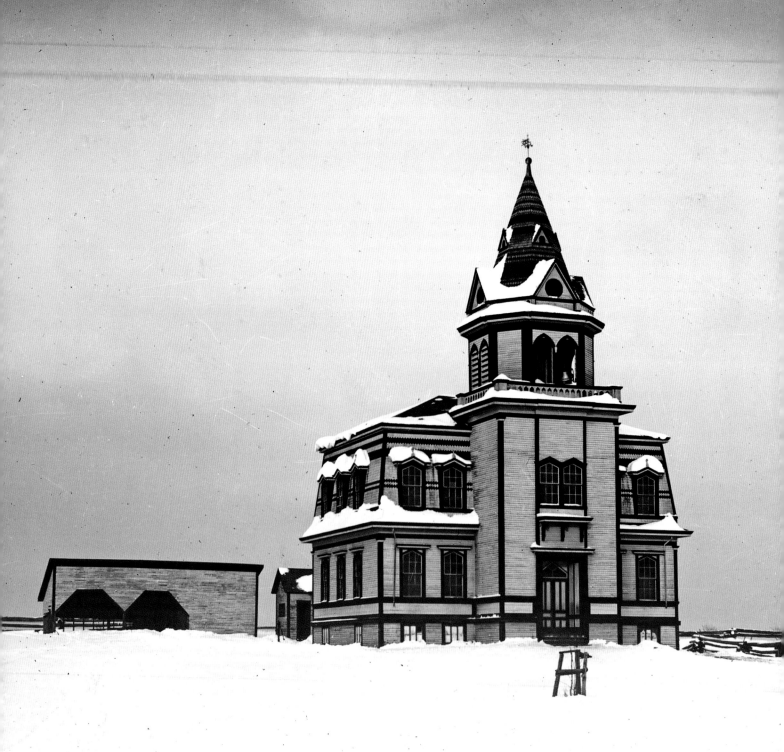

Ashland School The Ashland village district school, built in 1893, exhibited what might be termed a naïve architectural pretense of mansard and Queen Anne features. With seventy scholars, the building it replaced had been hopelessly overcrowded. The primary children remained in the old building, the grammar grades moved into the lower floor of the new building, and the high school students moved in upstairs. In 1913 the school was sold to the Odd Fellows, who decapitated the tower before moving the building to their lot.

The split-rail fence is a throwback to Ashland's days of early settlement.

Portage A steam-powered log hoister, mounted on a scow on Portage Lake, is employed "shingling," or stacking, logs (probably spruce) for the Portage Lumber Company. The mill began operations in 1914, well timed to take advantage of rising lumber prices caused by the war in Europe.

The lumbering business was essentially a transportation business. Large quantities of supplies had to be transported into the woods, and logs had to be transported from the woods to mills—and the lumber produced by the mills then had to be transported to markets. For many years, only the extensive networks of waterways—rivers, lakes, streams—by which pine and spruce logs and pulp wood could be driven made logging in much of Maine's vast woodlands possible.

Railroads changed the equation and also spurred the utilization of hardwoods. Before the construction of the Bangor & Aroostook Railroad's Fish River line, which made the construction of this and other mills feasible, logs landed in Portage Lake were driven north, down the Fish River system of streams and lakes to the St. John River, then south over Grand Falls to be sawn by mills at St. John, New Brunswick. The railroad upset the old order.

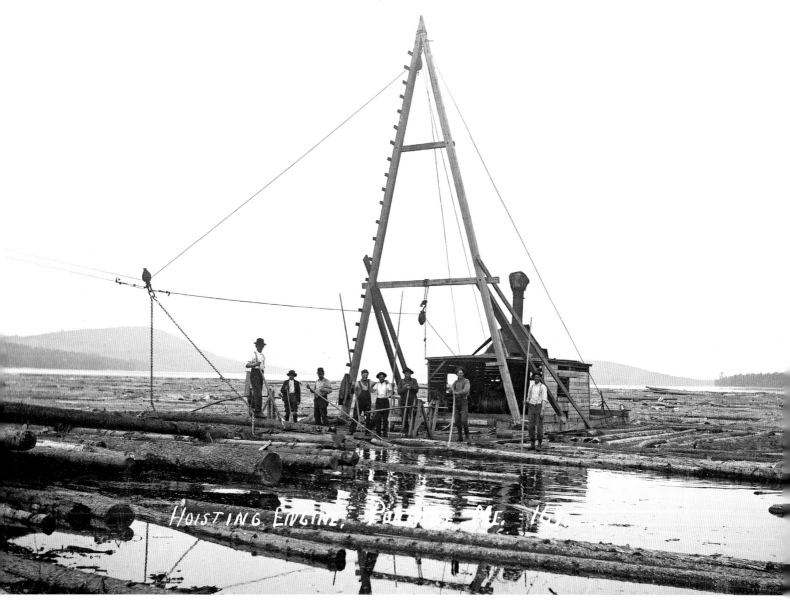

Eagle Lake Mills The construction of the Fish River Lumber Company mill complex in 1902 coincided with the arrival of the Fish River branch of the Bangor & Aroostook Railroad. The little frontier settlement of Eagle Lake quickly became a booming mill town and supply depot for logging camps.

From right to left we see the long-lumber rotary mill (sawing spruce); a kindling mill (operated from 1908 to 1919 under a different company name); and the shingle mill. Log booms assembled on the lake were delivered to the mill by two steamers.

It was no coincidence that railroad president Albert Burleigh, of Houlton, was a major owner of Fish River Lumber, along with its extensive timberlands, which had previously been purchased for very little. The lumber boom lasted as long as the timber lasted, about thirty years. During those years the mill was mortgaged many times for many times its cost. The workers did not fare nearly as well as did the mill owners, and in the 1930s the town itself was declared bankrupt.

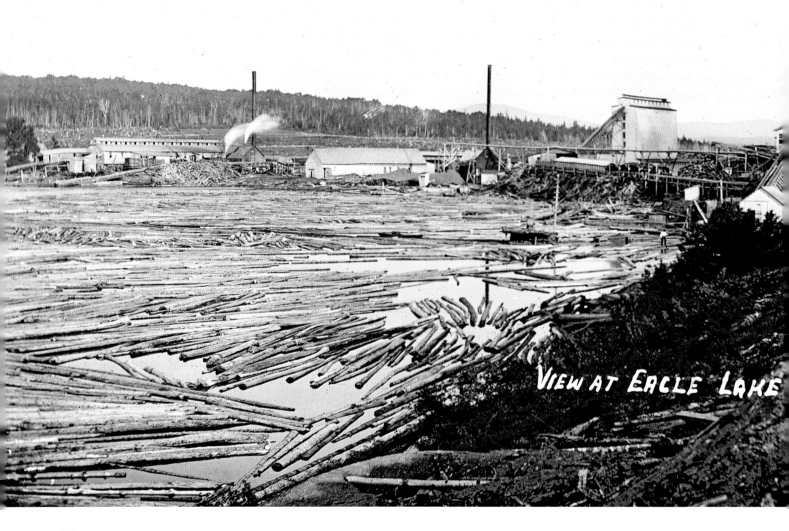

VIEW AT EAGLE LAKE

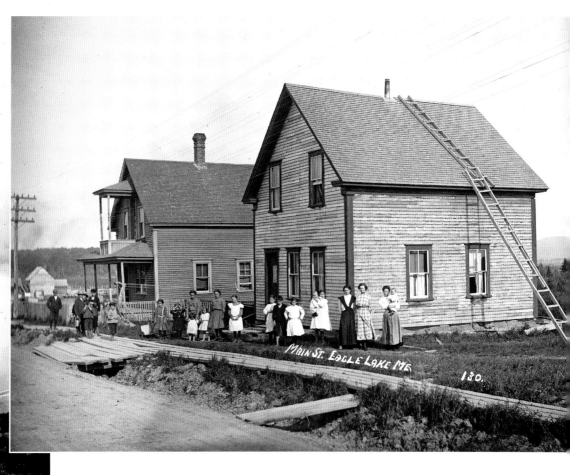

Main Street, Eagle Lake Eagle Lake's village sprouted
with the arrival of the railroad and the building of sawmills and
other industries and businesses. The Fish River Lumber Com-
pany alone built twenty-five tenements and a boardinghouse
for employee housing, and, as elsewhere, that neighborhood
was soon called "Slab Alley." These nearly identical houses on
Main Street may well have been company built, although they
appear now to be privately owned. The men of the houses are
likely at work in a mill.

No doubt slab wood from the mill was burned in village
stoves. The thin stovepipe employed as a chimney in the near
house would form creosote readily, and the threat of chimney
fires explains the presence of the rooftop ladders. The standard
chimney-cleaning tool was a large chain with small chains
attached. The Eagle Lake Telephone Company was established
in 1908.

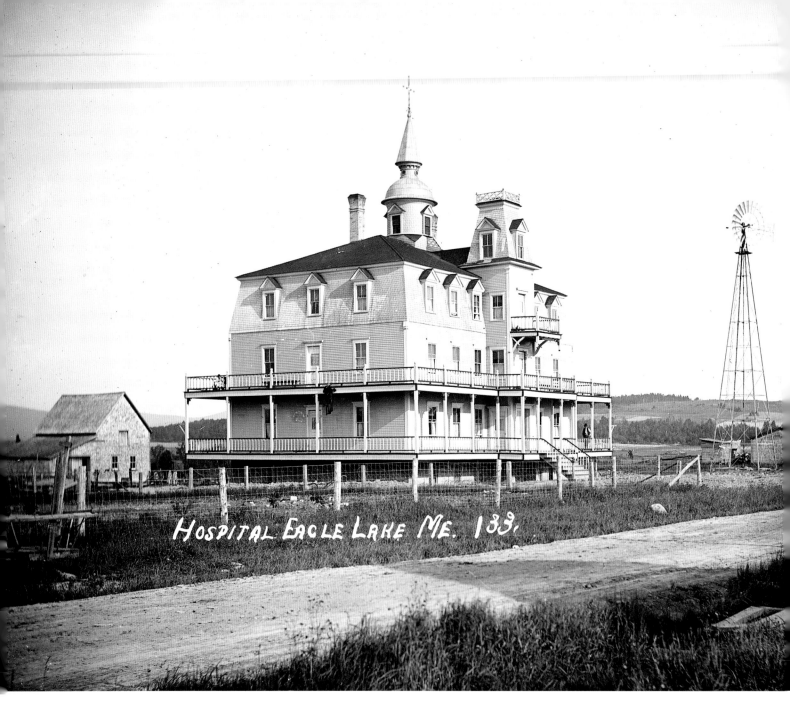

HOSPITAL EAGLE LAKE ME. 133.

Eagle Lake Hospital Built in 1905 in what might be termed "mill-town Mansard" style and managed by Franciscan nuns, the Northern Maine General Hospital, on the famous Aroostook Road, was the first hospital north of Bangor. The kitchen was in the basement, the men's ward on the first floor, the women's ward on the second floor, and the nuns' quarters and their chapel on the third floor. French, of course, was the default language.

Despite the supply of injured loggers and millworkers, and no end of babies to deliver, doctors did not stay long at Eagle Lake. This changed in 1921 with the arrival of Dr. William Kirk, who remained for over thirty years, during which time the building was enlarged. In the 1950s Dr. Kirk wintered in Florida, and seasonal stand-ins were required. In 1954 the vacancy was filled by young Dr. Anthony Betts, who was English, just off the boat, and not Catholic. Years later he would write a lively account of his novel introduction to America titled *Green Wood and Chloroform*.

Fort Kent Mill The Fort Kent Mill Company millpond and sawmill lies on the Fish River, above its confluence with the St. John. Unlike the big steam sawmills built along the upper St. John in the early 1900s after the arrival of the Bangor & Aroostook Railroad, the Fort Kent mill was powered by a fourteen-foot head of water forced through turbine "wheels."

Established on a preexisting mill site circa 1890 by four Bradbury brothers from New Limerick, the complex included the sawmill, a gristmill, a carding mill, and extensive tracts of timber in the Fish River watershed. About five million feet of lumber were cut for the mill each year, producing 20 to 25 million cedar shingles and one million feet of lumber.

The company also owned a large farm, producing potatoes, hay, and buckwheat, and a store carrying a full line of general merchandise, supplies for lumbermen, fertilizer, farm implements, carriages, harnesses, and so forth. Its lumbering operations employed as many as 140 men with teams of horses. The mill was bought by the Great Northern Paper Company in 1919 and never again operated.

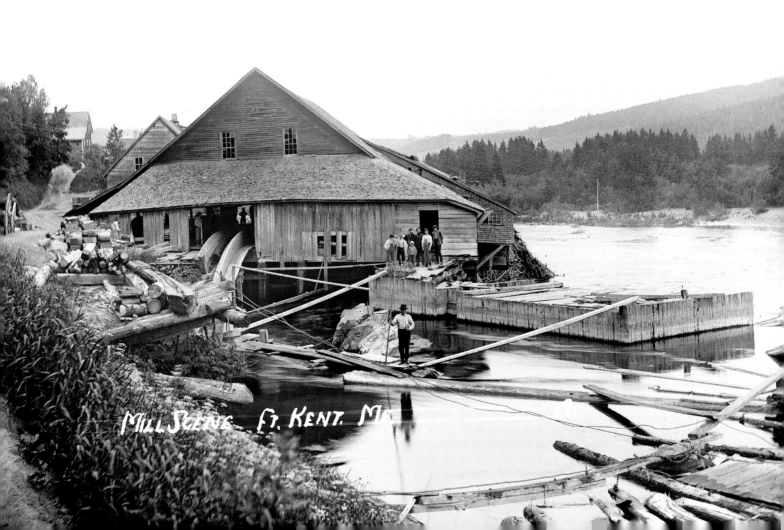

Mill Scene Ft. Kent, Me

FRENCHVILLE

Upper Frenchville This is Upper Frenchville as seen from St. Hilaire, New Brunswick, across the St. John River. Although separated by the international border, the people of the valley were, and remain, predominantly French-speaking Acadians with common ancestry. When this photo was shown to Phil Dechaine, of Sinclair, Aroostook County, he responded:

> *This is the first time I've seen a photo of Upper Frenchville this old. The photo was taken from land belonging to my great-grandfather on my mother's side of the family, which had been in the family for five generations or since the late 1700s or early 1800s. The big building across from the church is the Daughters of Wisdom convent. They provided medical as well as educational services in the early years, then educational only. The church seems to be the first one built. I think it burned down and was rebuilt. My grandmother and her husband Emile Sirois lived in the white house before the church. What we see is the third floor. The boutique, or blacksmith shop, was down in a gully. There is a road that comes down to the river and crosses to my grandfather Hilaire Cyr's land. That was before the days of strict enforcement of customs regulations.*

The Daughters of Wisdom, a Catholic order dating to the early 1700s, moved their ministries from France to northern Maine in 1904 following the secularization of French schools.

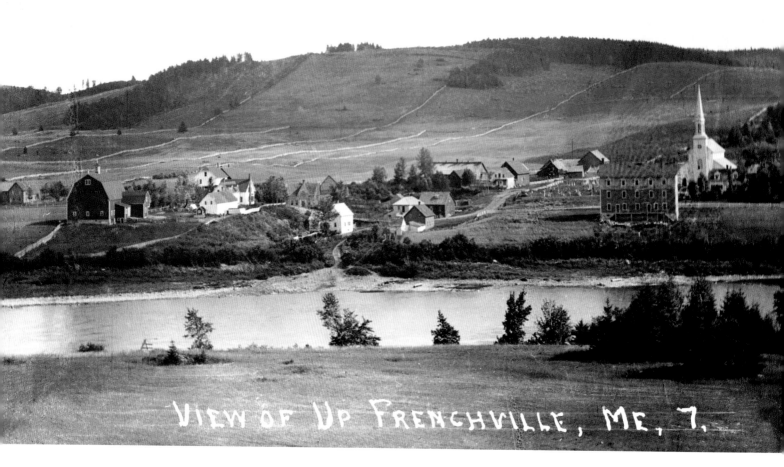

VIEW OF UP FRENCHVILLE, ME, 7.

DAIGLE, NEW CANADA TOWNSHIP

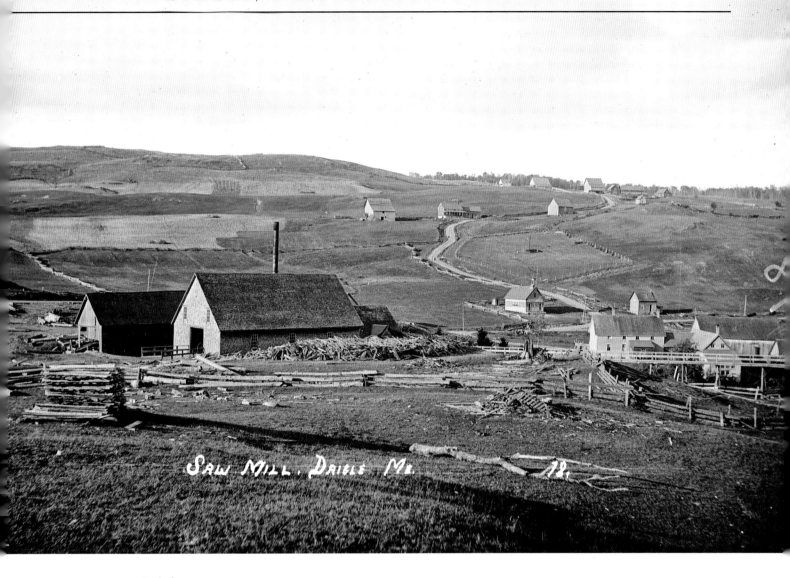

Saw Mill, Daigle Me. 18.

Daigle This is the community of Daigle around 1915. The first settler was Vital Daigle, who came south from Frenchville in the 1850s, to be followed by other Frenchvillians. At that time, of course, the land was heavily forested—the many children in typical Acadian families must have been of much assistance in clearing ground.

The mill in the photo is likely Denis Daigle's long-lumber mill, powered by the outlet stream from Black Lake. (The stream is hidden from view.) Another local mill was Chrysotome Daigle's shingle mill. Daigle brothers owned a potato starch factory. The postmaster and storekeeper was Isaie Daigle. Two other Daigles are listed in Maine Registers of the period as "smiths." It would appear that the Daigles had Daigle pretty much sewn up. Note the schoolhouse at center right background, doubtless also well supplied with Daigles.

VAN BUREN

Potato Digging Mechanical potato diggers were a great laborsaving invention for humans but not for horses, which required frequent rest breaks from the steady, heavy draft. The upper St. John valley was settled in the late 1700s by Acadian French, who had been expelled first by the British in Nova Scotia and later from New Brunswick by Tories. Note the Catholic church in the background.

Alongside the river lay narrow margins of good intervale soil, which resulted in the cutting up of river frontage into narrow farms extending a mile or so into the forested backcountry. Establishing the railroad right-of-way along the river ensured employment for many lawyers.

Caribou Potato Harvest This photo of digging potatoes with a tractor-drawn two-row digger likely dates from around 1940. While the long hours of sunlight early in the season promoted rapid growth, the early arrival of cold weather made prompt harvesting essential, and thus the vines were killed prematurely with a chemical spray.

The short growing season also hindered the seeding of cover crops, leaving the soil unprotected from erosion. The replacement of horses by tractors also reduced cover cropping, as did high potato prices during wartime.

In 1939, Maine—which is to say, primarily Aroostook—despite a poor crop, led all states in total yield, yield per acre, and production of certified seed. In Aroostook 5,003 farms grew nearly 29 million bushels of potatoes. Fort Fairfield, Caribou, and Presque Isle were the leading towns. Most of the crop was sold as table stock, with prices determined by production in other states. As a result, every year was a gamble, as farmers borrowed heavily in hopes of a boom to pay off the debts left by the busts.

Maine's potato production peaked in the late 1940s; today the acreage in potatoes is comparable to that of the 1880s. The yield per acre, however, is the highest ever, indicating that today's farmers are very good at what they do.

The picking crew will pick into ash baskets made locally by Maine Indians who traveled to meet the demand. The baskets will be dumped into the cedar barrels, which are made by Aroostook cooperages.

BAR Fort Fairfield At the Bangor & Aroostook Railroad station in Fort Fairfield, we see potato houses at right; at left we glimpse spuds in a boxcar. Locomotive #10 was one of fifty-nine 4-6-0 "ten-wheelers" on the railroad's roster, the most of any class and for many years the road's standard workhorse.

Although rough-riding, ten-wheelers were considered easy to fire and repair. All but three of the BAR's (changed from B & A in 1920) were built by the Manchester Locomotive Works of Manchester, New Hampshire. Number 10, built by Manchester in 1894, was scrapped in 1927. All told, some 17,000 4-6-0s were built for American railroads.

Potatoes, fertilizer, lumber, paper, coal, lime, pulpwood, and chemicals for the paper mills, as well as passengers, kept the BAR busy. In 1927 the railroad shipped 32,242 cars of potatoes. Cars were insulated, and in the winter each was fitted with a small stove tended by a "potato bug," and smoke streamed from the long train. In later years, the huge fleet of BAR reefer cars went west in the off-season to carry California produce east.

But the good times did not last. The end of the BAR's potato business, already declining from competition by trucking, came in the winter of 1969–70, when, due to delays in the Penn Central car interchange system, much of the crop froze in transit.

Note in the enlarged detail the fireman oiling rod journals.

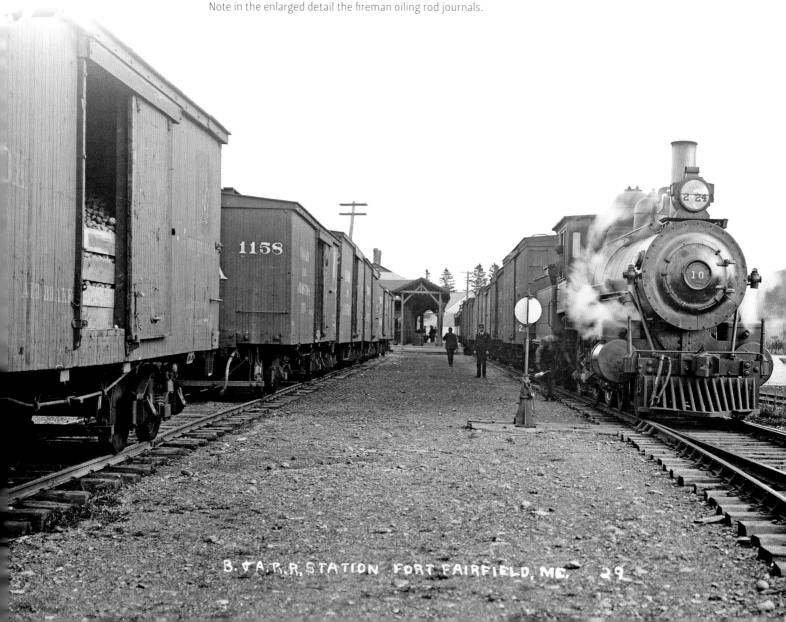

B. & A. R. R. STATION FORT FAIRFIELD, ME. 29

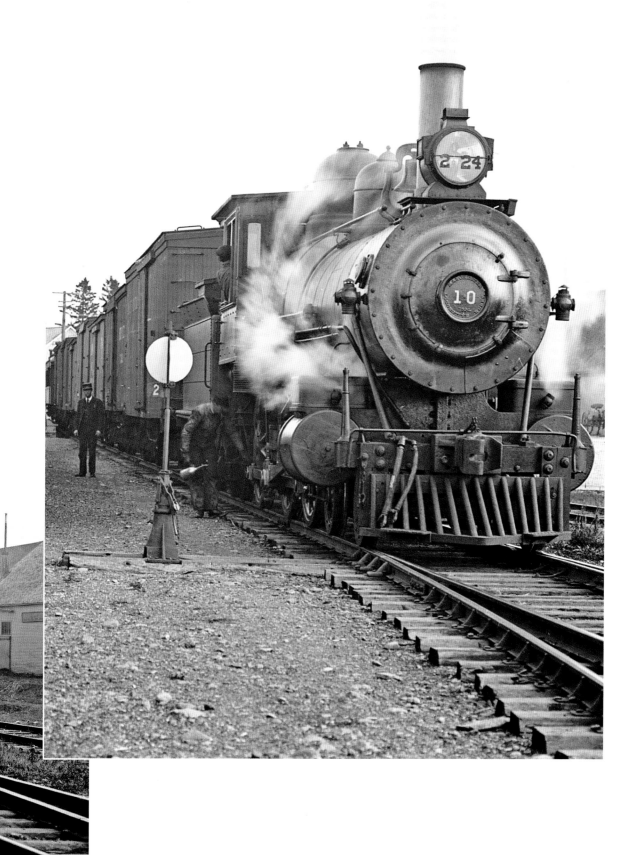

Fort Fairfield Hotel Fort Fairfield's Exchange Hotel in mud season. There were different kinds of hotels, including railroad (in the past, stagecoach) hotels, summer hotels, woodsmen hotels, residential hotels, sportsmen's hotels, and so forth. The Exchange Hotel, with a livery stable on one side and a restaurant on the other, was surely primarily a drummer's hotel, serving the plague of hungry drummers—salesmen—who descended on Aroostook in prosperous potato years like flies to a molasses barrel.

The lack of traffic indicates this is Sunday, the drummers' day off. If the Exchange "put out a good table," and if Maine's prohibition law was observed more in the breach than in fact, the lobby would be filled with stale jokes, tall tales, and the overpowering aromas of cheap cigar smoke and Bay Rum. Here, we may surmise, the jolly "knights of the grip," along with gullible local hangers-on, have lent their presence to save what otherwise would have been a most dreary and uninviting postcard. Proprietor R. J. McKee is prominent in his boiled white shirt.

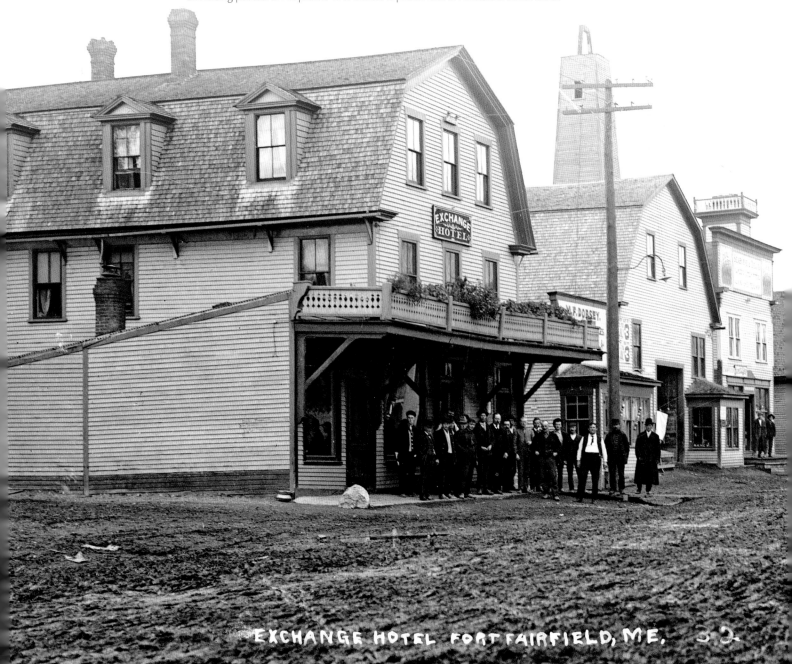

EXCHANGE HOTEL FORT FAIRFIELD, ME.

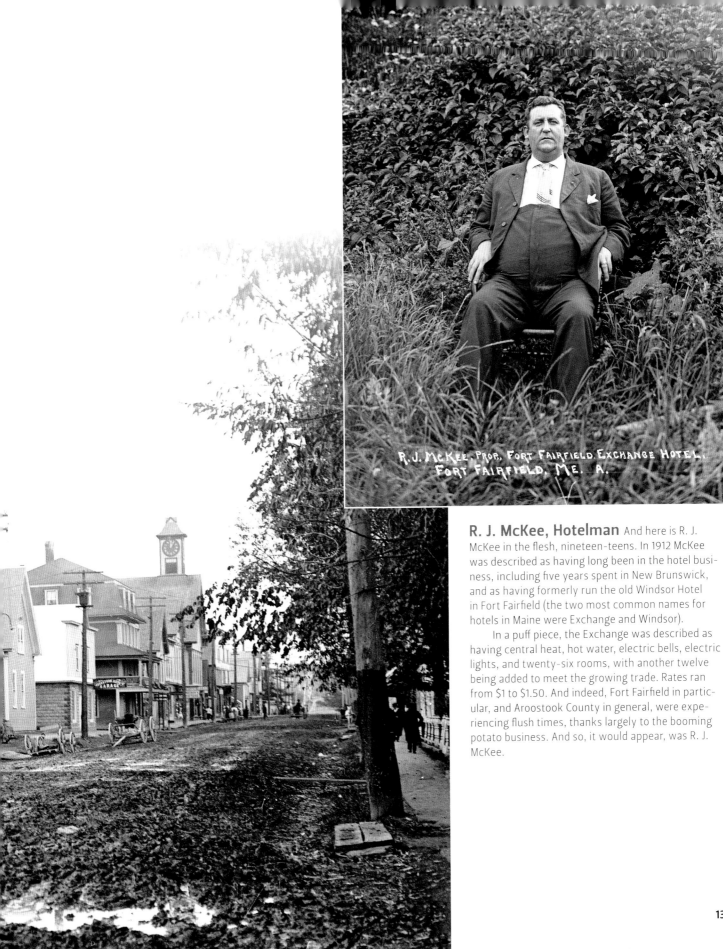

R. J. McKee, PROP., FORT FAIRFIELD EXCHANGE HOTEL, FORT FAIRFIELD, ME. A.

R. J. McKee, Hotelman

And here is R. J. McKee in the flesh, nineteen-teens. In 1912 McKee was described as having long been in the hotel business, including five years spent in New Brunswick, and as having formerly run the old Windsor Hotel in Fort Fairfield (the two most common names for hotels in Maine were Exchange and Windsor).

In a puff piece, the Exchange was described as having central heat, hot water, electric bells, electric lights, and twenty-six rooms, with another twelve being added to meet the growing trade. Rates ran from $1 to $1.50. And indeed, Fort Fairfield in particular, and Aroostook County in general, were experiencing flush times, thanks largely to the booming potato business. And so, it would appear, was R. J. McKee.

CHEMICAL #1, FORT FAIRFIELD, ME. 103.

Fire Engine The Chemical No. 1 fire engine poses outside the three-bay Fort Fairfield municipal building, which was built in 1916. The fire engine's builder, the Webb Motor Fire Apparatus Company, began in Vincennes, Illinois, in 1907 and by 1913 had relocated, via St. Louis, to Allentown, Pennsylvania, where it soon went into receivership. Webb built a full line of pumpers, chemical engines, combination fire and hose trucks, hook and ladder trucks, and wonderfully sporty "chief runabouts."

A chemical engine was essentially a big self-propelled soda-acid fire extinguisher used for quick response to minor fires, hopefully nipping conflagrations in the bud.

In the nineteenth century, disastrous visitations by the "fire fiend" were experienced—often more than once—by seemingly every built-up municipality in Maine. Although in some instances fire was an arguably beneficial agent of urban renewal, its victims—most horribly, the screaming trapped horses in livery stables—paid dearly. The arrival of automotive fire apparatus in the early 1900s finally gave volunteer firemen in small communities a fighting chance.

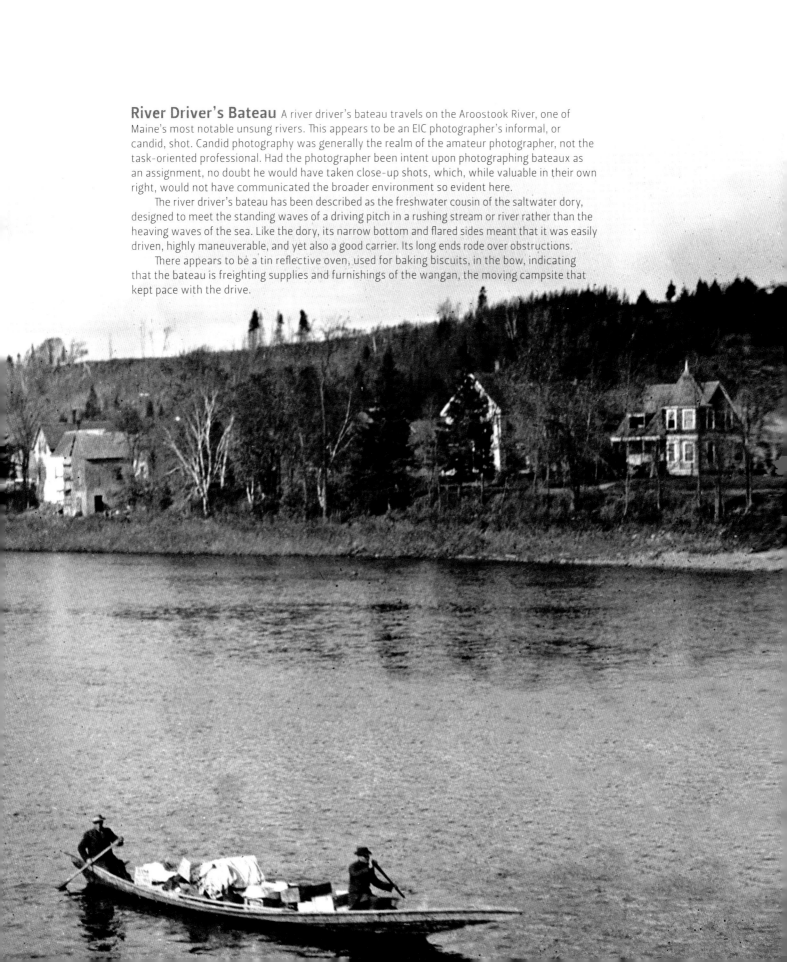

River Driver's Bateau A river driver's bateau travels on the Aroostook River, one of Maine's most notable unsung rivers. This appears to be an EIC photographer's informal, or candid, shot. Candid photography was generally the realm of the amateur photographer, not the task-oriented professional. Had the photographer been intent upon photographing bateaux as an assignment, no doubt he would have taken close-up shots, which, while valuable in their own right, would not have communicated the broader environment so evident here.

The river driver's bateau has been described as the freshwater cousin of the saltwater dory, designed to meet the standing waves of a driving pitch in a rushing stream or river rather than the heaving waves of the sea. Like the dory, its narrow bottom and flared sides meant that it was easily driven, highly maneuverable, and yet also a good carrier. Its long ends rode over obstructions.

There appears to be a tin reflective oven, used for baking biscuits, in the bow, indicating that the bateau is freighting supplies and furnishings of the wangan, the moving campsite that kept pace with the drive.

EASTON

Easton Potato Field A vast field of potatoes in bloom, a common sight in eastern Aroostook County, where visitors often felt transported from Maine to the Midwest. The bi-layered Caribou-Conant soils lying in a narrow band in the Aroostook River valley were among the best agricultural soils in the nation. Once heavily forested by hardwoods, nearly every acre was put into cultivation. With the coming of the Bangor & Aroostook Railroad in 1893, crops of potatoes, rotated with crops of hay and grains, boomed. In years of failed potato harvests elsewhere, and with good crops in the valley, serious money was made.

The short growing season and the highly erodible soil required careful management. The demands of two world wars, mechanization, chemical fertilizers, monoculture, and other poor practices all led to severe soil loss. While potato farming continued in the deep-soiled valley, many outlying farms vanished along with their thin layer of soil when plow points hit bedrock.

In 1910 the average value of an acre of Aroostook farmland—which included poorer as well as prime soils—was $29.15, while the average for the state (including, of course, Aroostook) was $13.73. The lowest valued farmland was Washington County's at $7.07 per acre.

A POTATO FIELD IN BLOOM EASTON ME. 18.

MARS HILL

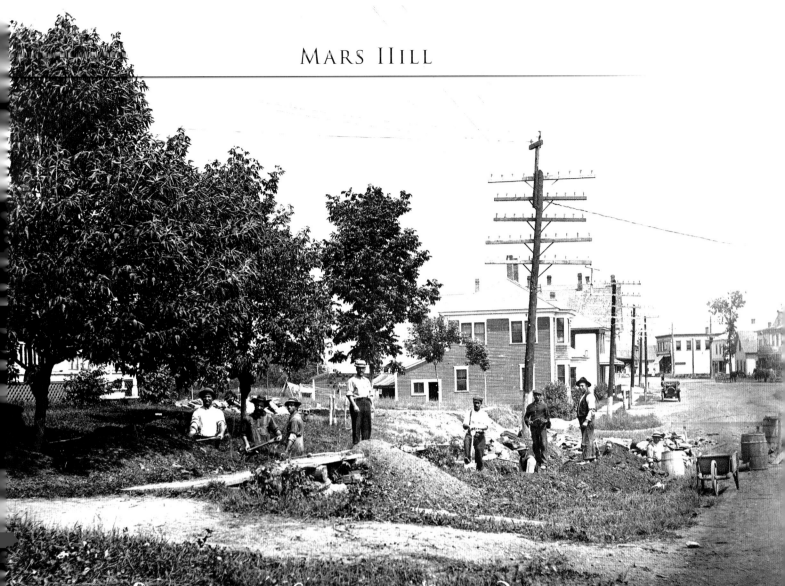

Sewer at Mars Hill, Constructed by Caggiano Bros.

Italians Italian "peek and shuvle" (pick and shovel) men dig a trench for a sewer line. From the late 1800s to 1920 some four million Italians arrived in the United States. Most were *contadini*, or peasants, from the impoverished south, where many had been virtual serfs, and sent money home to their families. Many returned to Italy during the winter.

Working under a *padrone*, an Italian contractor, the laborers had little opportunity to learn English or to mix with the natives. Arriving as a group in a small town, they were objects of much curiosity. Rumor had it that all Italians carried stiletto knives and had fiery tempers, but they proved peaceable enough, although prone to excitement if their pay was delayed. If one was injured or killed in an accident, the press referred to him simply as "an Italian."

The Italians typically "boarded themselves," erecting primitive shelters in make-shift camps, just as Irish laborers had once done. They built ovens for baking their bread and paid local boys for birds, woodchucks, and other wildlife to eat. After the construction of the Wiscasset, Waterville, and Farmington Railroad, in Lincoln and Kennebec counties, it was said that not a bullfrog was left in the valley of the Sheepscot.

Houlton Queen Anne The ample 1902 Queen Anne/Colonial Revival home of the "potato king," Edward L. Cleveland, is a dominant feature of Court Street in Houlton. Perhaps the kitschy, faux-well lawn ornament, complete with sweep and bucket, reminded Cleveland and neighboring residents of oversized Houlton houses of the frontier living conditions back in the not-so-distant day.

A native of coastal Camden, Cleveland relocated to Houlton in 1878 and became a potato shipper. By 1908 he had warehouse capacity, located in various county and also New Brunswick towns, for 500,000 bushels. He also did business in North Dakota.

Cleveland was a major shipper of seed potatoes, an important component of the Aroostook potato industry. Vigorous northern-grown potatoes gave heavier yields than did those of southern states, and thousands of carloads of Aroostook seed potatoes headed south annually to Virginia, Florida, Texas, and elsewhere.

In 1910, after a visit to Aroostook, a big potato grower from Colorado wrote: "The potato dominates every sentiment and idea. . . . Houlton . . . is the only place where I have been talked to a standstill on the subject of potatoes."

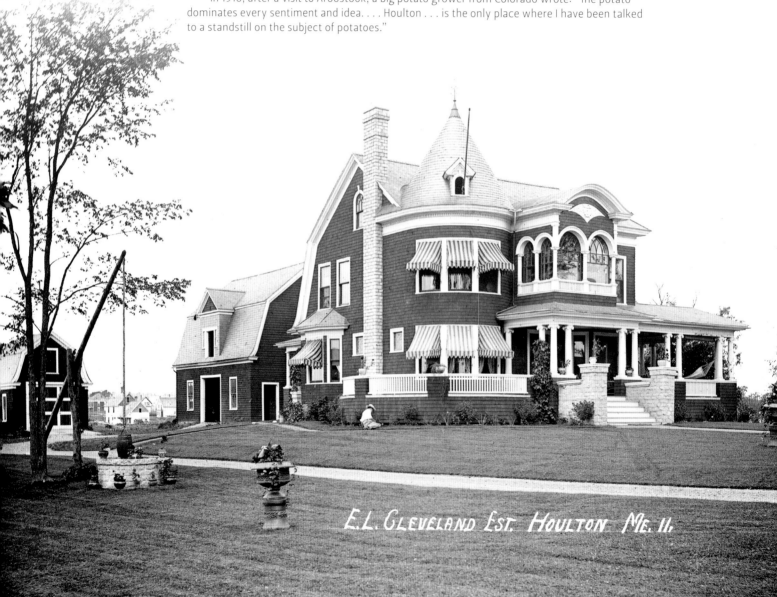

E.L. Cleveland Est. Houlton Me. 11.

WYTOPITLOCK VILLAGE, REED TOWNSHIP

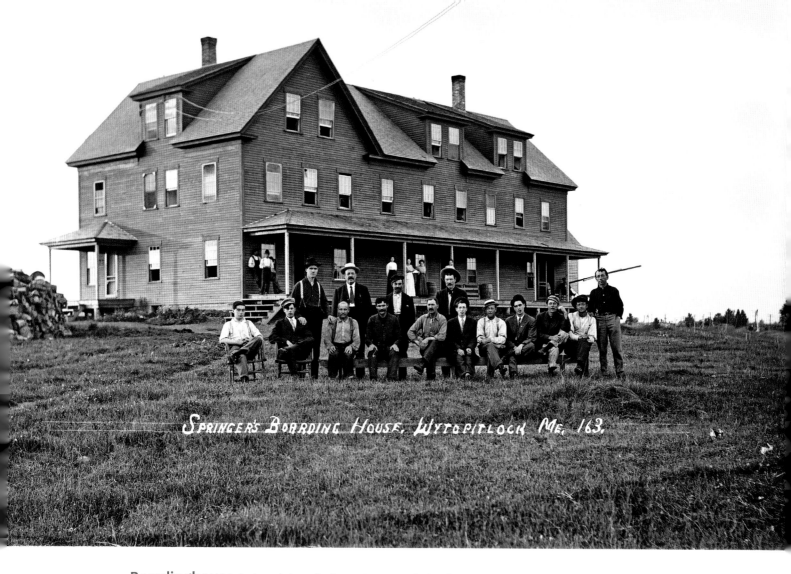

Springer's Boarding House, Wytopitlock Me. 163.

Boardinghouse Springer's boardinghouse in Wytopitlock Village was no doubt ancillary to the Springer's sawmill. A tiny portion of the many cords of hardwood required in the attempt to heat this drafty ark may be what we glimpse at left. Three women, likely the cook and two housekeepers, stand on the porch.

Before the coming of affordable, reliable automobiles and plowed winter roads, boardinghouses were a basic fact of rural economic and social life. Bedroom communities, which today surely include the majority of Maine towns, only existed adjacent to the larger cities and ideally on trolley lines.

The men working in lumbering occupations were mostly young, single, itinerant immigrants, along with lonely married men. This situation created a natural market not overlooked by practitioners of the world's oldest profession and by local bootleggers. Which is not to imply, of course, that any such untoward behavior ever occurred in Wytoplitlock.

Wytopitlock At center, Wytopitlock's postmistress Miss Florence McKay stands at her office door. The combined barbershop and pool hall, at right, was manned by barbers C. W. Springer and Otis Collier. Springer, evidently a man of enterprise and ability, was also the proprietor of the village garage.

Located in the southeastern corner of "The County" on the Mattawamkeag River and the old European & North American Railway branch of the Maine Central, Wytopitlock was at the height of its prosperity and population when this photo was taken.

The 1920 census enumerated 639 souls in Reed Township, about double that of recent census counts. In the early 1920s the lumber markets were strong, and the Springer sawmill was busily turning out long and short lumber to be shipped out by rail. Crews from R. B. Pride's last-block operations were busy felling maple trees and roughing out shoe-last blocks by the tens of thousands. But what goes up must come down, as it surely did.

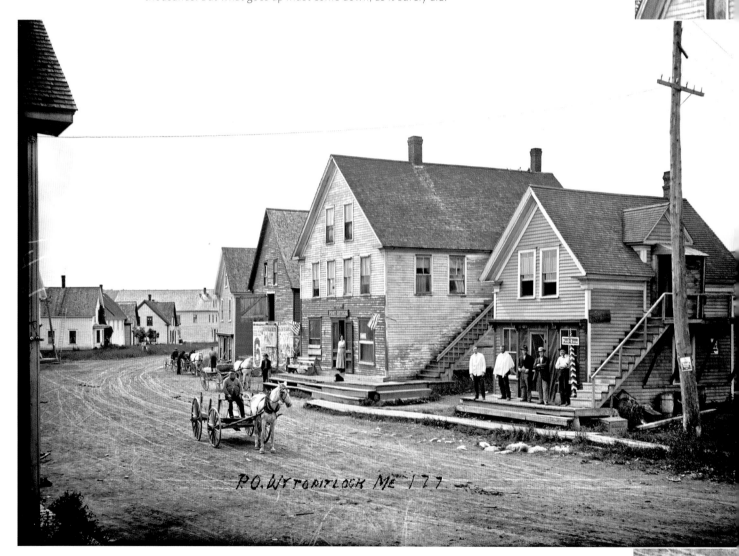

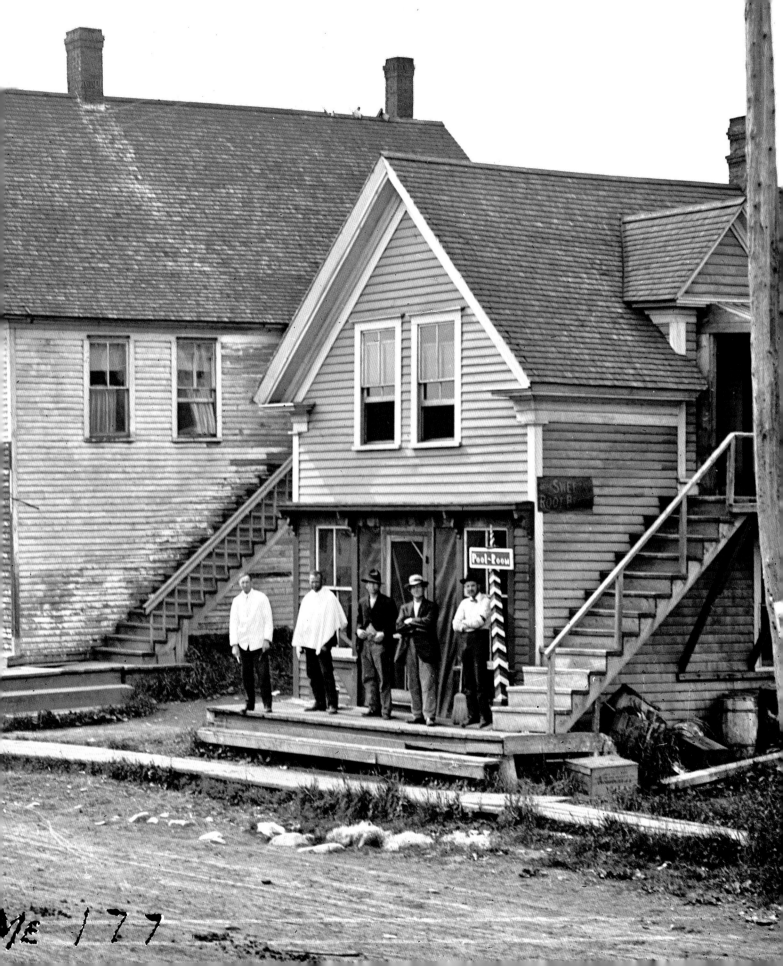

SWEF
ROOT B

Pool-Room

ME 177

DANFORTH

Danforth Soldier Danforth was on the Maine Central Railroad's old Eastern & North American line (shared with the Canadian Pacific from Mattawamkeag), which ran to the international border at Vanceboro. The photo is likely of a young man from a small town about to be shipped off during World War I. Out of about 1,200 inhabitants of Danforth, seventy-three men were in "federal government service" during the war, four of whom died.

Shortly after war was declared, Company I of the 103rd Maine Infantry, whose members were largely recruited from the Eastport area, were stationed at Danforth to guard railroad bridges. When their train pulled in, a parade was held that included the Danforth Band, Civil War veterans, the Boy Scouts, the Sons of Veterans, the Woman's Christian Temperance League, the Rebekahs, school children, future governor Col. F. H. Parkhurst, and, finally, the marching soldiers themselves. After about two months, Company I was moved to Camp Keyes, Augusta, and then left for France.

The day after the Armistice was signed, an even larger parade was held, which included an army tank sent by the government in recognition of Danforth's outstanding patriotism.

The structure on which the young soldier has placed his hat and coat appears to be the housing for a shallow well. The barn-like garage in the left background may have once been a livery stable. A portion of the railroad station is glimpsed at right.

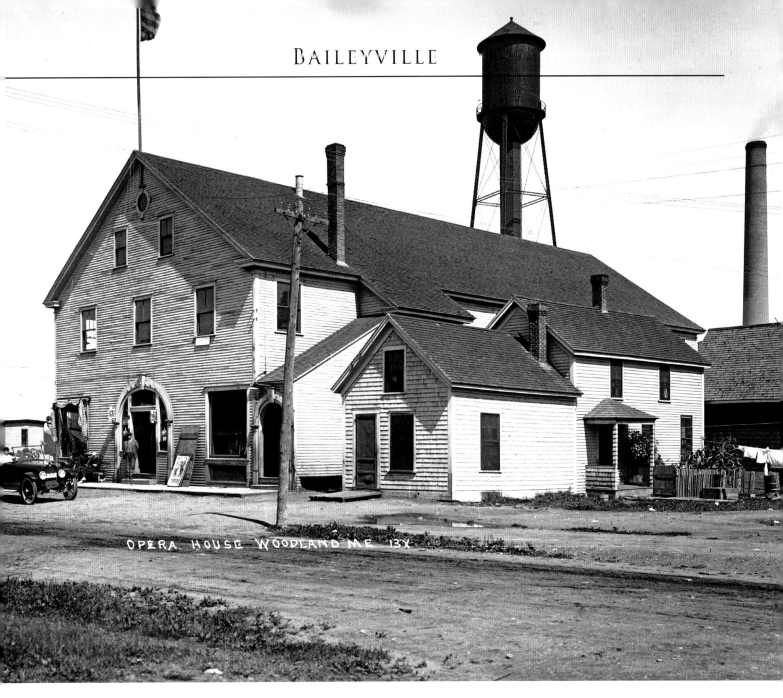

OPERA HOUSE WOODLAND ME 13X

Opera House Every ethnic group that has come to Maine has brought with it cultural values reflected in physical structures. The Italian laborers who arrived in the late 1800s and early 1900s wanted good bread and built makeshift clay ovens in their temporary camps. They also liked opera, and that is why, in 1907, Charles Murray built an opera house for his fellow Italians who, in large part, built the St. Croix pulp and paper mill in Baileyville and its supporting village of Woodland in the wilderness of farthest eastern Maine. The opera house was strategically located just outside the mill gate. Note the flagpole with flag and the decorative, welcoming doorway archway, contrasting with the building's no-nonsense industrial simplicity.

For over fifty years the "Opera House" served as Woodland's social and entertainment center, staging vaudeville, plays, boxing matches, motion pictures, bowling, graduations, and presumably also some actual opera. Mike Foggia, who began as manager, soon became owner and opened a first-floor store featuring fresh Italian bread. The "Opera House" closed in the late 1950s and was razed. The site became a parking lot.

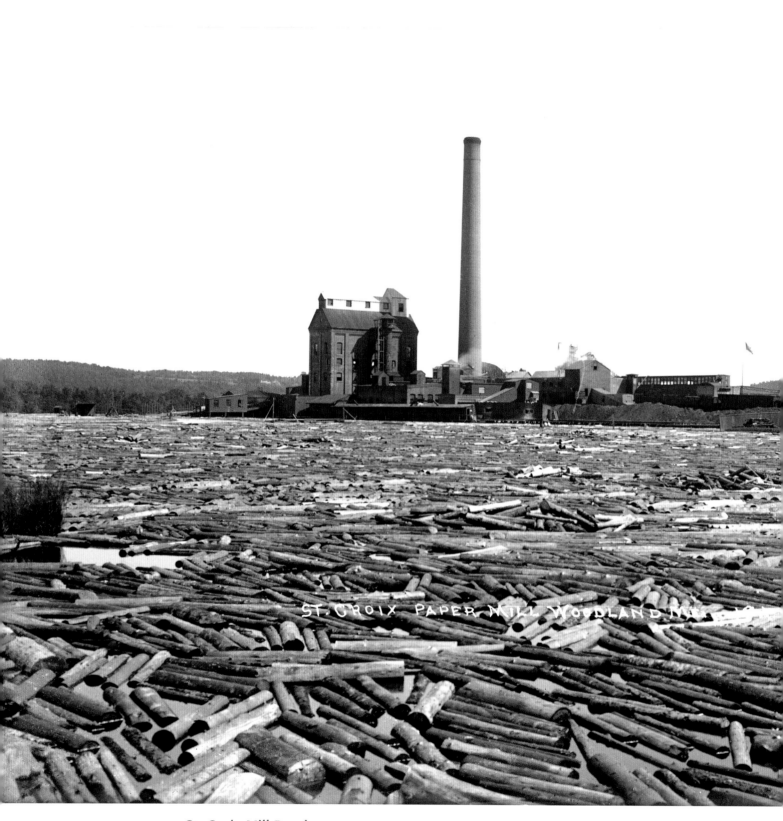

St. Croix Mill Pond

St. Croix Woodpile

The post–Civil War shift from long logs and sawmills to pulpwood and paper mills marked a new paradigm. Just as the 1850s textile city of Lewiston was a planned community located at a waterpower site, so were the paper-mill settlements of Rumford in the early 1890s; Millinocket, circa 1900; and Woodland in Baileyville, developed by the Boston-based St. Croix Paper Company.

What quickly became Woodland began in March 1905, when construction of a nearly 2,000-foot dam across the St. Croix River at Sprague's Falls and housing for workers got under way. By September 1906, when the first paper was made, over a hundred residences (some of "elaborate architecture") had been completed, with more on the way. There were also stores, two churches, and a school. A town hall was under construction. It was no coincidence that the creation of these large mills and mill towns coincided with the availability of cheap and willing Italian workers.

The watershed of the St. Croix covers nearly 1,200 square miles, encompassing 183 streams and 61 lakes. The mill's woodshed was proportionately extensive. Every stick of pulpwood was cut—and often peeled—by hand, in large part by immigrants from a variety of countries.

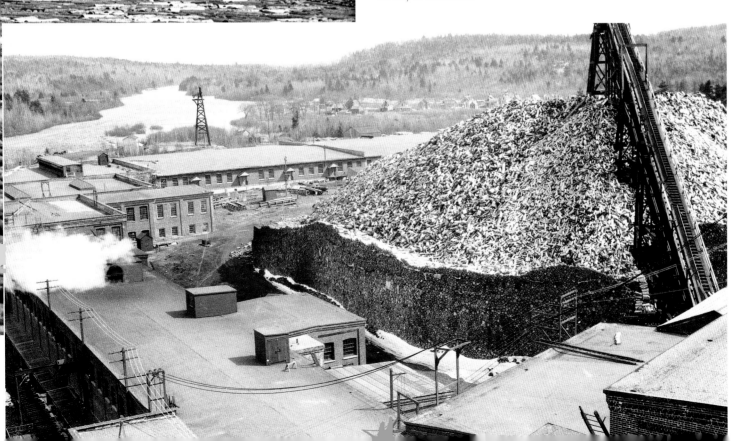

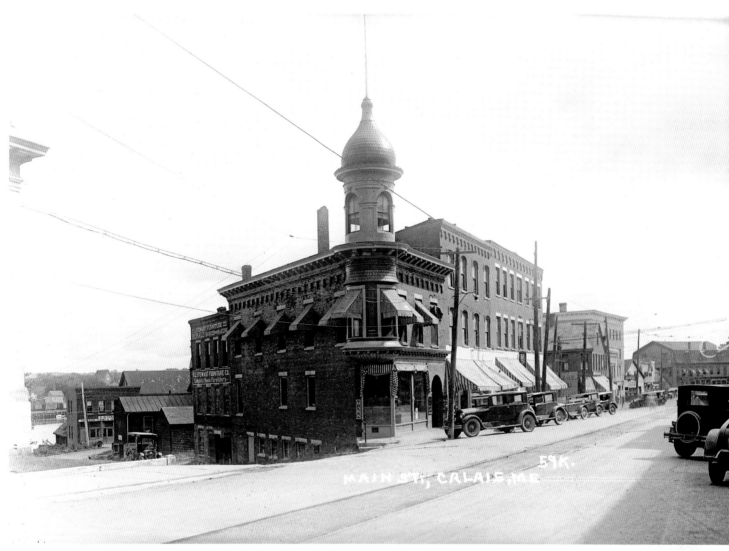

Calais Minaret The automobiles outside the minareted Calais Federal Bank building look to be from the 1920s. Before 1909 the building was the home of Joseph Kalish's "One Price Clothing" store. A native of Prussia, Kalish arrived in Calais in 1854. An 1892 profile stated that all of the clothing in the store was manufactured in-house. Son Bruno, who took over the business, is said to have added the playful minaret to remind his father of his youthful environs, giving credence to the story that Joseph grew up in Armenia. Bruno was elected mayor of Calais in 1902.

Joseph died in 1897, leaving a widow, eight children, and debt-free property in New York and Calais valued at $75,000 and $20,000 respectively. Son Max sued other family members over the terms of the will in a complicated case that in 1899 reached the New York Supreme Court. As an old Yankeeism would have it, while the family fought over how to cut the pie, the lawyers ate it.

The Kalishes were apparently Jewish, and if so were among many German and Eastern European Jews who established clothing stores in Maine towns. Many of the founders began as peddlers. Many of these stores survived into the late 1900s, and a few yet thrive.

That Joseph Kalish could also be active in New York reflected the year-round steamer service from Eastport to Boston, which gave the St. Croix region excellent access to the outside world. It is said that the sons of the Calais elite went to Harvard, not Bowdoin.

Calais Bunting The celebratory bunting festooning the Eaton Block on the occasion of Calais's centennial in 1909 cannot mask the dour visage of this grouch of Main Street, nor can the girls in white dresses out front. Adding a minaret would be like placing a party hat on Scrooge. But one should not judge a building by its exterior alone.

Originally this was the headquarters of H. F. Eaton & Sons, leading lumber manufacturers, and it stood at the head of Eaton's wharf, where lumber sawn at the Eatons' mills located upriver at Milltown was loaded into vessels, some of which the Eatons owned. The office proper was furnished with three dark roll-top desks and enlivened—if that is the right term—by mounted heads removed from two large moose and one very large elk. The elk's lofty rack was entwined with a vine emanating from a pot on Henry's desk.

About 1909, with the demise of the region's long-lumber era, the building became the St. Croix Club, the resort of Calais's elite. Billiard tables replaced the roll tops, and invasive florid wallpaper ran riot. In later years it became a bowling club, as it remains today.

The Union Jack is a friendly gesture to St. Stephen, New Brunswick, Calais's sister city across the narrow St. Croix River. Fixing the river as the border in 1842 may have been a convenient compromise for negotiators Daniel Webster and Lord Ashburton, but it would complicate the lives of local folk forever after.

Pool Room The town of Pembroke claims two notable doctors, one who did much good for humanity and another who did very well for himself. The former was Dr. Charles Best, the co-discoverer of insulin, and the latter was Dr. Thomas Pomeroy (or Pomroy), a mason who removed to New York, where he called himself a "clairvoyant physician." Falling into a trance-like state while holding a lock of hair or other artifact of the patient, he would ascertain the patient's illness and prescribe herbal treatments. His wife or niece would record his utterances, which he would interpret after returning from the other side.

Pomeroy was doing a large business with a devoted following until 1887, when he was charged with practicing medicine without a license. He then attended the Eclectic Medical College, graduating in 1888, and soon was licensed to practice "eclectic medicine," which combined herbal medicine and physical therapy,

Having become very wealthy, in 1898 Pomeroy built a great, rambling Queen Anne–style cottage overlooking the Pennamaquon River. Called the "Pomeroy Manor" by locals, it burned down in 1946, leaving behind, among many outbuildings, the good doctor's "pool room," or billiard hall—shown here—which was built in the same style as the mother cottage. Moved to another location, it is now a private residence.

THE DOCTOR'S POOL ROOM, PEMBROKE, ME. 25

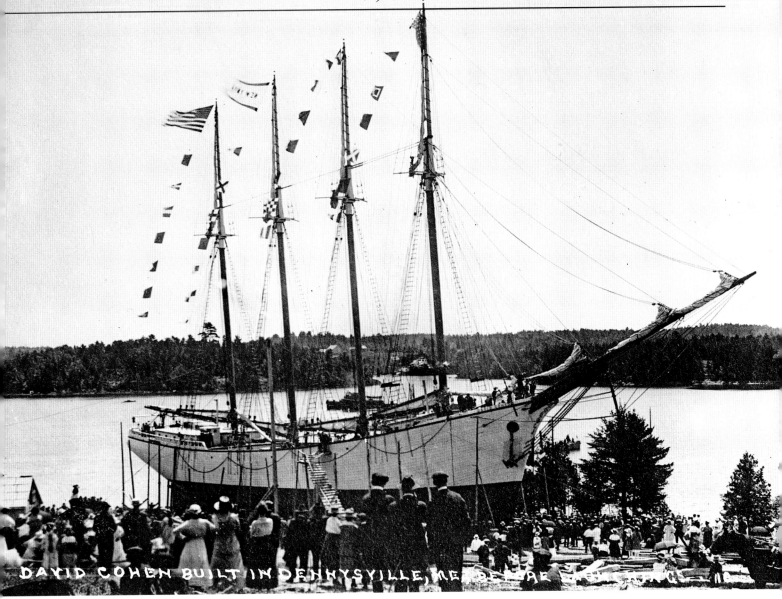

DAVID COHEN BUILT IN DENNYSVILLE, ME

Schooner *David Cohen* This is launching day for the four-masted schooner *David Cohen* at the Pushee Brothers yard. Among the 330 or so Maine-built four-masted schooners, the *Cohen* was a rarity in that she was fitted with two oil engines. She was also among the very last, sky-high wartime shipping rates having briefly inspired a revival of wooden shipbuilding. In 1919 the Pushees launched another four-master, the *Esther K.*

The cheerful crowd has arrived by train, team, and hundreds of autos. The Pushees had never built so large a vessel and proudly have her fully rigged, with sails bent and bunting snapping in the celebratory breeze. After Miss Wilhemina Pushee christened the schooner with roses and lilies, the *Cohen* made a satisfactory plunge into the bay, leaving emptiness where she long had dominated the scene.

Before her completion, the *Cohen*'s building contract had passed from her namesake, a New York shipbroker, to another New York firm. Due to the glut of tonnage after the war, in 1921 the *Cohen*, which cost $140,000 to build, brought but $10,200 (without engines) at a marshal's sale. David Cohen may have been a party to her purchase.

North Lubec Queen Annes These near twin-sister Queen Anne residences are owned by Edward P. and his brother Elias Lawrence. Edward built his house, at left, in 1885; Elias, in 1900. Their father, Moses P. Lawrence, established the Lubec Packing Company with two partners in 1881. Moses, along with sons Edward, Elias, and Frank and other family members, eventually owned factories in Rockland, Stockton Springs, Stonington, and elsewhere. Both Elias and Edward served as company president. Edward was an inventor and innovator, some of whose ideas were widely adopted by the industry.

The children of factory owners sometimes worked right alongside local children or children from the camps, usually as cutters. Sumner Pike, the son of another Lubec factory owner, was once elected spokesman by his fellow juvenile cutters to carry their demands for a higher piecework rate to his father. When, at the next Sunday dinner, his father announced that he had no stomach for feeding a labor agitator, Sumner caved, his pangs of hunger winning out over his feelings of guilt for having let down his fellow laborers. Sumner graduated from Bowdoin, became wealthy in the oil business, and served on the Securities and Exchange Commission and the Atomic Energy Commission.

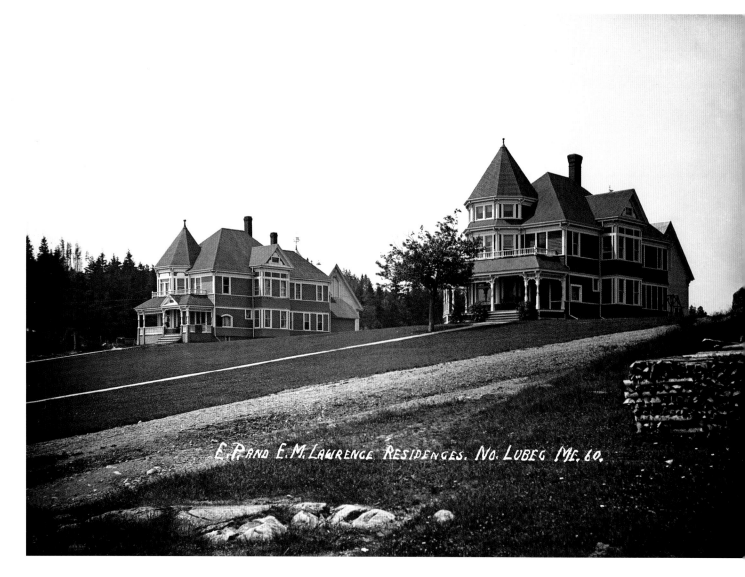

E. P. and E. M. Lawrence Residences. No. Lubec Me. 60.

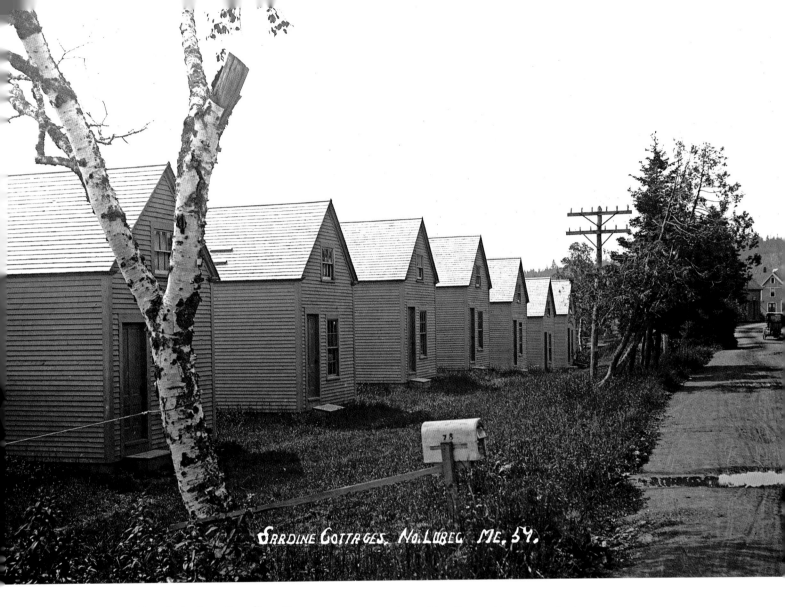

Sardine Cottages, No. Lubec, ME. 54.

North Lubec Sardine Camps These camps housed families working seasonally at a North Lubec sardine factory. The sardine-packing season ran from April into December, the busiest months commencing in August. Work was intermittent, depending on the supply of fish at the factories. A state labor agent wrote in 1907:

> Children are employed more numerously in Lubec, including North Lubec, than in Eastport. Coming around the corner of a factory one day, I saw a little girl at a tub, washing her hands. . . .
> "The fish scales stick awfully," she said.
> "And what does a little girl like you do?" I asked.
> "Oh, I've been cutting. I cut two boxes today," displaying two checks for five cents each . . . she said she worked with her mother when she wanted to; was six years old; and her people came from one of the nearby towns and lived in a camp for the season. These camps are owned by the proprietors of the factories and rented at a small amount. . . . They are small buildings, close together on either side of a lane and with very primitive sanitary arrangements. The people live very simply. The families come in large numbers and their homes are closed.

Workers came from New Brunswick as well as from nearby towns. A number of Syrians from New York were also employed.

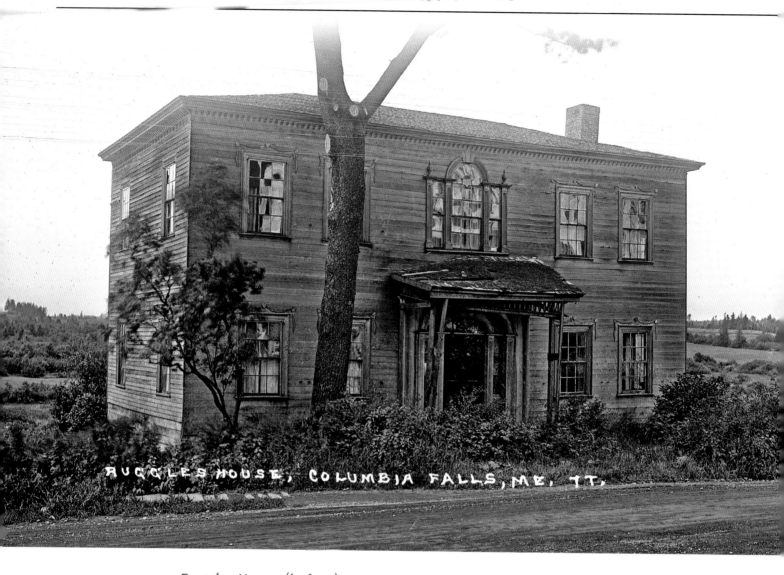

RUGGLES HOUSE, COLUMBIA FALLS, ME. 77.

Ruggles House (before) In the late 1700s Thomas Ruggles relocated to eastern Maine from Massachusetts to claim a land grant. In 1818, having amassed vast timberlands and a large fortune, he hired Aaron Sherman, a Massachusetts housewright, to design and build a proper Federal-style house complete with a flying staircase, mahogany paneling, and fine carvings. Sherman brought with him woodcarver Alvah Peterson. Ruggles moved into his grand house in 1820 but died that December. His gravestone epitaph reads in part: "In human hearts what bolder thoughts can rise / Than man's presumption on tomorrow's dawn."

Alvah Peterson, who became a local resident, may have completed the carvings in later years using a penknife. The Ruggles House remained in the family for a hundred years while the fortune vanished, the family line "daughtered out," and the house fell into disrepair. It was never modernized, and the last occupant, Lizzie Ruggles, made do with just a fireplace for heat. When Lizzie died in 1920, even the kitchen floor was unsafe to walk on, yet many of the original furnishings remained intact.

Mary Ruggles Chandler, a cousin, was the house's savior. Enlisting the aid of wealthy Bar Harbor summer residents and Boston's Society for the Preservation of New England Antiquities, she oversaw the initial restoration, which was completed in 1950. Work has continued since under the ownership of the Ruggles House Society.

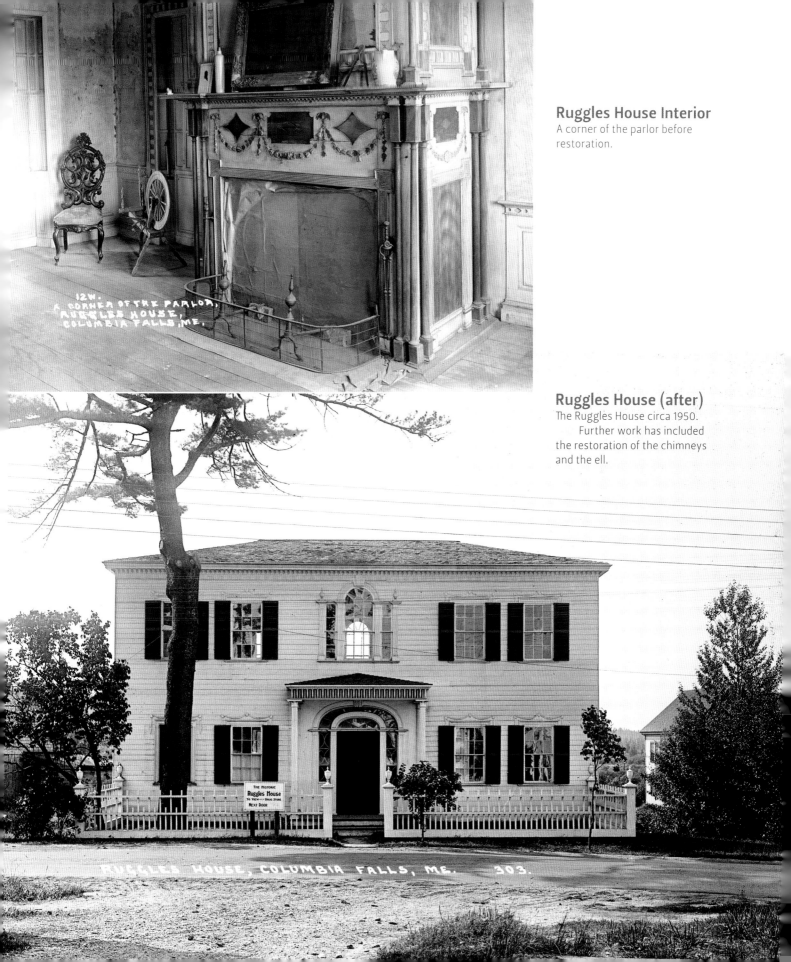

Ruggles House Interior
A corner of the parlor before restoration.

Ruggles House (after)
The Ruggles House circa 1950. Further work has included the restoration of the chimneys and the ell.

UNDERWOOD'S SARDINE PLANT, JONESPORT, MAINE M52C

Sardine Factory The William Underwood Company sardine factory, said to be the world's largest, on Moosabec Reach, is shown here circa early 1950s. Built in 1900, it was always considered to be an industry leader. Not in view is the large, attached "Tenement House" for workers; a ferry brought workers from neighboring Beals Island.

At left we see the bow of the 1941 sardine carrier *William Underwood*, and to the right of it the stern of the 1949 carrier *Henry O. Underwood*. Splice them together with your eye and you have a classic sardine carrier, which were among the handsomest and easiest-driven of all power vessels. Carrier skippers were master pilots, and even though the boats worked among ledges and shoals on dark and foggy nights to reach "shut off" coves where a school of small herring had been trapped, they were said to be insured at the lowest of rates.

The smaller boats are Jonesport-model lobster boats, also timeless classics. They have been receiving fish cuttings with which to bait their traps.

Wartime over-expansion, foreign competition, the growth of snack foods, declining numbers of fish inshore, and changing public tastes put Maine's sardine industry into a fatal decline after the early 1950s. In 1962 the Jonesport factory closed. Happily, the *William Underwood* is today undergoing restoration for a new life as cruising yacht.

GOULDSBORO

Summer Church Seasonal "summer churches" were common features of resort colonies, and the West Gouldsboro Union Church was clearly such a church, although the precise details behind its creation have evidently been lost.

The church's construction, from 1888 to 1890, coincided with the founding of the exclusive summer colony on Grindstone Neck in nearby Winter Harbor. That the ministers for the Union Church were supplied by the Maine Seacoast Mission, a Bar Harbor charity supported by wealthy seasonal residents, is significant. The colony would soon build its own summer Episcopal church, followed by a "mission" Catholic church for colony servants.

The church's architect is unknown, but clearly he was eager to employ as many Queen Anne–style features as so small a structure could support. The interior rendering has been described as ship-like. Indeed, the weathervane was a gift from the venerable Boston shipbroker John S. Emery, a native of nearby Sullivan.

The building of the 1907 English Tudor–style library is said to have been suggested by a minister at the Union Church. The architect, Fred Savage, designed a number of Bar Harbor's palatial cottages. Both buildings are on the National Register of Historic Places.

LIBRARY AND CHURCH, W. GOULDSBORO ME, 143.

COREA

Corea Harbor This view of Corea Harbor shows houses on the Crowley Island Road. The two houses on the left belonged to Daniel Young and Ephraim Crowley, respectively. Both Young and Crowley were descendants of settlers. In 1843 Captain Nathaniel Crowley married Isabella Young of what was then Indian Harbor. They had fourteen children whose descendants comprised a significant portion of the local population. These two houses have survived, but the other buildings have all since burned.

Half of a sugar hogshead is at lower right. Molasses and sugar from the West Indies arrived in large hogsheads which, when halved, found many uses in fishing villages. The boats are double-ended peapods. While another image shows half a dozen Friendship sloops and a couple of powerboats at moorings, the village of Prospect Harbor, with a sardine factory, was the center of maritime activity in Gouldsboro.

VIEW AT COREA ME. 7.

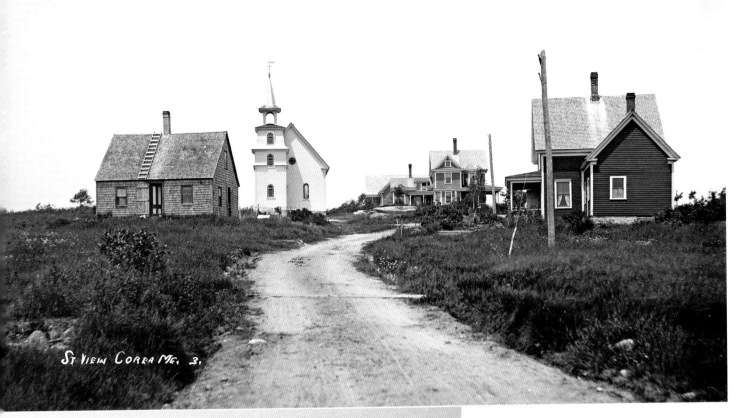

St View Corea Me. 3.

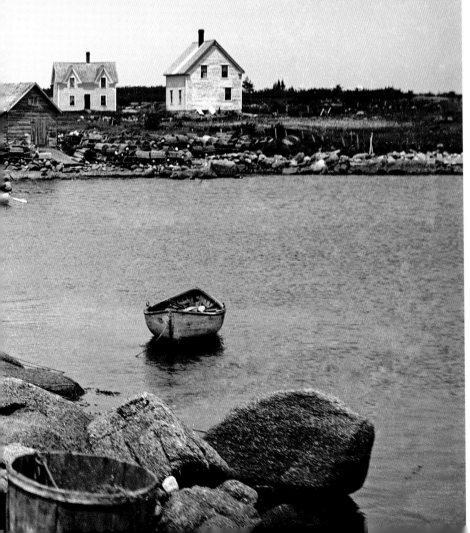

Corea Village Formerly known as Indian Harbor, Corea was one of four villages then in the town of Gouldsboro. It was named Corea—which is how Korea was commonly then spelled—when a post office was established there in 1896. (In 1896 Corea—that is, Korea—was much in the news.) We are looking from the village center north up Corea Road. The very old building at left, which is still standing, was used at times as a store and a pool hall. The Baptist church was built in 1890. Storekeeper Lewis Young owned the large house beyond the church; it burned in 1925. In 1926 the schoolhouse glimpsed beyond Lewis's house burned. The house on the right, owned by Hiram Davis, also burned many years ago. Fire insurance salesmen would have done well to give Corea a wide berth.

East Sullivan Brickyard The December 15, 1904, edition of the *Clay Record* reported: "Gibson Hanna has just started a brick works at East Sullivan, Me. Wood is now being cut ready for spring." Brickmaking, of course, was a seasonal industry. Gibson and his son Ralph posed for this photo with two workers. Brickyard workers, spending long days tossing bricks, two to a hand, and catching them as four, could surely clap out a paper hornet's nest with nary a sting.

The Hobbs "mud machine," minus its horse, may be seen back by the clay bank. A treadle-powered apparatus on the near side of the mud machine filled six brick molds at a time. At far right, elevated on posts, is the landward extension of the wharf at which small schooners were loaded, all 30,000 to 80,000 or so bricks loaded into a small schooner being tossed from hand to hand from wharf to deck to hold. Gibson Hanna also kept a store and was the local postmaster.

Store Wagon E. C. Hanna, storekeeper, rides shotgun in a store wagon. We don't know what is in the crates and cases, although one in the back is marked "EGGS." Presumably the wagon is headed either to or from the railroad station. Eugene Hanna had rented the East Sullivan store from his Uncle Gibson in 1914.

Storekeepers were the purchasing agents for their community, fending off the army of persistent drummers. Flour, sold by the barrel, was a big item that arrived by the carload, but the storekeeper ordered it in the form of bushels of wheat to be ground, yielding a byproduct (bran) that put the shopkeeper in the feed business as well.

Early storekeepers functioned as commodity brokers, exchanging incoming products for outgoing produce. To a significant extent this continued in rural areas well into the 1900s. Produce taken in exchange for credit included livestock (some quickly killed and retailed), potatoes, wool, axe handles, dried hake sounds (used to settle beer), butter, and especially eggs.

Eggs were costly and were shipped in cases to Boston wholesalers. An old story worth another telling concerns the Somerset County farmer who, when informed that the eggs of his "dung hill" hens were overly ripe, retorted, "Damn a hen that lays a rotten egg!"

Bristol Hotel In 1887 Herbert L. Cleaves and wife Nancy purchased the Stillman White house in Sullivan—a Second Empire concoction (which arguably fell short of the sum of its many elements)—and opened it as the Hotel Cleaves, which later became the Bristol Hotel. A bustle-like rear addition did not improve the building's aesthetics. After Herbert Cleaves's death in 1923, the hotel continued in operation under several tenants until it was purchased by Mrs. Ethel Newsome, who razed it to improve her view of the bay.

In 1916 it was estimated that there were 1,265 hotels, camps, and boardinghouses in Maine catering to tourists, with a capacity of 69,073 souls. A goodly number of images of summer hotels, for which the Bristol will serve as representative, may be found in the EIC collection. Favored names for summer hotels included Bay View, Lake View, and Ocean View.

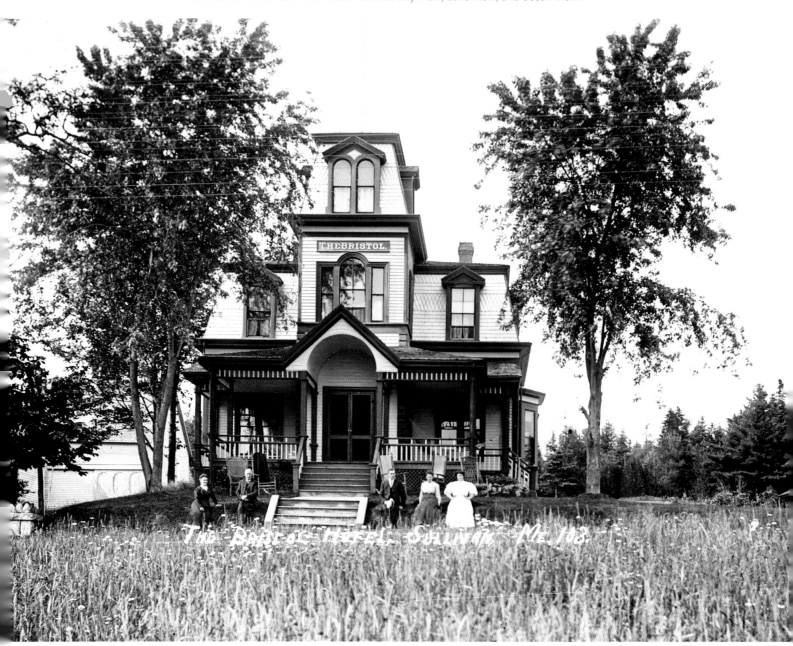

Kennedy Cottage New Yorker John S. Kennedy's summer cottage, "Kenarden Lodge," was built in 1892 in the French chateau style. Thomas Rowe and James Baker of New York were the architects. The Scottish-born Kennedy rose from selling rails to achieving a spectacular career in railroad finance. Having escaped destruction in the 1947 fires that vaporized a number of Bar Harbor's millionaire cottages, Kenarden Lodge was torn down in 1960 to be replaced by a new cottage in the '70s.

According to historian Samuel Eliot Morison, Mount Desert's first (non–Native American) summer visitors were artists and scientists, followed by professors and clergy. Next came East Coast people of "wealth and taste" who built big cottages and demanded amenities such as golf courses and yacht clubs. And following them came multimillionaires "fleeing from life's complications in Newport palaces," who promptly recreated the world they had left behind. To escape the frenzied Bar Harbor social scene, some then built "camps" on the Blue Hill Bay shore at which to recuperate.

Why the ultra-wealthy chose—and still choose—to complicate their lives with extravagant cottages is a good question. (And buying a yacht only compounded life's problems.) While commissions for such extravagances were plums, the architects and builders surely earned their fees, as their clients were liable to be pursuing very fixed, or worse, vacillating desires.

SOUTHWEST HARBOR, MT. DESERT ISLAND

LONG POND CONSERVATION CAMP, 158TH CO., SOUTHWEST HARBOR, MAINE, 301.

Southwest Harbor This view of the Long Pond Civilian Conservation Corps Camp, 158th Company, probably dates to 1934 or '35. Ralph Stanley, a native of the town, wrote of this photo:

The tents were temporary quarters and were probably made for the army during World War I as were the khaki dress uniforms that were issued to the men. My grandmother had a business where she altered clothing for the summer ladies. When the men were issued their khakis a lot of them didn't fit, so they would bring them to my grandmother to have the legs shortened or the waist taken in.

The tents were replaced by wooden barracks. The CCC did lots of work building fire roads, reservoirs, and trails in the Park and around the island. They also cleared most of the gooseberry bushes around the island, which were a carrier of white pine blister rust.

The CCC boys came from all over the state. A lot of them came from French communities in Aroostook County. Some could hardly speak English. Many married local girls and lived here the rest of their lives. Some found work at the boat yard and became proficient boat builders.

Burnt Coat Harbor, Swan's Island

Minturn Paving Blocks In Minturn village fronting Burnt Coat Harbor, circa 1910, we see a moraine of paving blocks, part of the quarrying operations of the firm of Baird, Stinson and Staples, which failed in the Great Depression. Awnings shade the paving cutters. Three Friendship sloops lie at their moorings.

ELLSWORTH

Ellsworth At the head of navigation, and with water powers at Ellsworth Falls, Ellsworth was long the sawmilling and lumber-shipping town for the Union River watershed. In the 1870s and '80s, the chief lumber customer was booming Bar Harbor, and ever since, especially after the rise of the automobile, Ellsworth and Bar Harbor have been closely linked economically. By the late 1800s the chief lumber product being shipped out of the Union River was barrel staves for Hudson River cement plants.

We are looking toward Bridge Hill, on the west side of the river, circa 1910–15. The building at center is the foundry for Ellsworth Foundry & Machine Works. In 1913 the company manufactured marine and stationary engines and operated both a marine railway and a garage. The foundry, along with other riverfront buildings, was destroyed in the Great Flood of 1923. The Great Fire of 1933 destroyed a large portion of the business district on the east side of the river.

The roof of the Masonic Hall is seen beyond the foundry, at center. The spire of St. Joseph Catholic Church on Bridge Hill is in the background. Three motor launches and a rowboat float in the foreground.

ON THE UNION RIVER ELLSWORTH ME. 1489

THE TRIANGLE FILLING STATION ELLSWORTH, MAINE

Triangle Filling Station The Triangle Filling Station and adjacent tearoom stood at the junction of Routes 1 and 3. The photo appears to date from the 1930s; a 1931 advertisement listed day and night service, with meals and afternoon tea available in the attractive salon or spacious veranda while your automobile was being serviced. The business was well situated to attract Mt. Desert traffic. Alonson E. Clement, the owner, also owned Card Brook Dairy Farm. Architecturally, this would be classified by filling-station devotees as an oblong box with canopy.

The Gulf Oil Company had its beginnings with the discovery of oil at Spindletop, Beaumont, Texas, in 1901. The largest investor in a refinery built to process the oil was William L. Mellon of the Pittsburgh banking family. In 1913 Gulf introduced the first drive-in gas station and early promoted branded gasoline of consistent quality. By the 1970s Gulf Oil was the ninth largest American manufacturing company, but in 1985, due to management blunders, it was engulfed—no pun intended—into Chevron. Branding rights in the northeast were bought by Cumberland Farms, which is why "Gulf" gasoline is still sold in Maine.

Arcady This view from Mrs. Ethelbert Nevin's Blue Hill Falls estate is northerly toward Blue Hill village and the hill itself. The late Mr. Nevin was a popular composer of parlor music, and in 1911 his widow named her new estate "Arcady" after one of his compositions.

Blue Hill became known for its musicians. Conductor Franz Kneisel, having acquired a cottage in the colony, entertained composer Fritz Kreisler, critic Henry Krehbiel, and other colleagues, a number of whom then bought, or rented, cottages. The musicians set a tone that attracted artists and academics rather than stuffed shirts and financiers, a flavor that may still be identified.

Which is not to say that the summer residents, as a rule, were not quite comfortably fixed. In addition to the usual run of Bostonians, New Yorkers, and such, there were a number of families from western Pennsylvania and Ohio with money derived from iron and steel. In the early 1900s, commodious cottages were sprouting on Parker Point, at East Blue Hill, and elsewhere. A few grand manses aside, however, most imparted an outward appearance of greater size and extravagance than they delivered internally, or, indeed, structurally.

By the 1920s, the colony's black servants, joined by compatriots from Mount Desert, annually held a "Colored Owls" ball. The festivities were open to all, and a number of free-spirited white Blue Hillers joined in.

VIEW FROM ARCADY, BLUE HILL, MAINE.

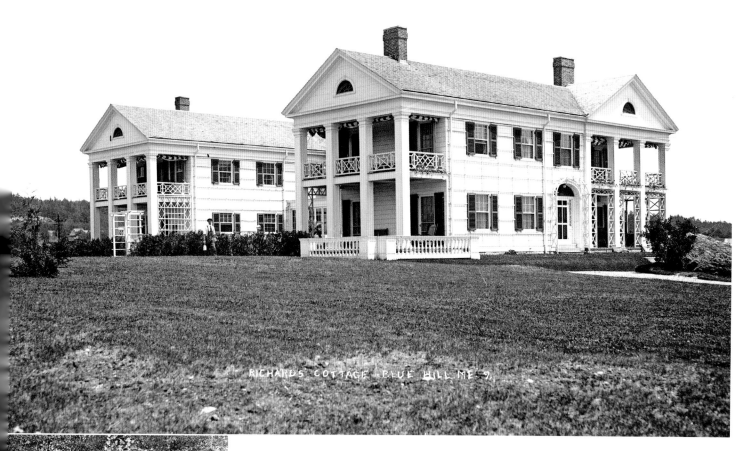

RICHARDS COTTAGE BLUE HILL ME 9.

Richards Cottage "Scrivelsby," a mega-cottage, was named after an ancient Lincolnshire manor to whose lord the cottage's owner, Cleveland industrialist F. B. Richards, had a distant claim of relationship.

Regarding the local rusticators' residences, a longtime Blue Hill summer resident observed:

> Cottages . . . seem to divide in name between British Redolence and Indian Evocation. "Scrivelsby" clearly belongs to the former, while I grew up in "Winnecowetts," an example of the latter. My favorite is a big cottage on Parker Point called "Dundree," which seems to come from the former but actually from a response of the builder . . . when asked if he had built any other houses that size.

"Scrivelsby" was built in 1911 to designs by the Boston architect Frank Chouteau Brown and was intended to evoke the spirit of the large Federal-era houses of the village, along with a touch of Mount Vernon. Unlike many cottages, it was well constructed, and unlike the village houses, it had numerous outbuildings and bathrooms, a walk-in cooler, and fine views of water and mountain. Its stark appearance would be softened with gardens and landscaping by Beatrix Farrand.

Ornamental Blacksmith Charles F. Wescott, Jr., a former farrier, became an ornamental blacksmith producing all manner of things iron—signs, weathervanes, tables, lamps, or whatever. Pre-expectorated tobacco juice lubricated his creativity. A recent advertisement on the Internet read:

> Market Fresh Form [sic] Roof Of A South Blue Hill Summer Cottage, A Life-Size Hand-Forged Sheet Metal Sea Gull Weathervane Complete With Its Original Set Of Directionals. . . . Attributed To . . . Charles F. Wescott, Jr., Whose Work Abounds The Length And Breadth Of The Blue Hill Peninsula Since He Opened For Business In The Early 1920s.

As a local institution, Wescott ranked right alongside the Kollegewidgwok Yacht Club and the Blue Hill Fair. He was a bridge linking the old-time native population with summer people. Pieces of his handiwork, carried home by summer visitors, served as talismans of magical summer days and nights.

The literature dealing with the complicated relationships between Maine locals and those from away is vast. Less well documented is the other old story of Mainers who move away. For example, Wescott's daughter, Elizabeth, became the head reference librarian at Penn State University and Brown University.

In recent years, Wescott's building has housed restaurants.

LITTLE DEER ISLE

Boatshack Do opposites attract? The boat appears to be an ordinary skeg-built lobster boat which has been converted to a pleasure craft with the addition of a raised deck forward and a rather stylized house. Perhaps she is undergoing some work on her stem, in which case this all makes perfect sense.

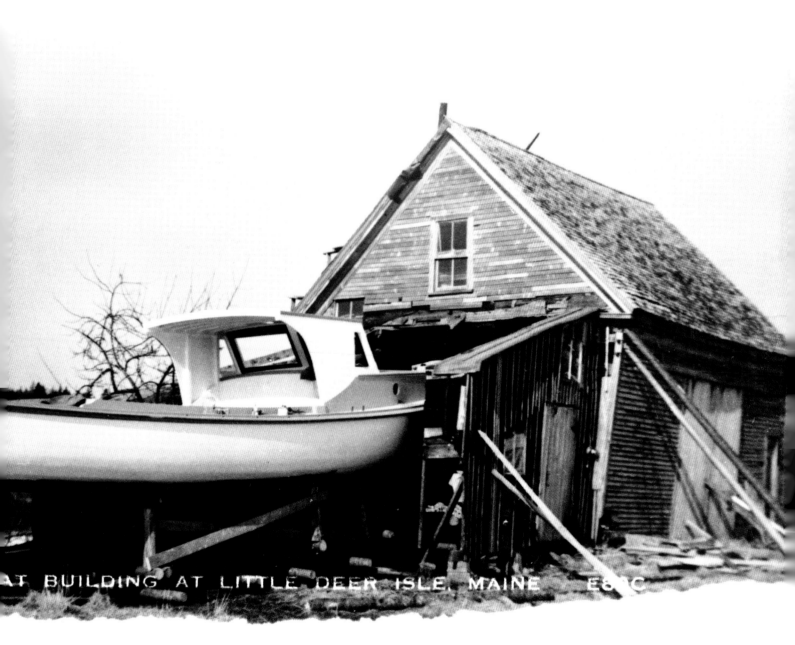

AT BUILDING AT LITTLE DEER ISLE, MAINE E8?C

STONINGTON, DEER ISLE

Stonington The tide is low, the year probably circa 1915. The five children at lower right make this a successful image rather than a lifeless "neutron bomb" villagescape with everything intact but nary a soul in sight. Deer Isle's commercial ties were then with Rockland, linked by steamers; after the bridge to the Blue Hill peninsula was built in 1939, Ellsworth became the place where islanders "traded."

Formerly a small fishing village known as Green's Landing, Stonington was incorporated in 1897, reflecting its booming granite industry. From about 1910 its population declined, matching the fading fortunes of the granite business. However, the big quarry on Crotch Island, just across the Deer Isle Thorofare from the village, remained quite active until World War II. The granite industry attracted immigrant workers, including many Italians who were mostly single men, making Stonington a lively place on Saturday nights.

Thin-soiled Deer Isle had a long tradition of fishing and seafaring. Beginning in the late 1800s many island men "went yachting," manning the "gold-plated" floating status symbols of the wealthy. Two *America*'s Cup defenders were crewed by Deer Islanders who displaced the regular Scandinavian "squarehead" racing sailors. Although both defenses succeeded, the practice was not continued, supposedly because the independent islanders were said to consider orders to be suggestions. "Going yachting" continued into modern times.

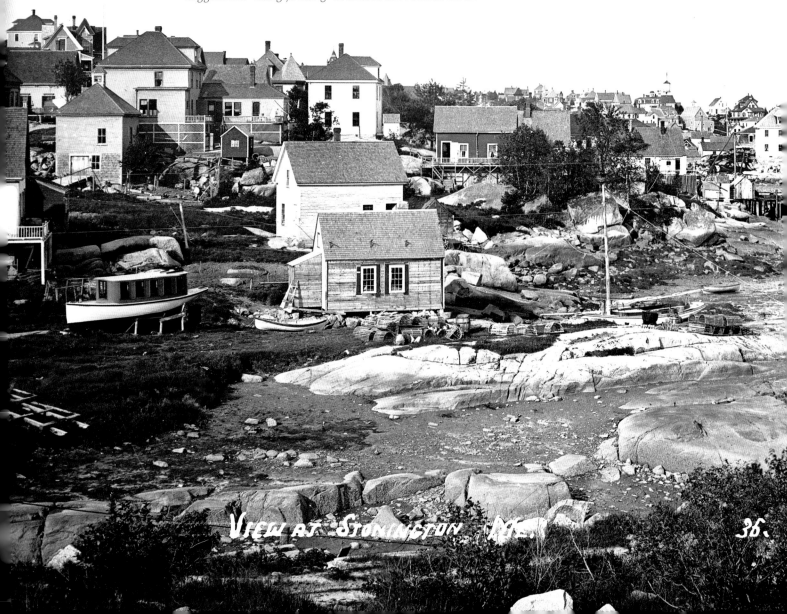

VIEW AT STONINGTON ME.

36.

Lobster Smack The handsome wet-well lobster smack *Arthur S. Woodward* of Beals Island, Washington County, discharges at a wholesale dealer's wharf. Wet-well smacks carried lobsters in a compartment flooded by holes bored through the hull.

In the late 1800s many sailing wet-well smacks ranged the coasts of Maine and the Maritime provinces, purchasing lobsters from fishermen at even the remotest coves and islands and serving as a link to civilization. The first powered smacks appeared by the end of the century. The *Arthur S. Woodward*, built at Beals by Riley Beal and Sons—and new when this photo was taken in 1949—was the last smack built in Maine; she carried 16,000 pounds in her well. She was built for Vernal Woodward, who did business from the smack and also at his home wharf, buying from fishermen and smaller dealers and delivering lobsters to wholesale dealers far and wide.

By the late 1950s the business was fast turning to delivery by trucks, and the Woodward was converted to a sardine carrier. But in 1949 these changes lay in the future, and the *Woodward*'s maiden trip was celebrated by all aboard her. Sitting on the rail is Elizabeth Beal (later Sawyer), an extended family member, as was the boy near her, Leon Simmons. Crewman Stevie Peabody, formerly captain of the coaster *Lizzie D. Peabody*, talks with a fisheries warden. The young man holding up a lobster for the photographer is Arthur S. Woodward himself; behind him, obscured, is his father, Vernal, proud owner and skipper.

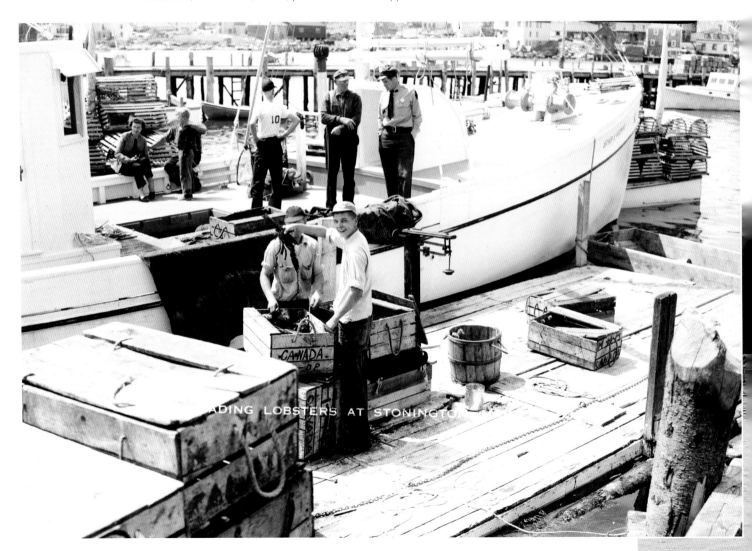

LOADING LOBSTERS AT STONINGTON

Friendship Sloop The sloop *Lula Marion* at Bucks Harbor, at the western end of Egge-moggin Reach, in South Brooksville, a village in the town of Brooksville. Of an iconic model now collectively called "Friendship sloops," the *Lula Marion* was in fact built at Friendship in 1899. Friendship's most prolific builder was Wilbur Morse, and the *Lula Marion* bears all the hallmarks of a Wilbur Morse sloop. Most sloops fished or lobstered, but the *Lula Marion*'s owner, Melvin D. Chatto, owned the Bay View Hotel (which was affiliated with the adjacent Gray's Inn, the two arks standing on a rise above the steamboat wharf), and no doubt the sloop, skippered by a local fisherman, also took out sailing parties. Indeed, it would appear from other photos that she was one of three Friendships so employed. Chatto, a big fish in a small harbor, was also the president of the Bucks Harbor Granite Company and a state senator. The sloop is lying at what locals still call the pogy wharf.

In 1912 and 1915 the *Lula Marion*, sailed by Joe Ladd—presumably the local fisherman who took out the sailing parties—won the annual Eagle Island sloop race. In 1917, possibly marking her sale to a fisherman, an engine was installed. A few years later she disappeared from the mer-chant vessel list—perhaps she was sold as a yacht or fell apart or even blew up from gas fumes in her bilge. It happened.

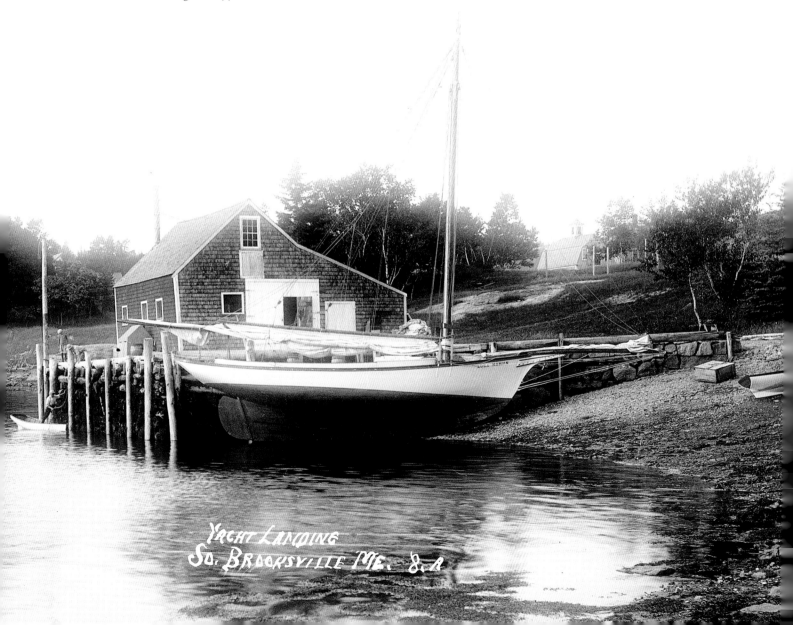

Yacht Landing
So. Brooksville Me. 8. A

Boat on Truck The viewer is free to speculate about the backstory of the boat on the truck at Blake's Point on Cape Rosier, in the village of Harborside, in the town of Brooksville. It may help to know that Maine did not start requiring the display of registration numbers on motorboats until 1960, nor would Maine registration numbers begin with "K."

One possibility is that the boat belonged to a summer person from out-of-state and was shipped by rail to Ellsworth. Of course, it did not arrive on a flatcar with the canopy rigged and flags flying; they would have been installed preparatory to the boat's celebratory arrival in Brooksville.

According to Maine auto historian Warren Kincaid, the "canopy" is the top of a pre-1923 touring car and is typical of a 1915 or so Model T Ford top. Early truck manufacturers used many of the same parts from the same suppliers, making identification difficult, but in this instance the radiator has mounting brackets typical of Sterlings and Packards, circa 1910–14. The electric lights were likely added later; they became popular around 1915.

Goose Falls This view from Dyer's Hill on the north side of Cape Rosier (in Harborside), circa 1900, looks toward Castine. A millpond is at right. The building at center is a tidal grist and lumber mill located on a granite ledge called Goose Falls, a tidal reversing falls. The mill privilege was granted to John Bakeman in the 1770s. Bakeman was a supporter of the Revolution, and during the war his house was dismantled by British soldiers and rebuilt in Castine. The grand house seen here was built by Bakeman in the 1780s as a replacement. Although Bakeman's wife was a loyal Tory, there is no truth to the local tradition that she was stolen by the British as well.

The buildings on the pond, at far right, were the engine house and shaft houses of the defunct (Cape) Rosier Consolidated copper mine. From the mid-1870s to the mid-1880s a mining frenzy swept Maine, with Hancock County at the epicenter. Forty-odd mines pocked Brooksville alone. More money was made from selling stock than from mining ore, although the mine at Goose Falls remained active for about seven years.

Several attempts were made to reactivate the mine. In 1968 Callahan Mining began digging a massive open pit, leaving behind a hole 320 feet deep and 600 to 1,000 feet across and a small mountain of waste rock, PCBs, and other pollutants. The most notorious Superfund site in Maine, it continues to pollute despite the many millions spent on remediation.

"Bangor River" Traffic on the Penobscot, or "Bangor," River. The Eastern Steamship Company's Boston-to-Bangor steamer *Camden*, headed downriver, is passing the Ross Towboat Company's tug *Walter Ross*, which has a handsome three-masted schooner and two small two-masted schooners in tow.

The twisting twenty-four miles from Bangor to Fort Point, at the head of Penobscot Bay, was always challenging, particularly for the great fleets of lumber vessels that once made the passage under sail. (Fort Point is where tows of smaller schooners were made up; big four- and five-masted coal schooners were often met by a tug in the lower bay, even off Monhegan.) The more-than-twelve-foot tidal range at Bangor is the greatest of any place on the coast west of the Bay of Fundy.

During the booming pine lumber days before the Civil War, over three thousand vessels arrived (and then, of course, departed) from Bangor during the seven-month shipping season. Even in the 1880s, when spruce lumber and ice were major exports, fifteen hundred arrivals might be expected. Sailors, loggers, longshoremen, saloons, and bordellos made for lively times, and the tough Irish cops patrolled in pairs.

In the early 1900s there were days when the waterfront still resembled its palmy days, but by 1920 the waterfront was all but dead, save for the daily Boston steamer and the odd schooner and barge.

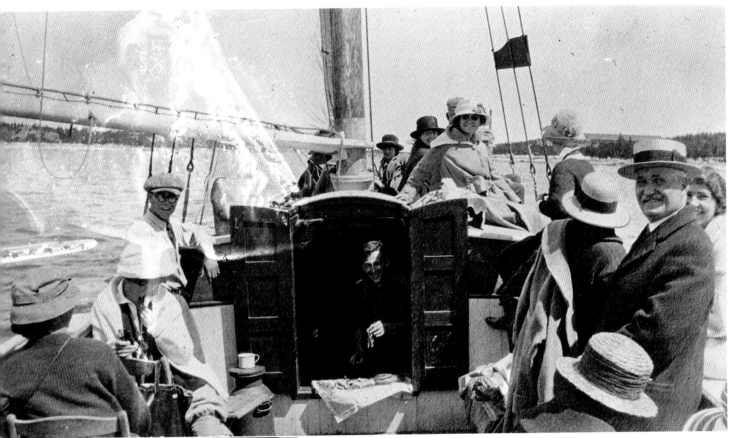

Sloop *Lydia* A cheery party, presumably of summer people, enjoys a sail aboard the sloop *Lydia*, circa 1920, on what is likely West Penobscot Bay. The women are bundled against the pleasant chill. Some comestible offering has emerged from below. Liquid refreshment may be had from the creamery can via the communal cup.

Writing in the 1960s of early twentieth-century summer people, Gerald Warner Brace categorized them into old families, the wealthy, the spinsters, the two-weekers, the retired, and the passing tourists. "The old [family] summer folk were not really a leisure class, nor parasites of any sort: they were professionals geared to a slower-paced world. . . ."

Esther Wood, a Blue Hill native, wrote of the early 1900s summer people: "Walking was a favorite recreation. Walkers were of two schools. Some strolled. The strollers always returned laden with spoils: huge bunches of wildflowers, pockets filled with shells, cups of ripe berries. Others hiked. The hikers returned worn out but triumphant. . . ."

And Richard Hallet wrote of old-time summer people who "lolled in old-fashioned hammocks, reading *Ben Hur* and *The Prisoner of Zenda*, or fished for cunners off the rocks with long bamboo poles, or picnicked in the woods on hard-boiled eggs and gingerbread packed into a shoe box with twists of salt and pepper."

The *Lydia*, built at Friendship in 1916, had a round bow, a full rig, and a sixteen-horsepower engine. She was originally documented at Castine as a passenger vessel. Within a few years her port of hail was Belfast, and in 1926 she was listed as a freight vessel belonging to Maurice Gray of Harborside, Brooksville.

Waldo-Hancock Bridge On opening day for the new Waldo-Hancock Bridge over the Penobscot River, connecting the town of Prospect with Verona Island, the Boston-Bangor steamer *Belfast* passes beneath. At lower right lurks an automobile, whose tribe's explosive popularity created the need for the bridge, and which, in four years, will end the 102-year history of Boston-Bangor steamer service.

The steamer, bridge, and auto each represented state-of-the art technology when built. The Bath-built 335-foot *Belfast* and her sister *Camden* were the first steel-hulled, screw-propelled vessels and the first true seagoing vessels employed on this route. They were also two of the first three American-built turbine-powered vessels. While flammable, they were not the ever-potential floating conflagrations they replaced.

The bridge was among the earliest to employ pre-stressed wire strand cables and the Vierendeel truss later used in the Triborough and Golden Gate bridges. It also cost well under budget, permitting the construction of a second bridge between Verona Island and Bucksport and a road route across the Penobscot twenty miles downriver of Bangor. The Bucksport–Prospect ferry, which the bridges replaced, was a scow that had long inspired both rage and ridicule.

WALDO-HANCOCK BRIDGE, BUCKSPORT, MAINE,

OLD TOWN CANOE CO, OLD TOWN, ME. II.

Old Town Canoe The Old Town Canoe Company became the world's largest canoe factory. The front section was originally a shoe shop; for some years the top floor was used for the manufacture of Bickmore's Gall Cure—"Be Sure to Work the Horse" was its ingenious slogan. Canoes and gall cure were both very successful businesses of the Gray family. The second brick addition dated from 1914.

The development of the canvas-covered canoe in the late 1800s is credited to builders from the Bangor and Old Town area, beginning with E. H. Gerrish, followed by E. M. White and batteau-builder Guy Carleton. The Old Town Canoe Company traced back to 1898 when George Gray, the owner of a local hardware store, hired A. E. Wickett to build canoes in the back of the store.

Gray's entry into the business coincided with the beginning of a national canoe craze, which followed the creation of trolley parks, with canoe liveries, built by trolley lines to attract Sunday ridership. By 1915 Old Town was producing 8,000 canoes a year and 250 paddles daily. Distribution, of course, was made possible by rail freight.

Canoeing, by offering young couples an opportunity for privacy, soon became associated with romance, and, in the fertile minds of moral guardians, scandalous behavior. However, the song "There'll Be a Hot Time in the Old Town Tonight" preceded the Old Town canoe.

EAST CORINTH

East Corinth Corn Factory Sweet corn is husked at a corn shop, or canning factory. The canning of corn and lobsters in Maine preceded the Civil War, but it was the wartime demand—canned beef was then a major item—and high profits that firmly established the industry. Canned sweet corn became the premier product, and by 1920 there were more than 120 Maine "corn shops."

Factory managers contracted with local farmers who typically grew one to three acres with factory-supplied seed. Come September, the managers set the prices paid, and farmers rarely saw the profits they had anticipated. As compensation, the refuse huskings made good stock feed, which cattle processed into future stalk feed.

Heavy manuring supposedly gave Maine corn its unique sweetness. Also, small stands were picked more than once, reducing the percentage of under- or over-ripened ears. The high reputation of Maine canned corn led some Western canners to label their product as being Maine corn.

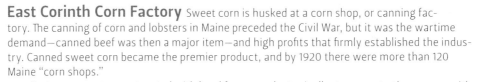

HUSKING CORN. E.

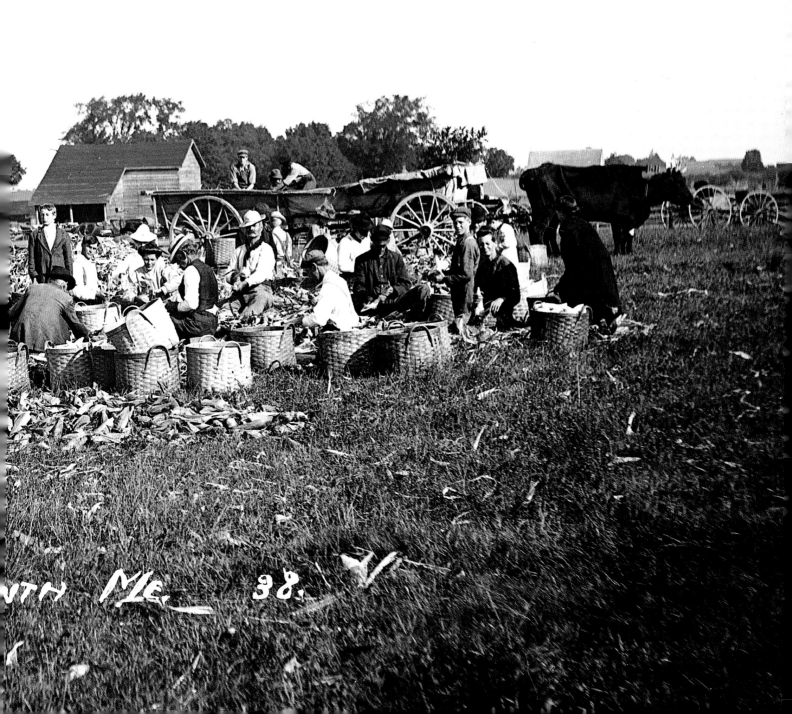

UTH ME. 38.

BUTTER FACTORY, E. CORINTH ME. 36

East Corinth Butter Factory A butter factory, or creamery, alongside the tracks of the Charleston branch of the Bangor Railway & Electric Company inter-urban trolley line. The icehouse is behind. Milk or cream was received under the portico from wagons. Factories that accepted whole milk paid for the butterfat and sold the skimmed milk back to farmers to feed calves, hogs, and chickens.

The BR & E was a conglomerate of Bangor-area streetcar lines and electric utilities. Although autos killed the trolley lines, the demand for electricity grew and, renamed Bangor Hydro, so did the company.

The growth of Maine's dairy industry followed the establishment of creameries, or butter factories, and markets for fluid milk created by faster rail transportation. Unlike most commodities, the return on milk was reduced the more it was processed—and the longer it took to reach a market, the more it had to be processed.

In 1905 there were about sixty butter factories or creameries in the state. The average number of patrons per facility was 197, and the average number of cows per patron was 5.83. Slightly more than half of the facilities primarily sold sweet cream, and the remainder sold butter. Some made butter from spoiled cream, giving Maine butter a poor reputation in some markets. Good butter was expensive, giving rise to numerous adulterated and non-dairy substitutes.

Carmel

Bella the Baboon Bella the baboon contemplates a tethered life at Harry Wise's Auto Rest Park, long a popular destination for motorists, eleven miles west of Bangor on Route 2. (Route 2 was the principal east-west highway before the building of Interstate 95.)

Auto Rest Park had its beginning in 1922 as a filling station with a chained bear. In 1925 it was purchased by Russian immigrant Harry Wise and his wife. Harry combined shrewdness with the flair of a showman, and, in time, Auto Rest Park included a restaurant; a dancehall, which attracted well-known big bands; a roller-skating pavilion; a games arcade; a merry-go-round and other rides; overnight cottages; and a "licensed zoo" (presumably an improvement over the common, cruel roadside menageries of the day).

Music from the dancehall, relayed via telephone line, was broadcast on radio station WABI. Kids received free ice cream at the end of the school year. And the smiling Harry was always there.

In 1949 the Wises' son, who was then the park manager, drowned in a freak accident, and soon after, Auto Rest Park was sold. But without Harry, and with the public's tastes changing, it went into a decline. When the restaurant burned in the late 1950s, it closed the show.

BELLA FROM AUTO REST PARK, CARMEL, ME.

Marching Campers Campers drill at Camp Winnecook. Although elaborate "war games" were long a part of camp activities, they typically mimicked the asymmetrical warfare of Indians or sappers, not marching infantry units. The jodhpurs worn at far left are a good indication that this is an exercise in World War I patriotism-building.

The hostilities in Europe affected Maine before the US entered the war. Worn-out schooners were sold for fabulous prices, and new ones were built in a hurry. In June 1915, an Augusta shoe shop received an order for 500,000 pairs of shoes for the British army, and in October, the Grand Trunk Railroad expanded its East Deering stockyards to accommodate the shiploads of horses leaving Portland for England for use as army remounts to replace the many thousands killed in battle.

In August 1916, a Biddeford firm manufactured snow shovels for Germany to be loaded aboard the cargo-carrying submarine *Bremen*; an earlier order had been carried by her sister, *Deutchland*. In January 1917, the Portland Company received an order for twenty-two locomotives from Russia.

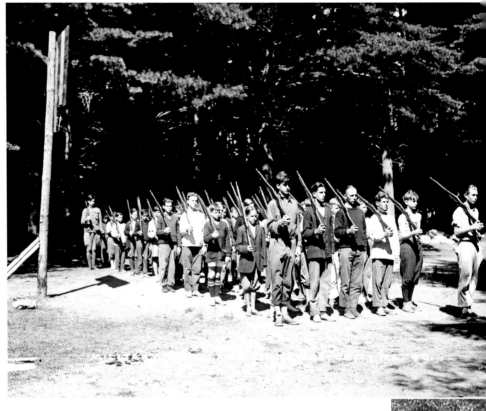

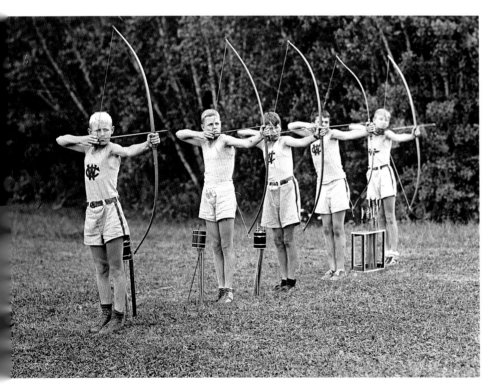

Camper Archers A camp for boys aged ten to sixteen, Camp Winnecook was established in 1903 on the eastern shore of Lake Winnecook (better known as Unity Pond) by Unity native Herbert L. Rand, then a principal at the Salem Normal School (teacher's college) in Salem, Massachusetts. In the mid-1940s, under new ownership, it briefly became a camp for girls. In 1950 the property was sold to a private party. Kids, do not try this at home—this is why you were sent to camp!

Powwow Camp Winnecook advertised its "Indian tribes," "Indian pageant," and "head-dresses awarded for Deeds of Valor." The six-week season ended with an "Indian powwow" ceremony like this one, including bareback riding, drumming, war paint, and fire dancing.

Chief Winnecook's Plains Indian war bonnet aside, the turkey-feathered headdresses of his braves are acceptable approximations of Abenaki headwear, since Abenaki fashion mavens tolerated wide variations on a theme.

Camp cultures typically included rituals and invented traditions, serving not only as fun and games but to instill a tribal loyalty, as it were, hopefully reflected in the future support and patronage of alums.

White Americans loved to play at being American Indians, but, as a society, punished Native Americans for not being more like white Americans

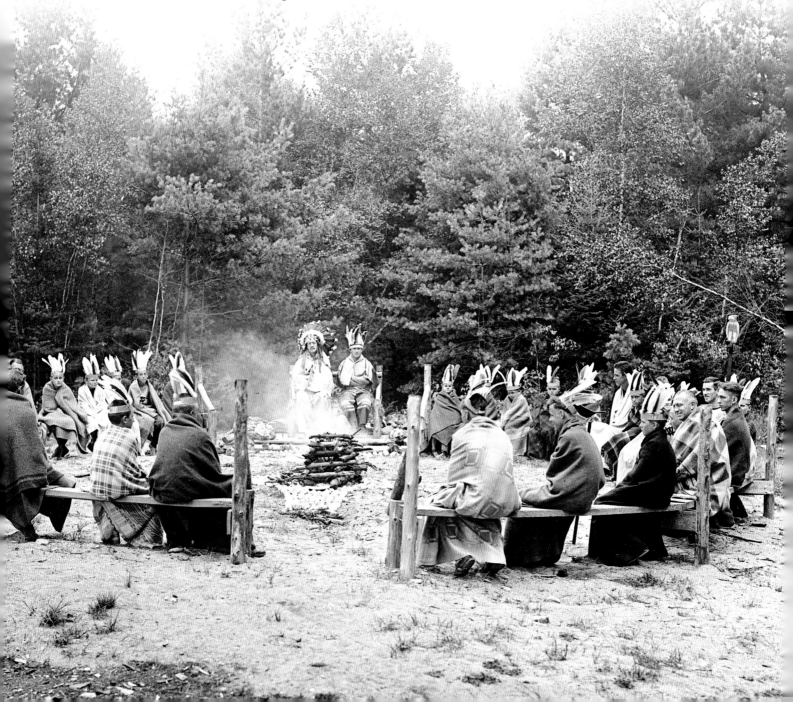

MORRILL

Morrill Scholars Looking into the bright eyes of children who all have long since died compels the viewer to contemplate his or her own mortality. Life expectancy in Maine today is about seventy-nine years. In 1900 it was forty-seven, but this was less on account of people dying in their forties than it was of infant and childhood deaths.

In 1900 one in eight Maine babies died under age one, and 20 percent of all deaths occurred before age twenty. Children died of birth complications, of infectious diseases, and of diseases from poor sanitation. The leading cause of death for all ages was tuberculosis. Others killers included influenza, scarlet fever, smallpox, acute pneumonia, cholera, typhoid, and diphtheria. The 1918 Spanish influenza killed five thousand Mainers.

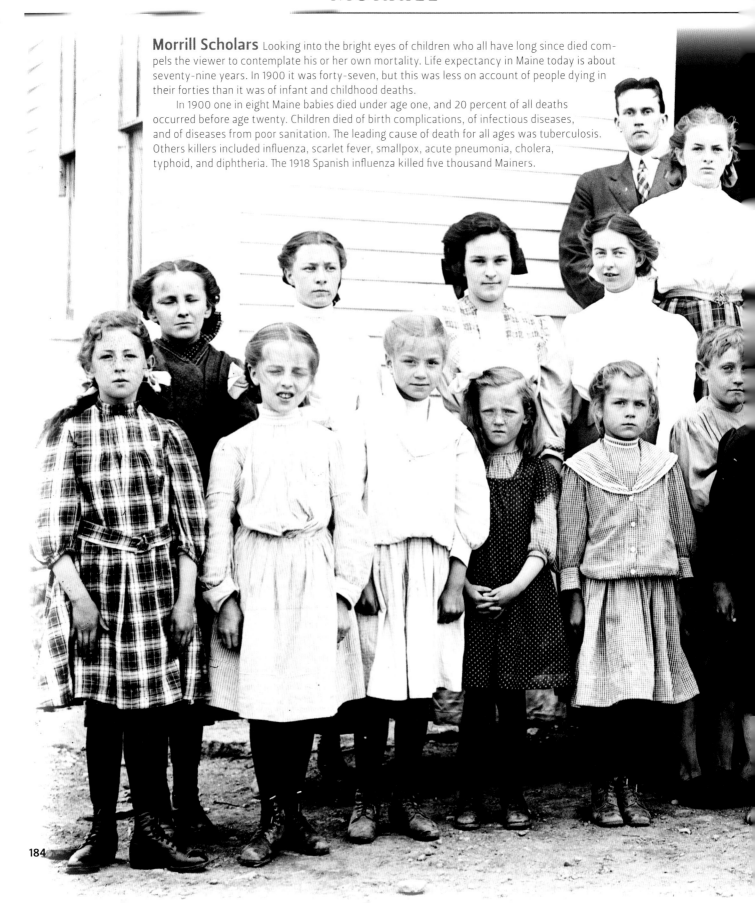

Changing the subject, most teachers were unmarried because a male teacher could not support a wife and family on the low pay, and female teachers who married had to resign. One explanation given is that teaching was one of the few professions open for single rural women. Another is that the marriage of a female teacher would give rise to speculation about her sexuality among her scholars. Or that a married female teacher would likely soon be leaving due to pregnancy.

To change the subject again, the bare feet of young boys were long considered to be insensible to cold or pain.

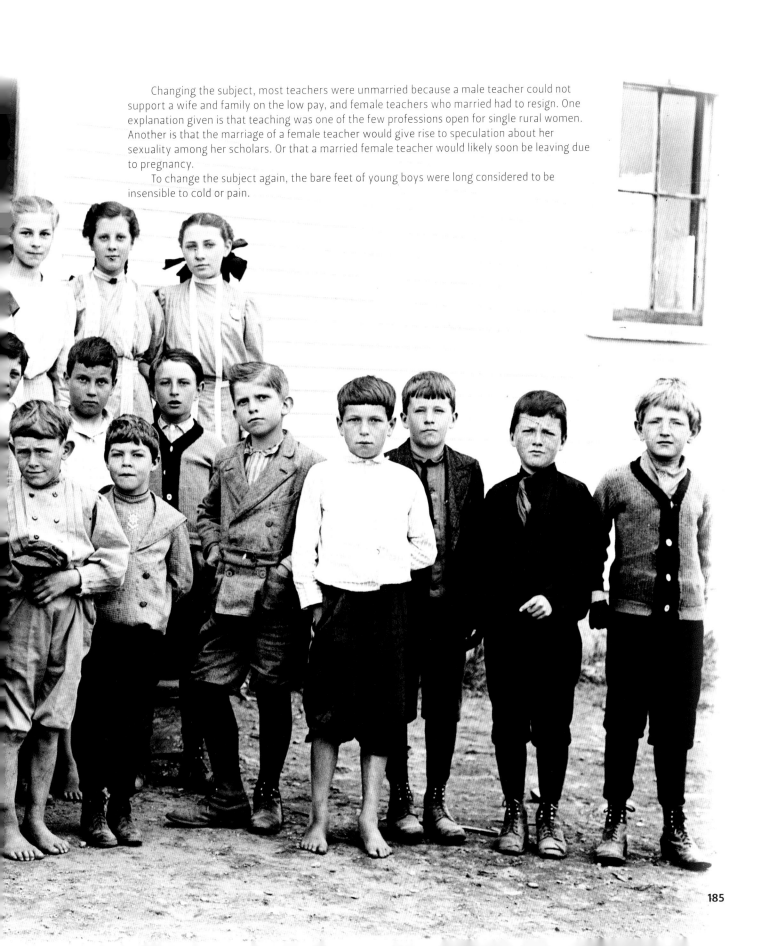

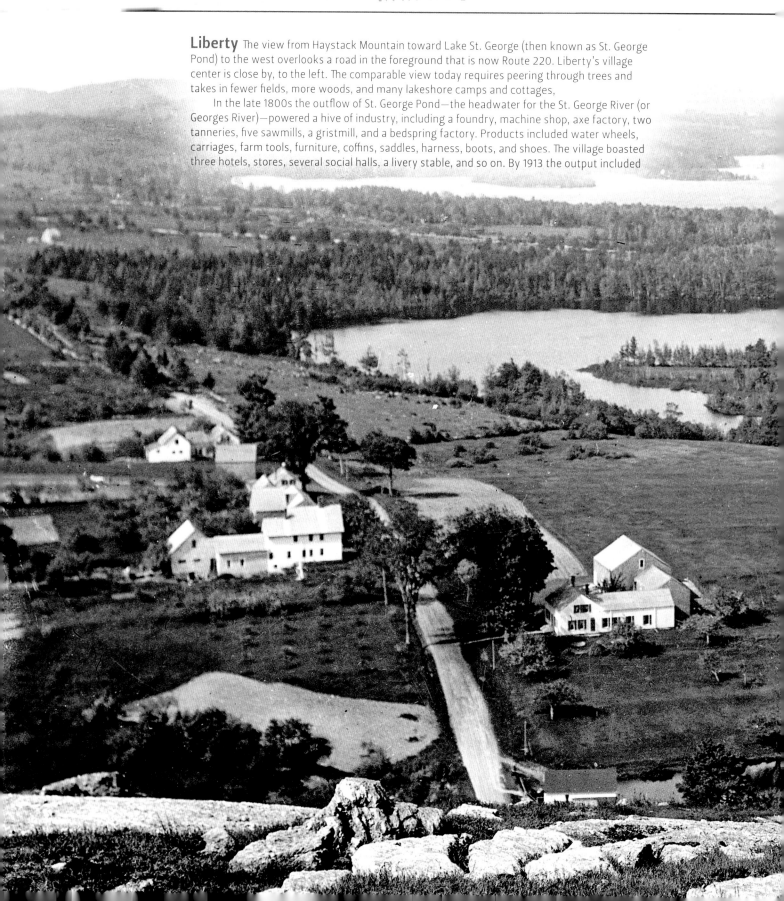

Liberty The view from Haystack Mountain toward Lake St. George (then known as St. George Pond) to the west overlooks a road in the foreground that is now Route 220. Liberty's village center is close by, to the left. The comparable view today requires peering through trees and takes in fewer fields, more woods, and many lakeshore camps and cottages,

In the late 1800s the outflow of St. George Pond—the headwater for the St. George River (or Georges River)—powered a hive of industry, including a foundry, machine shop, axe factory, two tanneries, five sawmills, a gristmill, and a bedspring factory. Products included water wheels, carriages, farm tools, furniture, coffins, saddles, harness, boots, and shoes. The village boasted three hotels, stores, several social halls, a livery stable, and so on. By 1913 the output included

canned fruits and vegetables, apple barrels, clapboards, staves, steel stoves, and iron castings. The surrounding farms supported a creamery; in 1912 a buyer bought 22,700 barrels of apples within seven miles of the village.

Liberty today represents a legion of Maine towns that were once centers of industry; in the early 1900s, despite their neat appearances and still-orderly agricultural landscapes, they were sliding into an economic somnambulism. Today they are primarily bedroom communities, thanks to the mobility provided by the automobile, the very device that did so much to kill the local economy.

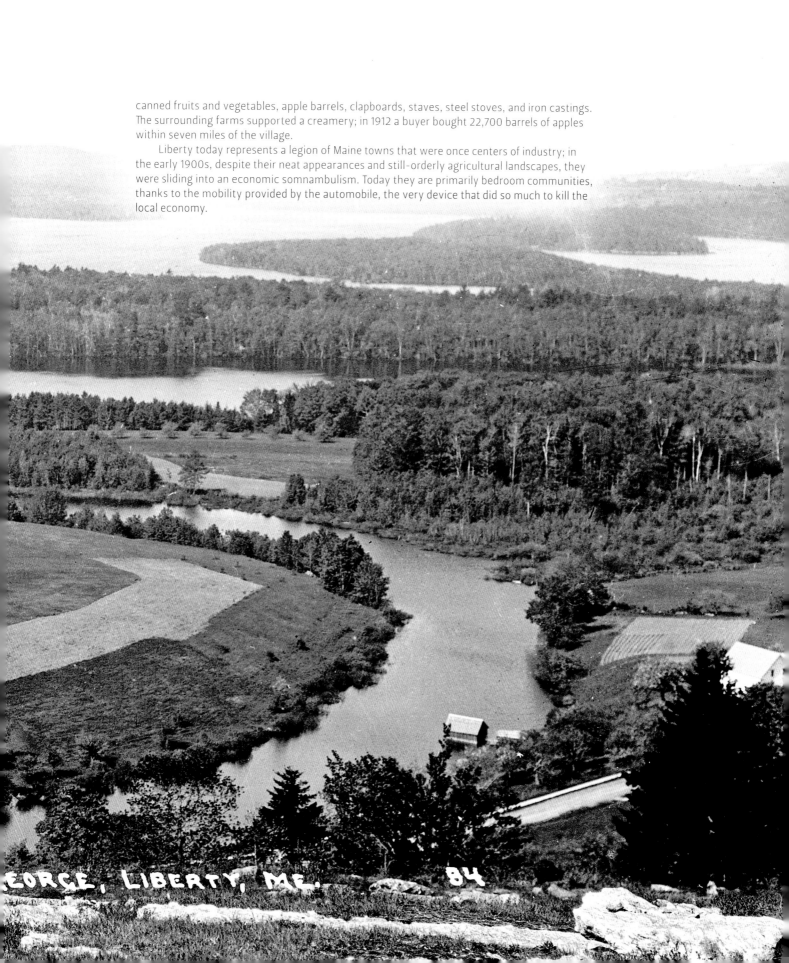

EORGE, LIBERTY, ME. 84

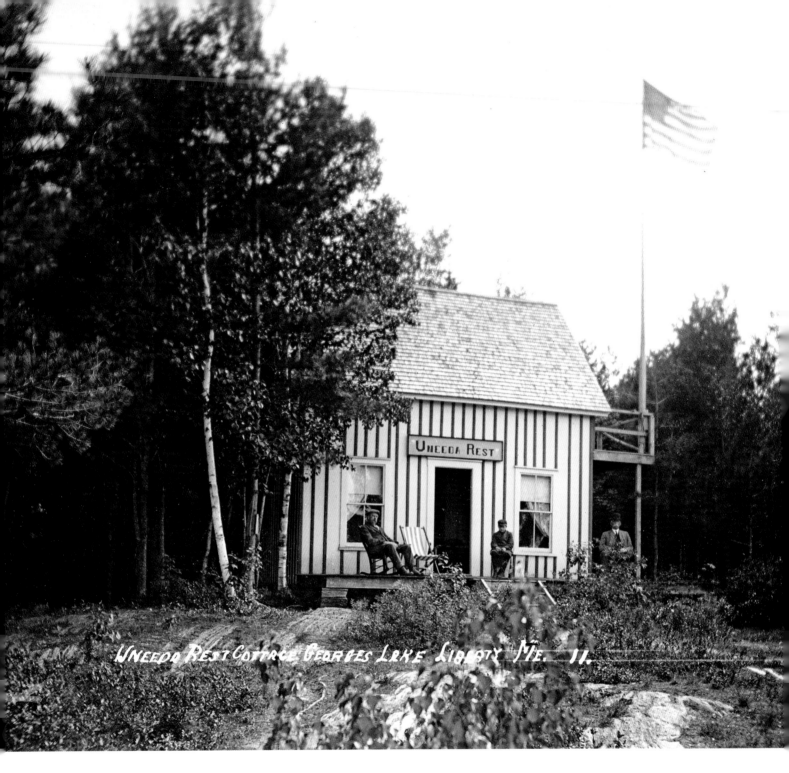

"Uneeda Rest" Ordinary Americans, unlike the British or ultra-wealthy Americans with grand houses, were not inclined to name their primary residences. Camps and cottages, however, were often named. Perhaps they served a similar function as yachts, which were always named, and smaller-to-small pleasure boats, which often were as well. And just as the owner of a large cottage might derive no more pleasure from his trophy than did the owner of a tiny board-and-batten camp such as "Uneeda Rest," no owner of a 100-foot yacht could experience even half the joy of an eight-year-old child turned loose in a ten-foot skiff. And if the skiff bore a name on its transom, so much the better.

BELFAST

Colonial Theatre Returning to Belfast, where this meandering journey through Maine began, we find ourselves in front of the Colonial Theatre in 1935 (as dated by the poster for the movie "Village Tale," starring Randolph Scott and Kay Johnson). The Colonial was once one of three Belfast movie houses. Built in 1912 to seat 880, it featured a stage in front of the screen for the live performances that preceded the showing of the movie. In 1923 a fire destroyed both the Colonial and the new, nearby Dreamland Theatre. In 1924 the rebuilt Colonial, as shown here, opened its doors.

In 1929 the Colonial was bought by a Boston theater chain, and in 1947 it was completely renovated in art deco style. In 1995 the old theater was given a new lease on life when it was purchased by two local residents. The interior has been reconfigured with three screens, and the roof now serves as the sanctuary for Hawthorne, the life-sized elephant who formerly resided at a famous Belfast roadside attraction, aka tourist trap, Perry's Nut House.

When was the last time any Maine boy wore a tie and jacket to the movies? Hopefully copies of this book will not be seized and pulped by the owner of the copyright on the image of the ridiculous shoe- and shorts-wearing rodent at center.

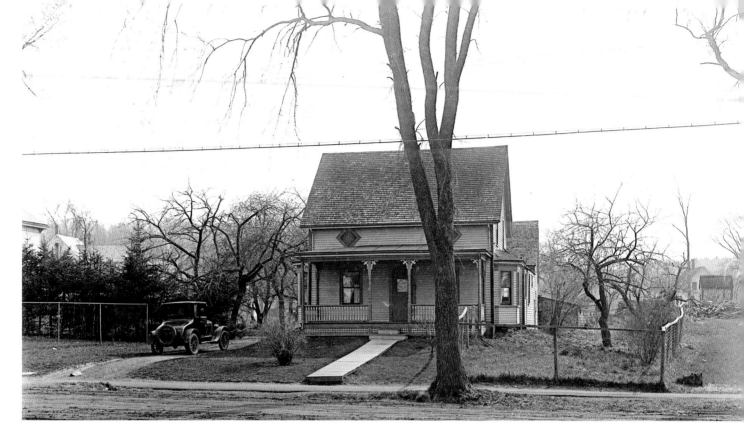

Belfast Puzzle This one's a puzzler. A modest dwelling displays a little architectural whimsy, with an attached barn, and apple trees in the yard. The auto appears be a 1930s Model A Ford coupe. But what's with all the people in one image and none in the other? It might be helpful if we knew which image was taken first—did the photographer decide that he needed some people to give the photo life, or did he shoo them away for blocking the camera's view of his prime subject, the house? And why this house, of all houses?

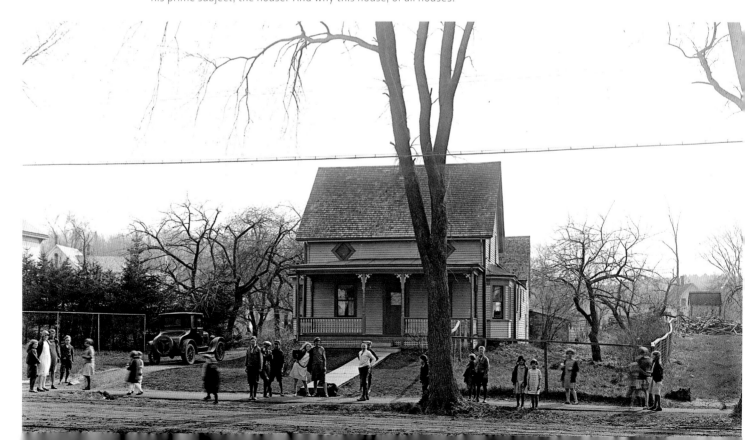

Float Plane A Fairchild Model 71 aircraft taxis in Belfast Harbor. The sailboats at left are headed into the prop wash.

The Model 71, first built in 1926 at Long Island, New York, was an eight-place aircraft with a fabric-covered steel tube fuselage and fabric-covered wood-framed wings. Powered by a nine-cylinder Pratt & Whitney radial engine of 420 horsepower, it had a range of more than 800 miles at a cruising speed of over 100 miles per hour. Because it could fly steadily while carrying a heavy camera, one version was widely used for topographical photography. Rugged, reliable aircraft, the 71s were a favorite of bush pilots.

In 1933 two 71s were owned by Maine Air Transport of Rockland, but their registration numbers did not match this one, NC1118H. In 1929 this aircraft was registered to Pennsylvania Airline. Possibly it was acquired by MAT after 1933, or perhaps its presence at Belfast was connected to wealthy "Philadelphians" who summered at Islesboro.

It is remarkable that an aircraft of the caliber of the FC Model 71 was produced only twenty-three years after the Wright Brothers' tenuous first powered flight.

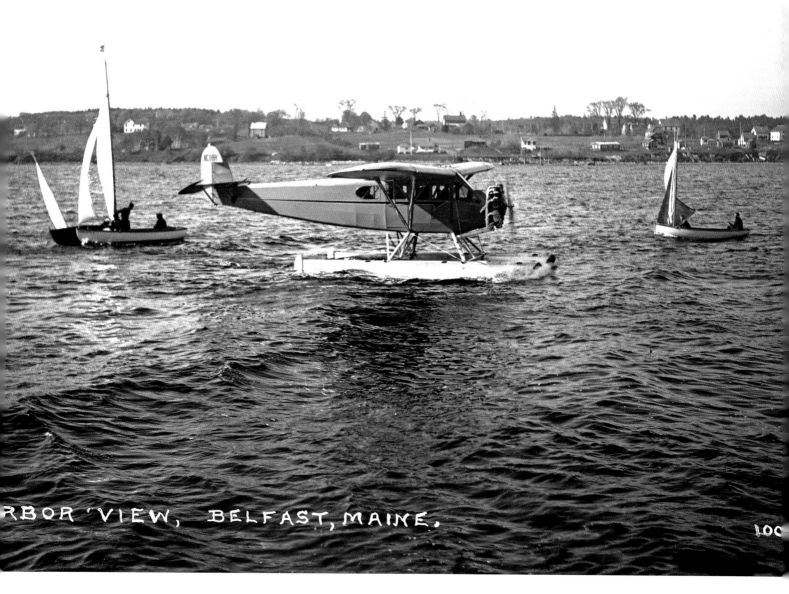

RBOR VIEW, BELFAST, MAINE.

Broiler Queen Broiler Queen Betty Perry poses with an unidentified chicken at Belfast's second annual Broiler Day Festival, July 1949. The self-proclaimed Broiler Capital of the World, Belfast maintained a love/hate relationship with the poultry industry for about fifty years, exchanging plentiful low-wage jobs for a rank smell, feathers in the streets, and the most polluted harbor on the coast.

In the late 1800s Lorenzo Dow, the "Egg King" of Waldo County, collected the eggs laid by "dung hill hens" that farmwives traded for credit in country stores. Dow shipped the eggs to Boston, where they, and also chickens for slaughter, brought high prices.

In the early 1900s, advances in the housing and care of modest-sized flocks, and the hugely important discovery that a hen's egg-laying traits were passed on through her sons, not her daughters, came out of the University of Maine. But the explosion of the poultry industry came after World War II, when processed feeds containing antibiotics made raising mass concentrations of birds both possible and economical.

Belfast became a major processing center thanks to a labor force eager for even revolting, low-paying jobs; a rail line to bring in grain; a hinterland filled with small farmers and returning veterans willing to take on debt to survive or to chase a dream; and a harbor into which the poultry companies could conveniently dump their filth at no cost to themselves.

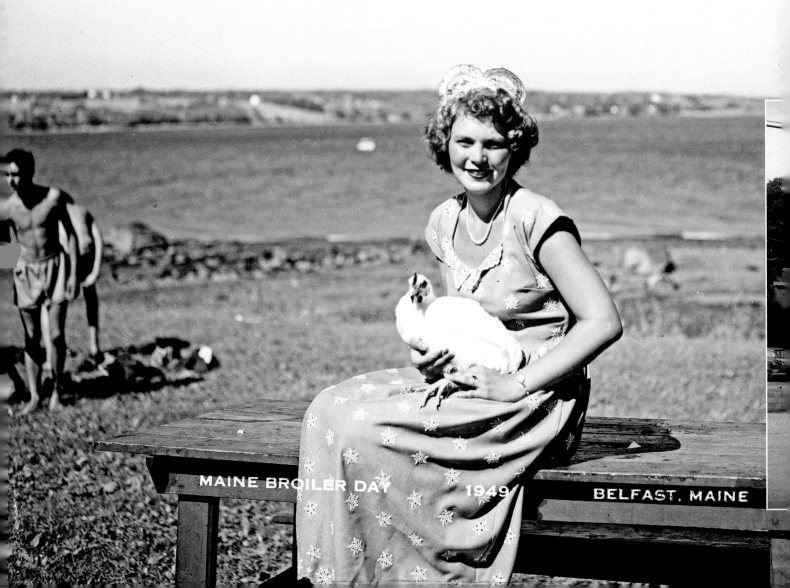

MAINE BROILER DAY 1949 BELFAST, MAINE

Wrecker Shute & Shorey's circa 1949 GMC Holmes wrecker existed for those times when the automobile becomes a no-go-mobile. The Shute & Shorey garage was right across High Street from Eastern Illustrating and was often used for drying photo postcards.

Mobilgas The year of this grand opening is likely circa 1950. The window stickers read, "Carmakers Say: Check Oil Every Time You Get Gas," and "Get Our Tire Trade In Offer." Tires accepted for trade-in were likely recapped.

The Mobilgas station looks as though it magically appeared in bricked Belfast one morning, fully formed, like a puffball in a forest. In the progression of gas station architecture, this is classic "modern," an oblong box free of traditional influences, with clean ceramic or steel siding, large windows, minimal exposed structure, and no ornamentation. Stations much like it could be found from Maine to California, forerunners of the successive waves of formulaic architecture replicated coast to coast, ad nauseam, by franchised fast-food dispensaries, motel chains, and big box stores.

In 1911 Standard Oil was broken up into thirty-three companies, including Standard Oil of New York—Socony—which registered Mobiloil as a trademark in 1920. In 1931 Socony merged with another Standard Oil offspring, the Vacuum Oil Company, creating Socony-Vacuum. In 1955 Socony-Vacuum renamed itself Socony Mobil. In 1962 the brands Mobilgas and Mobilgas Special were replaced by Mobil Regular and Mobil Premium. In 1999 Mobil and Exxon merged to form ExxonMobil.

Colonial Gables Mr. and Mrs. Leo Perry, developers (in 1957) of the Colonial Gables motel and cottage "tourist court," pose out front. The motel was (and still is) in East Belfast (between Belfast and Searsport), with views of, and frontage on, Penobscot Bay and Route 1.

Kennebunkport novelist Kenneth Roberts detested the billboards and roadside signs he passed when driving along Route 1 in York and Cumberland counties and listed many of them in his 1938 nonfiction book *Trending Into Maine*. Herewith a sampling:

BALLANTINE'S ALE • SPILLER'S SHORE DINNERS • 19 MILES TO THE NORMANDY • STOP AT AMHI • HOT DOGS • ROOMS FOR TOURISTS • 11 MILES TO MAXWELL'S ROOMS AND CABINS—AWARDED 1ST PRIZE BY MAINE DEVELOPMENT COMMISSION • SIGNS FOR EVERY PURPOSE DESIGNED AND BUILT • PULLETS FOR SALE • COCA COLA—GET THE FEEL OF REFRESHMENT • SURE, SON: FILL HER UP NO-NOX ETHYL • A LONG COOL DRINK MADE WITH 4 ROSES • OLDEST TOWN IN MAINE—KITTERY • RIPLEY'S CABINS • FULLER'S—FLUSH TOILETS

Despite Maine's admirable anti-billboard law, Route 1 from Belfast to Searsport still offers a sufficient clutter of onsite business signs to provide motorists with nearly continuous reading material.

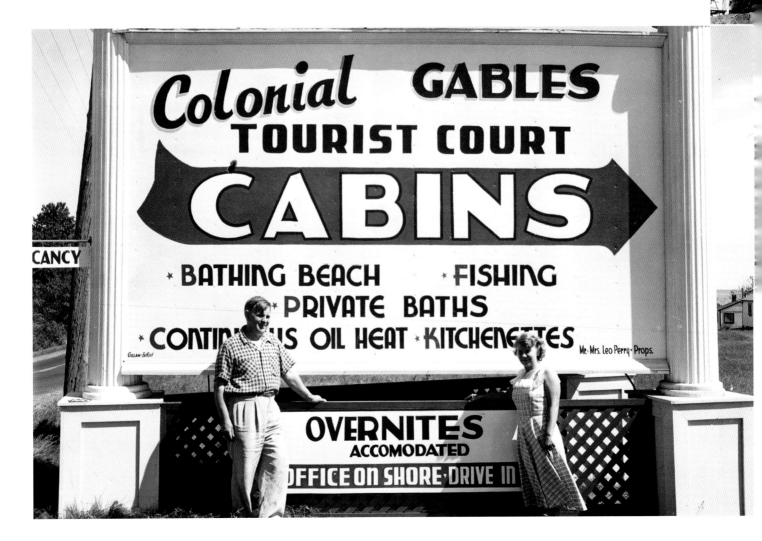

ONIAL GABLES COTTAGE NO. 41. BELFAST, MAINE J18

Colonial Nash Evidently postcards were produced for every one of the nearly fifty cabins at the Colonial Gables "tourist court," of which this is number 41. Built over a period of years, the cabins reflected changing fashions. A number featured Palladian gable windows, and there was even a log cabin.

It is now recognized by the travel industry that even when touring exotic destinations by day, Americans want to sleep at home at night. Colonial Gables figured this out long ago, and Cabin 41 is a miniature version of the American ranch-style house found in suburbia from coast to coast, right down to the aluminum deck chairs, venetian blinds, and television antenna.

The 1955 Nash Tudor Rambler—a version with the Hudson insignia was also available—bears Massachusetts plates. It has been to the White Mountains of New Hampshire, where it obtained bumper stickers for Clark's Trained Bears and Polar Caves; both attractions are still in business. A sticker proclaiming that the car climbed Mt. Washington is likely affixed to the rear bumper. Styled by the great Pininfarina, Nash cars were advertised as the choice of "the boy who wanted a Stutz Bearcat," but they proved too exotic for the average American car buyer.

LINCOLNVILLE

The Shays' Tent Mrs. Florence Nicolar Shay, a Penobscot from Indian Island, Old Town, weaves a basket while minding the seasonal sales tent that she and her husband, Leo, established along Route 1 at Lincolnville Beach. In their first season at this site, about 1930, Florence and Leo and two of their children lived in the back of the tent; in later years they rented rooms in their landlord's farmhouse, seen in the background.

The tradition of Maine Indians—primarily Penobscots—selling baskets and other handicrafts at coastal summer resorts dated well back into the nineteenth century. In the early 1900s, such seasonal encampments could be found in Maine, Massachusetts, Rhode Island, New York, and even New Jersey. (The Nicolars had for many years traveled to Kennebunkport.) The Great Depression largely ended this tradition, although a few stalwart souls carried on into the 1960s.

Florence, a master basketmaker, was from a prominent family and was a tireless advocate for Native American rights. During World War II she and Leo worked at the Boston Navy Yard while three of their sons served in the armed forces and a fourth was in the merchant marine. Son Charles, an army medic, landed on Omaha Beach and was awarded the Silver Star and four battle stars, but when he returned to Maine he—like his brothers—was denied the right to vote, an outrage that Florence fought to correct.

PENOBSCOT INDIAN CAMP -- INDIAN BASKET MAKERS --
LINCOLNVILLE, MAINE C79

Camp Tanglewood Camp Tanglewood—shown here in the 1940s—was a creation of the 1130th Company of the Civilian Conservation Corps, which from 1935 to 1941 developed what would become Camden Hills State Park on 1,500 acres in Camden and Lincolnville. Although the facilities at Tanglewood (including the stone steps pictured), completed in 1939, were intended for use by vacationers, from 1939 until 1972 the Bangor-Brewer YWCA used the property as a summer camp for girls.

Since 1982, Tanglewood has been used by the University of Maine as a 4-H camp. Forty-six buildings constructed by the CCC have survived, and Camden Hills State Park remains an invaluable asset to the Camden area in particular, to the state of Maine in general, and for countless visitors—WPA critics and today's critics of governmental environmental activities notwithstanding.

SOURCES

The Internet has revolutionized the research process for a work such as this. If references to the subject of a caption are readily available online they likely will not be listed here. In most instances only principal sources are listed. Individuals whose names are in Roman type were interviewed for the book; those whose names are in italics contributed research on an image for the Penobscot Marine Museum, with at least some of their research having aided in the writing of the caption. All whose efforts contributed to the cause are hereby thanked most sincerely.

The Eastern Illustrating & Publishing Company, by Kevin Johnson
Bogdan, Robert. *Exposing The Wilderness: Early—Twentieth Century Adirondack Postcard Photographers* (Syracuse, NY: University Press, 1999).

Harding, B. R. *Roadside New England, 1900–1955* (Portland, ME: Old Port Publishing, 1982).

Vaule, R. B. *As We Were: American Photographic Postcards, 1905–1930* (Jaffrey, NH: David R. Godine, 2004).

Belfast
Mayor Hanson's House. Williamson, *History of the City of Belfast*, p.14ff. *Journal of the AMA*, April 28, 1906, vol. 46, issues 14–26; 1910; vol. 55, pp. 40–41; "Nostrums and Quackery and Pseudo-medicines," vol. 1, 1912, p. 275. *American Druggist and Pharmaceutical Board*, Vol. 48, Jan–July 1906. *Republican Journal*, Dec. 24, 1903. Earle G. Shettleworth, Jr. *Megan Pinette.*

Schooner *Pendleton Brothers. Bangor Daily Commercial,* Oct. 22, 1903. Marine railway, *Republican Journal,* Oct. 2, 1884. Hay trade, *Bangor Industrial Journal,* July 17, 1885. See W. H. Bunting, *A Day's Work,* vol.1 (Gardiner, ME, Tilbury House:1997), p. 54-5. A schooner's steam whistle was not a legal noisemaker for navigational purposes.

Steamer *Belfast* at Belfast. *Republican Journal*, Nov. 19, 1908, May 13, 1909, June 24, 1909, July 1, 1909; June 13, 1910.

Belfast Band. Joseph Williamson, *History of the City of Belfast* (Portland, ME: Loring, Short & Harmon: 1913), p. 265.

Thorndike
Town Teams. Leola Mitchell and Edith Mitchell, *Troy, Maine: Past and Present* (Troy, ME: 1977).

Stockton Springs
Northern Maine Seaport. Alice V. Ellis, *The Story of Stockton Springs, Maine* (Belfast, ME: The Historical Committee of Stockton Springs, 1955), pp. 162–77. *Basil Staples.*

Searsport
Searsport Library. Re: shipmasters, *Republican Journal*, Dec. 23, 1909. *Faith Garrold.*

Belfast
Belfast Tearoom. Kenneth Roberts, *Trending into Maine,* (Boston: Little Brown, 1938), p. 14.

Islesboro
Steamer *Castine. History of Isleborough, Maine,1893–1983,* (Islesboro, ME: Islesboro Historical Society, 1994), pp. 27–28. John M. Richardson, *Steamboat Lore of the Penobscot* (Rockland, ME: *Courier-Gazette,* 1941), pp. 105–06.

Schooner *Alice E. Clark. History of Isleborough, Maine,1893–1983,* (Islesboro, ME: Islesboro Historical Society, 1994), pp. 126–27. *Republican Journal,* July 8, 1909.

Bayside, Northport
Bayside Carnival. *Republican Journal*, Aug. 20, 1914.

Camden
Camden Dinette. Barbara F. Dyer in *Courier Gazette/ Camden Herald*, Jan. 24, 2011.

Penobscot Bay
Schooner *James A. Webster*. 112460. Giles M. S. Tod, *The Last Sail Down East*, pp. 150, 151, 271.

Carvers Harbor, Vinalhaven
Carvers Harbor. *Republican Journal*, Nov. 7, 1907. *Report of Industrial and Labor Statistics for the State of Maine* (Augusta, ME: 1910), pp. 22, 23.

Green's Island, Vinalhaven
Heron Neck Light. Jeremy D'Entremont, *The Lighthouses of Maine* (Beverly, MA: Commonwealth Editions, 2009), pp. 301–06.

Isle au Haut
Gooden Grant. *Oceans*, May 1974. *Virginia MacDonald.*

Thomaston
Barkentine *Reine Marie Stewart*. Giles M. S. Tod, *The Last Sail Down East* (Barre, MA: Barre Publishing, 1965), pp. 48–50. Capt. W. J. L. Parker, USCG ret., "Sail, Ships & Cargoes," *Down East*, March 1971.

St. George
St. George School. Wilbert Snow, *Codline's Child* (Middletown, CT: Wesleyan University Press, 1968), pp. 80–83.

Long Cove Quarry Paving blocks, *Sixth Annual Report of the Bureau of Industrial and Labor Statistics for the State of Maine, 1892* (Augusta:1893), pp. 205-06.

Schooner *Abbie Bowker*. Albert J. Smalley, *History of St. George, Maine* (St. George, ME: Jackson Memorial League, 1976) pp. 194–200, 215. *James Skoglund.*

Port Clyde, St. George
Port Clyde Lobster. *Bangor Industrial Journal*, July 1905. *Gene Dalrymple.*

Tenant's Harbor, St. George
Killer Whale. John R. Stilgoe, *Old Fields* (Charlottsville, VA: University of Virginia Press, 2014), pp. 288–89. *Gene Dalrymple.*

Friendship
Friendship School. Hudson Vannah, *Five Generations on a Maine Farm* (Nobleboro, ME: Hudson Vannah, 1984), pp.37–39. *Margaret Gagnon.*

China
Willow Beach. Joanne Bailey Campbell.

Benton
Benton Creamery. Art Ray was my source for information re: early electrical service.

Oakland
Social Hall. *Forest and Stream*, Jan. to June, 1915. *Field and Stream*, May 1922. *The American Angler*, May 1917. *Outing*, April 1917. *Recreation*, April 1916. Paul M. Maureau, *The Masardis Saga* (Woolwich, ME: TBW Books, 1984), pp. 117–30.

Belgrade
The Lodge. Henry Richards, *Ninety Years On, 1848–1940* (Augusta, ME: Kennebec Journal Press, 1940).

Gardiner
Depot Square. O. R. Cummings, "Trolleys to Augusta, Maine," *Transportation Bulletin*, National Railway Historical Society, no. 78, Jan.–Aug., 1969.

Commonwealth Shoe. *Gardiner & Bostonians* (Gardiner, ME: Gardiner Board of Trade, 1951). Danny D. Smith and Earle G. Shettleworth, Jr., *Gardiner on the Kennebec* and *Gardiner* (Mount Pleasant, SC: Arcadia Publishing). Ralph B. Skinner, *Auburn, 100 Years a City* (Auburn, ME: Auburn History Committee, 1968), p. 120. Conversations with Walter Morgan, Jon Lund.

Dresden
Bowman House. Emma Huntington Nason, *Old Colonial Houses in Maine Built Prior to 1776* (Augusta, ME: Kennebec Journal Press, 1908), pp. 93–94.

Dresden Ferry. *Bangor Daily Commercial,* Jan. 16 1904.

East Boothbay
Bayville. Francis Byron Greene, *History of Boothbay, Southport, and Boothbay Harbor, Maine,* 1623–1905 (Portland, ME: Loring, Short & Harmon, 1906), ch. xxiv. *Bangor Industrial Journal,* June 30, 1899 (seals). Barbara Rumsey, Julia Merrill, Jim Stevens.

Boothbay Harbor
Motor Vessel *Argo.* Jim Hunt.

Southport
Steamer *Southport.* Constance Rowe Lang, *Kennebec Boothbay Harbor Steamboat Album* (Camden, ME: Down East, 1971), pp. 6–9. Wonderful essay by Richard Hallet.

Monhegan Island
Monhegan Harbor. *Republican Journal,* June 30, 1910.

Woolwich
Woolwich Cow. Nathan Lipfert, Dan Wood.

Woolwich Ferry. William Avery Baker, *A Maritime History of Bath, Maine* (Bath, ME: Maine Maritime Museum, 1973), pp. 551–64. Henry Wilson Owen, *The Edward Clarence Plummer History of Bath, Maine* (Bath, ME: The Times Company, 1936), p. 309.

Bath
Washington Street. *Bath Daily Times,* Jan. 16, 1888. Ralph Snow, Charles Burden, Nathan Lipfert, Earle G. Shettleworth, Jr.

Brunswick
Balsam Pillows. Adirondack Almanack website.

South Portland
Flying Boat. Victor Vernon, "Memoirs of an Early Bird" at www.earlyaviators.com.

Biddeford Pool
The Basin. Earle G. Shettleworth, Jr., and W. H. Bunting, *An Eye for the Coast* (Gardiner, ME: Tilbury House, 1998), p. 206.

Kennebunkport

Kennebunkport Beach. Joyce Butler, *Kennebunkport: The Evolution of an American Town*, vol. 1 (Kennebunkport, ME: Louis T. Graves Memorial Public Library), p. 384. See excellent Wikipedia article "Klu Klux Klan in Maine." Also Harold B. Clifford, *Charlie York: Maine Coast Fisherman* (Camden, ME: International Marine, 1974), pp. 100–01.

Limerick

Limerick. Linda Maule Taylor, ed., *Limerick Historical Notes* (Limerick, ME: Town of Limerick, 1975). *Fourth Annual Report of the Bureau of Industrial and Labor Statistics* (Augusta, ME: 1891), p. 130.

York

York Shingle-Style. Roger G. Reed, *A Delight to All Who Know It* (Portland, ME: Maine Historic Preservation, 1995). *York Harbor, Maine* (York, ME: The Village Corporation of York, 1936).

Albany

E & B Spool. Leading Citizens of Oxford and Franklin Counties, Maine (Boston: Biographical Review Publishing Company, 1897), p. 276. "Lillian 'Dot' Brown's Albany, Maine Notes," at www. albanymaine.org.

East Peru

East Peru Ferry. Mary Seamless Vaughn, *A History of the Town of Peru* (Rumford, ME: Rumford Publishing Company, 1971).

Rangeley

Mingo Springs. Gary N. Priest, *A History of Wrangle's Hotels and Camps* (self-published, 2003), pp. 30–31.

Rangeley Lakes Hotel. Ibid., pp. 46–47.

Rangeley Boat. *Bangor Industrial Journal*, July 17, 1885; Aug. 25, 1894, July 10, 1896. Stephen A. Cole, *The Rangeley and Its Region: The Famous Boat and Lakes of Western Maine*. (Gardiner, ME: Tilbury House, 2007). Donald R. Palmer, *The Rangeley Lakes Region* (Mount Pleasant, SC: Arcadia Publishing, 2004). Julia A. Hunter and Earle G. Shettleworth, Jr., *Fly Rod Crosby* (Gardiner, ME: Tilbury House, 2000).

Kennebago. Maine Revised Statutes 1903, ch. 32.

Grant's. Ibid., p. 23. Gary N. Priest, *The Gilded Age of Rangeley, Maine* (self-published, 2009), p. 327.

North Jay

North Jay. *Board of Trade Journal* (Portland, ME: May 1907), p. 395.

Farmington

Farmington Canning Factory. Paul B. Frederick, *Canning Gold: Northern New England's Sweet Corn Industry* (Lanham, MD: University Press of America, 2002).

Smithfield

Camp Norridgewock. *Lewiston Sun Journal Magazine*, Jan. 2, 1954. *Sargent's Handbook of America's Private Schools* (1922).

Solon

New Solon Bridge. *Lewiston Sunday Journal, April 8 1926*. Resolve of the Legislature, March 7, 1913. The ferry income had been $700 per annum.

Cambridge

Quimby Farm. Randall Quimby.

Ripley
Ripley. Sandra Wintle Blaney, *Entering Ripley* (Dexter, ME: Dexter Print Shop, 2007). *Annual Register of Maine* (Portland, ME: 1921), p. 1038.

Monson
Monson Slate. *Bangor Industrial Journal,* Feb. 1916.

T3 R11 WELS
Pulp Boom. Alfred Geer (Orono, ME: University of Maine Press, 1931), pp. 137–40. *Lewiston Sun Journal,* Nov. 20, 1933.

Seboeis Stream, T6 R7 WELS
Seboeis Deer. USDA Farmer's Bulletin 628, Game Laws for 1914 p. 41. *Maine Automobile Road Book* (Portland, ME: Maine Automobile Association, 1914), p. 204.

Patten
Lombards. *Bangor Industrial Journal,* Jan. 11, 1901. See excellent Wikipedia article on Holt Manufacturing Co. W. H. Bunting, *A Day's Work,* vol 2 (Gardiner, ME: Tilbury House, 2000), p. 198.

Island Falls
Island Falls Tannery. Nina G. Sawyer, *A History of Island Falls, Maine* (Island Falls, ME: 1972), pp. 33, 34, 111, 112.

Masardis
Haywood. The story of Miss Stimson was picked up by numerous newspapers found on the Internet. *Annual Register of Maine* (Portland, ME: 1910). Phil Dechaine, Ella Weeks.

Ashland
Ashland Village. *Reflections of Early Ashland* (Ashland, ME: Ashland Sesquicentennial Book Committee, 1987)

Eagle Lake
Eagle Lake. James C. Ouellette, *Eagle Lake: The History of a Lumbering Town in Aroostook County, Maine* (Harpswell, ME: Harpswell Press, 1980).

Eagle Lake Hospital. Faye Daigle, "Little Franciscans of Mercy" on the Internet. Anthony Betts, M.D., *Green Wood and Chloroform* (Camden, ME: Down East Books, 1998).

Fort Kent
Fort Kent Mill. *Fort Kent Centennial 1869–1968* (1969), p. 73. Laurel T. Daigle, *Fort Kent,* (Mount Pleasant, SC: Arcadia Publishing, 2009), pp. 20–21.

Daigle
Daigle. *Annual Register of Maine* (Portland, ME: 1900, 1910).

Caribou
Caribou Potato Harvest. Clarence A. Day, *Farming in Maine 1860–1940* (Orono, ME: University of Maine Press, 1963), pp. 281–82.

Fort Fairfield
BAR Fort Fairfield. Jerry Angier; Herb Cleaves, Herb, *Bangor and Aroostook, the Maine Railroad.* (Littleton, MA: Flying Yankee Enterprises:1966).

Fire Engine. Andy Swift.

Easton
Easton Potato Field. *Thirteenth Census of the United States, 1910. Abstract Supplement for Maine,* pp. 608–09.

Houlton
Houlton. Day, *Farming in Maine*, p. 133.

Wytopitlock
Wytopitlock. *Annual Register of Maine* (Portland, ME: 1910, p. 537; 1920, p. 639; 1924, p. 516). Mitch Lanky, "Challenges of Managing a Small Town," *The Maine Townsman*, April 2004.

Danforth
Danforth Soldier. Wilbur J. Love, *A History of Danforth* (circa 1930), pp. 52–56.

Baileyville
Opera House. *Al Churchill.*

St. Croix Mill Pond and Wood Pile. *Bangor Industrial Journal*, March 1905; October 1906. *Al Churchill.*

Calais
Calais Minaret. George Bacon, *Calais, Eastport and Vicinity Representative Businessmen* (Newark, NJ: Glenwood Publishing Company, 1892), p. 22. 1892 New York Supreme Court, *Max Kalish v. Julius Kalish and other Respondents. Al Churchill.*

Calais Bunting. *Al Churchill.*

Pembroke
Pool Room. *Bangor Daily News*, Jan. 10, 1997. When searching on the Internet enter both "pomroy" and "pomeroy." *Gail Menzel.*

Dennysville
Schooner *David Cohen*. Capt. Douglas K. Lee, *Ron Windhorst.*

North Lubec
North Lubec Queen Annes. Interview of Moses Pike by W. H. Bunting in the 1970s. *Pauline and Harold Bailey.*

Columbia Falls
Ruggles House. Nancy Greeney and Clara H. Drisko (Cherryfield, ME: Narraguagus Printing Company, 1976). Ruggles House Society.

Gouldsboro
Summer Church. *George Daly, Mary Lou Hodge.*

Corea
Corea Village and Harbor. *Historical Researches of Gouldsboro, Maine.* (Gouldsboro, ME: Daughters of Liberty, 1904). *Jennifer Stucker, Morna Briggs.*

East Sullivan
East Sullivan Brickyard. *Gary and Jean Edwards.*

Store Wagon. R. E. Gould, *Yankee Storekeeper* (New York, McGraw-Hill, 1946) p. 73. *Jeanne Edwards.*

Sullivan
Bristol Hotel. *Gary Edwards.*

Bar Harbor
Kennedy Cottage. Samuel Eliot Morison, *The Story of Mount Desert Island* (Boston: Little Brown, 1960), pp. 49–50.

Southwest Harbor
Southwest Harbor. *Ralph Stanley, Willie Granston.*

Burnt Coat Harbor, Swan's Island
Minturn Paving Stone. *Gwen J. May.*

Ellsworth
Ellsworth. David C. Smith, *A History of Lumbering in Maine 1861–1960.* (Orono, ME: University of Maine Press, 1972), pp. 124–25. *The Maine Register, 1913. Darlene Springer.*

Triangle Filling Station. *Darlene Springer.*

Blue Hill
Arcady. Robin Clements. *Brad Emerson.*

Richards Cottage. Robin Clements. *Brad Emerson.*

Stonington, Deer Isle
Lobster Smack. Arthur S. Woodward, *Adventures and History from Downeast Maine* (Winterport, ME: International Maritime Library, 2014).

South Brooksville
Friendship Sloop. *Friendship Sloop Society Yearbook*, 1992.

Brooksville
Goose Falls. *Traditions and Records of Brooksville, Maine* (Brooksville Historical Society, circa 1936), pp. 69-70.

Penobscot Bay
Sloop *Lydia*. Gerald Warner Brace, *Between Wind and Water* (New York: W. W. Norton, 1966), p. 75. Lang, *Kennebec Boothbay Harbor Steamboat Album*, pp. 6-9. Wonderful essay by Richard Hallet.

Old Town
Old Town Canoe. *Bangor Industrial Journal*, June 1905; May 1914; Jan. 1915.

East Corinth
East Corinth Butter Factory. *Report of the Commissioner of Agriculture of the State of Maine* (Augusta, Me. 1904 p. 221; 1905, p. 195.

Unity
Marching Campers. See *Bangor Industrial Journal* issues from 1914 and after.

Camper Archers. *Lori Roming.*

Morrill
Morrill Scholars. Dr. Dora Anne Mills, "Chronic Diseases: The Epidemic of the Twentieth Century," *Maine Policy Review*, vol. 9, issue 1, 2000.

Liberty
Liberty. Alfred Hurwitz, *History of Liberty, Maine, 1827–1975* (Liberty, ME: Liberty Historical Society). *Bangor Industrial Journal*, April 1912.

Belfast
Float Plane. Bob Bailey.

Broiler Queen. *Liz Fitzsimmons, David Ruberti.*

Mobilgas. Dwayne W. Jones, *A Field Guide to Gas Stations in Texas.* Texas Dept. Of Transportation, 2003. On the Internet.

Wrecker. *David Ruberti.*

Lincolnville
Shays' Tent. Charles Norman Shay.

Camp Tanglewood. *Liz Fitzsimmons.*

INDEX OF IMAGES

The Eastern Illustrating collection arrived at the Penobscot Marine Museum in 2007 and has since grown from 5,000 to more than 50,000 negatives as "escaped" negatives have been located and reunited with the collection. The museum's goal is to make the images available to the public through an online database on its website. By 2016, more than 30,000 of the negatives were digitized and linked to database records—a slow and expensive process abetted greatly by a dedicated group of volunteers.

The digitized images are available to educators, historians, researchers, genealogists, and the interested public and can be used for publication or licensing or purchased as fine art prints. Each negative is assigned a unique image number, and the images can be searched from the museum's website by keyword, subject, or image number. A "feedback" button on each record allows users to contribute information about a photo. You can support this work by donating to PMM, volunteering at the museum, becoming a member, or buying a print. For more information, visit the photography archive at www.penobscotmarinemuseum.org or call the archive at (207) 548-2529 extension 210 or 211.

The Eastern Illustrating photographs used in this book are listed below in their order of appearance. Each is identified by book caption title and Penobscot Marine Museum object identification number.

Vinalhaven
Carvers Harbor, LB2007.1.109756; Heron Neck Light, LB2012.25.122454.

Isle au Haut
Gooden Grant, LB2010.9.117645.

West Rockport
Mirror Lake, LB2007.1.103067.

Appleton
Appleton CemeteryLB2007.1.100030.

Thomaston
Thomaston Main Street, LB2007.1.102728; Barkentine *Reine Marie Stewart,* LB2007.1.102738.

St. George
St. George School, LB2013.22.122599; Long Cove Quarry, LB2007.1.101253; Schooner *Abbie Bowker,* LB2007.1.101249.

Port Clyde, St. George
Port Clyde Lobster LB2007.1.113533.

Tenants Harbor, St. George
Killer Whale, LB2010.9.117573.

Friendship
Friendship School, LB2007.1.106111.

Washington
Medomak Camp, LB2007.1.111041.

China
Willow Beach Camps, LB2010.9.117914.

Benton
Benton Creamery LB2008.19.115966.

Oakland
Social Hall, LB2007.1.103749.

Rome
Bear Spring, LB2008.19.116655.

Belgrade
The Lodge, LB2007.1.103296.

Readfield
Camp Maranacook Cabin, LB2007.1.102160.

Monmouth
Maxwell in Monmouth, LB2007.1.101858.

Augusta
Water Street, Augusta, LB2007.1.106389.

Gardiner
Depot Square, Gardiner, LB2007.1.112615; Commonwealth Shoe, LB2007.1.112921; Gardiner Ice Cream, LB2007.1.106204.

East Pittston
East Pittston Haying, LB2007.1.100642.

Dresden
Bowman House, LB2007.1.103025; Dresden Ferry, LB2007.1.103023.

East Boothbay
Bayville, LB2007.1.100091; Bayville Demi, LB2007.1.100090.

Boothbay Harbor
Motor Vessel *Argo,* LB2010.9.118754, Grumps, LB2010.9.118749.

Southport
Southport Steamers, LB2007.1.102552.

Monhegan Island
Monhegan, LB2010.9.118081; Monhegan Harbor, LB2007.1.101550.

Woolwich
Woolwich Cow, LB2007.1.114122; Woolwich-Bath Ferry, LB2007.1.103090.

Bath
Front Street, Bath, LB2007.1.100078; Washington Street, Bath, LB2007.1.112956.

Phippsburg
Jersey Steers, LB2007.1.102061; Popham, LB2007.1.118618.

Brunswick
Balsam Pillows, LB2007.1.100332.

Danville Junction, Auburn
Danville Junction Girl, LB2007.1.100480; Danville Junction Diamond, LB2007.1.112589.

New Gloucester
J. C. Hammond Farm, LB2008.19.116253; New Gloucester Intervale, LB2007.1.108347.

South Portland
Flying Boat, LB2007.1.102534.

Biddeford Pool
The Basin, LB2007.1.117386.

Biddeford
Frye's Place, LB2007.1.101139.

Kennebunkport
Kennebunkport Beach, LB2007.1.107322; LB2007.1.107323.

York
York Shingle-Style, LB2007.1.112909.

Limerick
Limerick, LB2007.1.101465.

Denmark
Camp Wyonegonic , LB2008.19.115462.

Harrison
Narrow Gauge, LB2007.1.112623.

Albany
E & B Spool, LB2010.9.118221.

Rumford
Rumford Center Ferry, LB2007.1.102272.

East Peru
East Peru Ferry, LB2007.1.100641.

East Dixfield
Baby Buggy, LB2007.1.100580.

Rangeley
Mingo Springs, LB2007.1.102151; Rangeley Lake Hotel, LB2007.1.114471.

Stetsontown Township, Rangeley Lakes Region
Kennebago Falls, LB2008.19.115626; Rangeley Boat, LB2008.19.115624; Grant's Camps, LB2001.7.100923; Grant's Pasture, LB2008.19.115621.

Phillips
Charles Wheeler's Cattle, LB2007.1.109184.

Weld
Blue Mountain Camp, LB2007.1.111750.

North Jay
North Jay Granite, LB2007.1.101841.

Jay
Chisholm Flat, LB2007.1.100415.

Farmington
Farmington Canning Factory, LB2007.1.100745.

Vienna
Maine Skewer and Dowel, LB2007.1.102803.

Smithfield
Camp Norridgewock, LB2007.1.103793.

Madison
Madison Library, LB2007.1.101318.

Solon
New Solon Bridge, LB2007.1.114357.

Cambridge
Ora B. Quimby Farm, LB2007.1.100371.

Ripley
Ripley Village, LB2007.1.102179.
East Dover
East Dover Brickyard, LB2007.1.100587.

Derby Village at Milo Junction, Milo
Derby Village, LB2007.1.105280.

Abbott
Abbott, LB2007.1.103815.

Monson
Monson Slate, LB2007.1.101647.

Misery Gore
Somerset Junction, LB2007.1.109880.

Rockwood
Moosehead Salmon, LB2007.1.110178.

T3 R11 WELS
Pulp Boom, LB2007.1.111462.

Seboeis Stream, T6 R7 WELS
Sebois Deer, LB2007.1.108982.

Patten
Lombards, LB2007.1.112337; LB2007.1.112338.

Island Falls
Island Falls Tannery, LB2007.1.101069; Birch Point Pavilion, LB2007.1.101074.

Masardis
Haywood Post Office, LB2007.1.101018.

Ashland
Ashland Village in Winter, LB2007.1.104025; Exchange Street, Ashland, LB2007.1.100034; The Exchange Hotel, LB2007.1.100033. Ashland School, LB2007.1.100035.

Portage
Portage, LB2007.1.112816.

Eagle Lake
Eagle Lake Mills, LB2007.1.100552; Maine Street, Eagle Lake, LB2007.1.100550; Eagle Lake Hospital, LB2007.1.100551.

Fort Kent
Fort Kent Mill, LB2007.1.100833.

Upper Frenchville
Upper Frenchville, LB2007.1.114423.

Daigle, New Canada Township
Daigle, LB2008.19.116101.

Van Buren
Potato Digging, LB2008.19.116819.

Caribou
Caribou Potato Harvest, LB2008.19.116697.

Fort Fairfield
AR Fort Fairfield, LB2007.1.112608; Fort Fairfield Hotel, LB2007.1.105968; R. J. McKee, Hotelman, LB2007.1.100820; Fire Engine, LB2007.1.100816; River Drivers' Bateau, LB2007.1.114780.

Easton
Easton Potato Field, LB2007.1.100664.

Mars Hill
Italians, LB2007.1.101355.

Houlton
Houlton Queen Anne, LB2007.1.114270.

Wytopitlock Village, Reed Township
Boardinghouse, LB2007.1.103115; Wytopitlock, LB2007.1.103241.

Danforth
Danforth Soldier, LB2010.9.119148.

Baileyville
Opera House, LB2007.1.103007; St. Croix Mill Pond, LB2007.1.103009; St. Croix Woodpile, LB2007.1.113982.

Calais
Calais Minaret, LB2007.1.114233; Calais Bunting, LB2007.1.114238.

Pembroke
Pool Room, LB2007.1.112413.

Dennysville
Schooner *David Cohen*, LB2007.1.100512.

North Lubec
North Lubec Queen Annes, LB2007.1.101856; North Lubec Sardine Camps, LB2007.1.101852.

Columbia Falls
Ruggles House (before), LB2007.1.100420; Ruggles House Interior, LB2007.1.100422; Ruggles House (after), LB2007.1.100423.

Jonesport
Sardine Factory, LB2010.9.118049.

Gouldsboro
Summer Church, LB2007.1.103048.

Corea
Corea Village, LB2007.1.100430; Corea Harbor, LB2007.1.106113.

East Sullivan
East Sullivan Brickyard, LB2010.8.120988; Store Wagon, LB2010.8.117129.

Sullivan
Bristol Hotel, LB2007.1.112844.

Bar Harbor
Kennedy Cottage, LB2007.1.106268.

Southwest Harbor, Mt. Desert Island
Southwest Harbor, LB2007.1.102558.

Burnt Coat Harbor, Swan's Island
Minturn Paving Blocks, LB2007.1.102700.

Ellsworth
Ellsworth, LB2007.1.100694; Triangle Filling Station, LB2007.1.100639.

Blue Hill
Arcady, LB2010.9.118248; Richards Cottage, LB2007.1.104293; Ornamental Blacksmith, LB2010.9.118290.

Little Deer Isle
Boatshack, LB2010.9.119618.

Stonington, Deer Isle
Stonington, LB2007.1.102611; Lobster Smack, LB2010.9.118512.

South Brooksville
Friendship Sloop, LB2007.1.114428.

Brooksville
Boat on Truck, LB2007.1.104274; Goose Falls, LB2007.1.100968.

Penobscot Bay
Sloop *Lydia*, LB2007.1.114961.

Penobscot River
"Bangor River", LB2007.1.117456.

Prospect
Waldo-Hancock Bridge, LB2007.1.104664.

Old Town
Old Town Canoe, LB2007.1.102029.

East Corinth
East Corinth Corn Factory, LB2007.1.100577; East Corinth Butter Factory, LB2007.1.105416.

Carmel
Bella the Baboon, LB2007.1.102253.

Unity
Marching Campers, LB2007.1.111006; Camper Archers, LB2007.1.102778; Powwow, LB2007.1.114972.

Morrill
Morrill Scholars, LB2007.1.101684.

Liberty
Liberty, LB2007.1.107517; "Uneedarest", LB2008.19.116379.

Belfast
Colonial Theatre, LB2007.1.114782; Belfast Puzzle, LB2010.9.118225; LB2010.9.118226; Float Plane, LB2007.1.106380; Broiler Queen, LB2007.1.104454; Mobilgas, LB2007.1.109562; Wrecker, LB2007.1.106308A; Colonial Gables, LB2007.20.119764; Colonial Nash, LB2007.20.119796.

Lincolnville
The Shays' Tent, LB2007.1.107647; Camp Tanglewood, LB2007.1.101222.